"Photographers have evidently made up their minds that it is high time to introduce some new style of portraiture to the public, and we entirely agree with them.... One thing is clear. Photographers must pull together if they want to make a definite step. This we urge upon them very earnestly, and if any suggestions come to us on the subject we will readily give them the publicity...."
The Photographic News, London, 1880

FACE

"The human face is indeed, like the face of a God of some Oriental theogony, a whole cluster of faces, crowded together but on different planes so that one does not see them all at once." Marcel Proust, 1919

Roland Fischer *Soldiers*, from the series 'Collective Portraits' 2002

FACE
THE NEW PHOTOGRAPHIC PORTRAIT

WILLIAM A. EWING, WITH NATHALIE HERSCHDORFER

WITH 258 ILLUSTRATIONS, 166 IN COLOR, 92 IN DUOTONE

"The face, however, still continued to grow with enormous rapidity, and in a short time the head filled up the whole of the album aperture, and the body disappeared altogether."
The Photographic News, London, 1880

Thames & Hudson

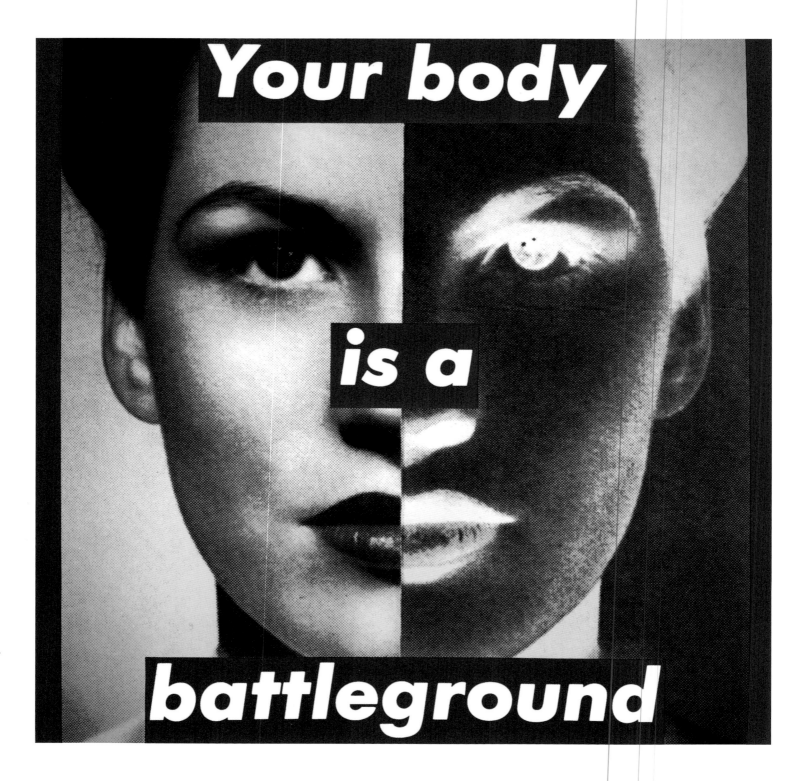

Barbara Kruger *Untitled (Your body is a battleground)* 1989

CONTENTS

PRE FACE

In the last decades of the twentieth century the body was a dominant theme in photography. And no wonder. Bodies were beginning to be seriously reconfigured and reconstituted by scientists and engineers. It seemed that an era of 'real' replicants and cyborgs – the suave blending of organic and electromechanical capacities – was finally upon us. Image-makers felt the need to keep pace. The nude, that venerable tradition of the soft, pliant and passive female body, which had dominated photography for more than a hundred years, necessarily gave way to the grittier, messier and fleshier genre of 'the body', which began to take into account the various ways in which the sciences (genetics, cell biology, neurology, pharmacology, etc., etc.), biomedical technologies (including non-invasive electronic imaging of the interior of the body), related technologies (robotics, artificial intelligence, nano-technology), commercial and advertising stratagems, feminism, sociology, psychology, cultural studies, and so on, were either reinventing or reimagining the envelope that comprises a human being. The artist Barbara Kruger summa-rized the turmoil succinctly in 1989 with: 'Your body is a battleground.' Kruger's message echoed an earlier warning of communication theorist Marshall McLuhan, who argued that the nascent electronic world was simply an extension of the human body's nervous system, concluding that 'the field of battle ... was shifting from the material world to mental image-making and image-breaking'.[1]

Interestingly, Kruger chose a face to convey her message rather than a body. Body photography had generally made a point of avoiding faces, which were distracting, too *personal* – too sight-specific, as it were. Body photographers sought to

Loretta Lux *Dorothea* 2001

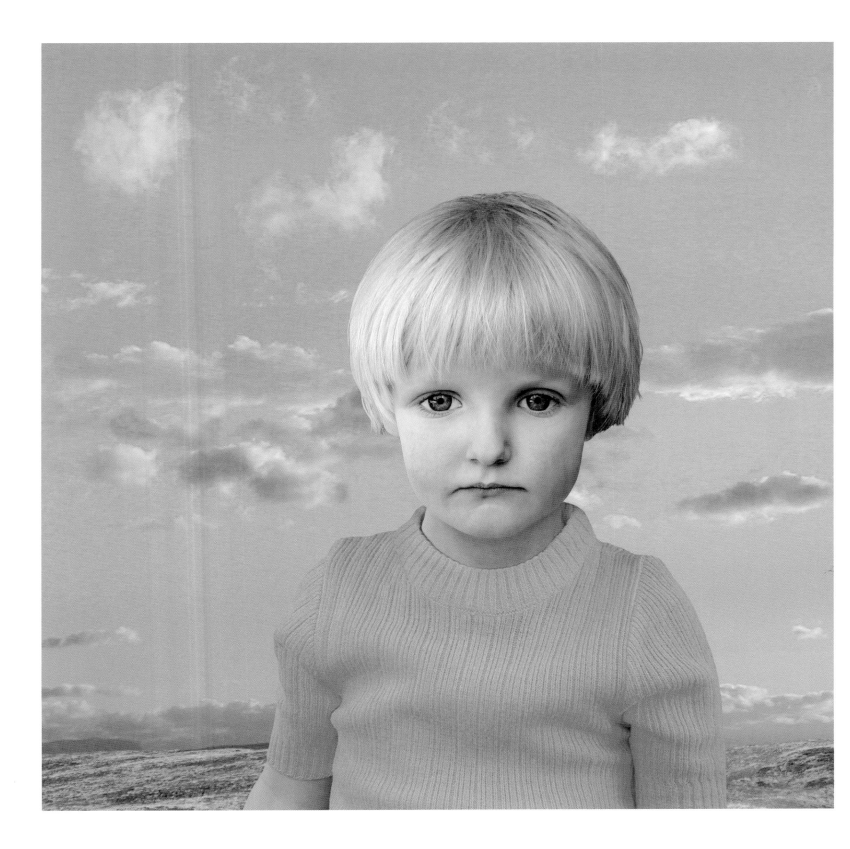

Stranger: "That's a beautiful child you have there." Mother: "That's nothing. You should see his photograph."

make statements about the universal human condition (or a subset like the female body, the male body, the ageing body, the suffering body, and so on), and showing faces inevitably subverted this goal, tying the message too closely to a particular individual. But for viewers of body photography, such exposure *was* an intensely personal experience – after all, we are seldom able to scrutinize another naked body in the public sphere. We do, however, walk around with our *faces* exposed to the gaze of others. While the body, therefore, remains largely a private affair, despite our culture's obsession with it, the face is a public one.

It was therefore inevitable that the body/face pendulum would swing back in forceful fashion in favour of the face. Faces are fundamentally important to social life. 'We are not solitary mammals like the fox or the tiger; we are genetically social, like the elephant, the whale and the ape,' wrote Ben Maddow in 1977 in his masterful history of the portrait in photography. 'What is most profoundly felt between us, even if hidden, will reappear in our portraits of one another.'[2] And anthropologists remind us that faces predate human beings by eons: 'Facial displays are evolutionary-designed devices to elicit responses' [from fellow animals], notes primate specialist Signe Preuschoft: 'Studying the faces of non-human primates is like using a looking-glass. Reflected back at the human beholder is an animal passionately involved in social events, communicating its emotional attitudes through its face – cheating, tricking, bluffing, but also behaving with baffling honesty.'[3]

The faces we negotiate on a daily basis, however, are not only of the physical, flesh-and-blood variety, but the age-less, defect-free, care-free, cloned faces of the billboard (amplified by virtue of their prodigious scale) and glossy magazine page (the French expression, *papier glacé*, or mirrored paper, is apt; these pages reflect our collective desires). Retouched to *super*human perfection, these faces are composite products of many commercial artists – models, art directors, stylists, make-up artists, designers, photographers, retouchers, photoshopkeepers, lithographers and printers. While the faces they construct are meant to seduce in a fraction of a second, their 'after images' are retained much, much longer – making for a highly effective mental drip-feed. Taken together, these radiant faces constitute a fluid environment of never fully attainable desire – for beautiful faces (one's own and those of others) and the beautiful things that are promised for their owners. As Wang Yaoyao told a row of judges at a recent 'Miss Artificial Beauty' contest, 'Beautiful people also have beautiful dreams.'

For millennia, one's face was one's destiny, fixed and immutable. But today the face can be rejuvenated by 'cosmeuticals, nanotechnology make-up and lush mascara with more patents than a rocket ship', as a recent newspaper announce-

ment put it.[4] Or it can be restructured – even, as of late, replaced – via cosmetic surgery. Genetic engineers, meanwhile, tell us that surgery is a merely temporary strategy, and talk of a near-at-hand glorious future of 'pre-birth alteration' whereby features will be chosen from designer catalogues.

The global uniformity of consumption with its appropriately homogenized faces does not only involve markets of goods and services, but political products as well. In the dazzling new mediascape, meticulously staged 'photo-opportunities' are designed to render politicians and their agendas as desirably as 'designer' trinkets.

The face of human individuality is a more troublesome concept now. The old identity photographs on our passports and driving licences are no longer detailed enough to represent us as individuals. The truly meaningful differences, we are told, are 'invisible' to the naked eye, and powerful new mapping scanners have been developed to distinguish one person from the next. 'Facial recognition systems' tell us that the iris of the eye has 240 structural variables, or 'degrees of freedom', as they are sometimes called – an ironic term, given that the technology can only end up restricting individual liberties. 'People know we're watching,' notes one such specialist with chilling precision. 'Word travels fast. Fear travels as well.'[5]

Thus, today, art photographers who wish to say something meaningful about the face are looking for strategies and tactics to match its rapidly evolving social and technological environment. In the past century portraiture had a far more restricted agenda: it was either limited to the aim of revealing 'inner truths' about individuals, or making generalized statements about 'the face of our time'. If the former turned out to be a hollow, though seductive, claim, photographers who took the latter route fared better: we have only to think of the great, sweeping achievements of August Sander, Diane Arbus or Richard Avedon. But then, the face – as an object, a thing – was a stable affair. Today, it is quicksand.

The approaches of the photographers shown in this book are extremely diverse and creative. But at least one factor unites the disparate imagery: a belief in the relevance, indeed urgency, of the task. The face is a battleground – for science, technology, industry, commerce and art – and we had better take sides, for as McLuhan warned almost a half-century ago, 'Once we have surrendered our senses and nervous systems to the private manipulation of those who would try to benefit from taking a lease on our eyes and ears and nerves, we don't really have any rights left.'[6] The conventional twentieth-century approach to the portrait is outmoded and irrelevant. Happily, the photographers of 'Face' have decided to tear down the crumbling façade and rebuild anew.

I have taken a wide degree of poetic licence in the juxtaposition of commentaries and photographs, which does not necessarily reflect the opinions and intentions of their makers. Words and images make for uncomfortable bedfellows and, although I have tried to remain faithful to the essence of each work, I ask for indulgence for any perceived transgressions.

William A. Ewing

INTRODUCTION

ABOUT FACE

The word 'portrait' carries a great deal of historical baggage, and no small amount of confusion and contested meanings. When photography came along in the mid-nineteenth century, some assumed that it was simply an extension of the painted portrait – 'Rembrandt perfected', in Samuel Morse's then celebrated phrase.[1] Indeed, members of a family sometimes requested to be photographed individually, assuming that a portrait of a group would take much longer, as would posing for a painting.[2] Those who believed that painted portraits were by definition superior to anything the upstart daguerreotype could offer pointed to the cold metallic surface and the total absence of colour. The general public, however, were not put off by elitist disdain: they instinctively understood that the photograph heralded a new age, no less so than the steam-engine, the railway and the telegraph. 'Is not magic surpassed?' wrote one commentator in London's weekly *Photographic News*. 'We can have enclosed in a frame the mother we revere, the child we idolize....'[3] So magical was the process that people were initially content to buy portraits of absolute strangers – models who simply knew how to sit still and unblinking for the long minutes the earliest sittings required.[4]

Luigi Gariglio *Marina, Lap dancer, Glasgow* 2005

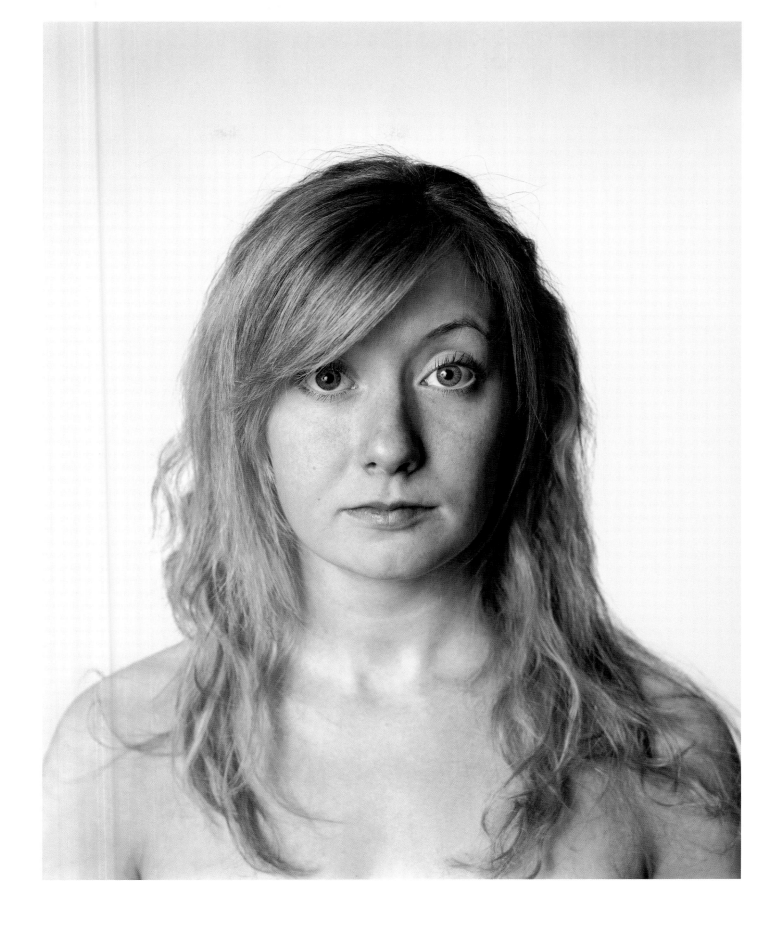

"'The face is what one goes by, generally,' Alice remarked in a thoughtful tone. 'That's just what I complain of,' said Humpty Dumpty. 'Your face is the same as everybody has — the two eyes, so —' (marking their places in the air with his thumb) 'nose in the middle, mouth under. It's always the same. Now if you had the two eyes on the same side of the nose, for instance — or the mouth at the top — that would be *some* help.'"
Lewis Carroll, 1871

Westerners have long been amused by the seemingly universal belief of 'primitive' peoples that the photograph 'steals' the soul. Today, we are wiser and less condescending, understanding that photography is very much a social transaction, and often an unequal one at that. The rich Westerner 'takes' a photograph of a poor Indian, but what does the latter get in return for being 'taken'? The distrust felt by the subject is, in fact, based on a vague intuition that the photographic act represents an imbalance of power – and probably not one in his favour. This intuitive grasp that *something* is at risk was also manifest in the apprehension many Westerners apparently felt in the early days of portraiture, as the great Parisian portraitist Nadar reported. 'I found among dignified men, even the most eminent of them,' he wrote, 'an anxiety, an extreme nervousness, almost anguish, concerning the most insignificant detail of their dress or nuance of their expression.'[5] Nadar, on the power side of the lens, as it were (like the rich tourist), couldn't understand what all the fuss was about. 'It was saddening, even repugnant,' he complained. But the famous photographer was being disingenuous: he knew more than anyone that people were coming face to face with their images for the first time, and that most of his clients had never even seen a clear and crisp reflection of themselves in a mirror.

While the modern mirror dates from the mid-sixteenth century, when the Venetians of Murano compressed a layer of mercury between a sheet of glass and a sheet of metal, allowing for perfect, distortion-free reflections, few people had access to one. The new mirrors slowly replaced the much inferior bronze, pewter, silver and gold varieties, but remained almost exclusively in the hands of royalty and the

nobility. Ordinary people had no way of keeping track of the slow ravages of time on their own faces. 'How could one see one's double chin in the bottom of a copper pot?' asks historian Véronique Nahoum, concluding that 'the mirror stage is not only an important one for the baby of six months, but *an important stage in history*' [author's italics].[6] The anthropologist David Le Breton concurs, stressing that 'no mirror would decorate the walls [of ordinary homes] before the end of the nineteenth or the beginning of the twentieth century'.[7]

This lack of self-awareness, in the visual sense at least, helps to explain the hysteria that accompanied the early years of photography. No less a visionary than Honoré de Balzac refused to be photographed – in the belief that it would strip away a microscopic layer of his being.[8] Balzac was not alone in intellectual circles for believing the medium to have suspect properties; Herman Melville was another who flatly refused to be photographed. One American account of a daguerreotypist at work in 1849 relates how a client took one look at the mysterious machinery in the studio 'and dashed down the stairs as if a legion of evil spirits were after him'.[9] Unscrupulous photographers took full advantage of the novel mystique: one profitable practice was to take a portrait of a widow, sandwich the negative with that of another head taken from what was essentially a grab bag of old portraits, and present the gullible woman with a picture of the ghost of her husband hovering attentively overhead.[10] An equally credulous critic reported that a murderer could be identified simply by examining his victim's eyeballs, which would, he explained, have acted like a camera, 'capturing' the portrait of his killer.[11] Equally astonishing, one client arrived at

Nadar's studio, paid the clerk for his picture and then promptly left before having his portrait taken. When the photographer rushed after him, the man explained that he thought that simply paying was all one had to do, other than show up the next day to collect the prints.[12]

Numerous photographers' accounts relate how clients had little or no objective idea of their appearance and were often struck dumb when confronted with their first-ever portraits.[13] Nadar tells us that his clients were sometimes angry, refusing to accept that they appeared less good-looking than they had believed themselves to be. And on more than one occasion when a clerk mistakenly handed someone else's portrait to a client, the client nonetheless went away completely satisfied, even commenting favourably on its marvellous accuracy! When Nadar discovered his error and tried to make the switch, as often as not the person refused to believe him.[14]

For photoliterate peoples like ourselves, the image we see in the mirror is fugitive: you 'know' it isn't there when you aren't looking. But for a people who live without mirrors, the image *is* fixed – the proof being that every time you sneak a glance, you're there. How could it be anything other than magic, and terrifying at that? After all, if a shadow is 'attached' to the body, why not the image? The anthropologist Edmund Carpenter, having witnessed a twentieth-century variant of the experience in his work with natives of New Guinea, has been able to shed light on this phenomenon. Presented with mirrors for the first time in their lives, their natural habitat of muddy rivers and wells having offered no natural reflections, his subjects reacted with extreme consternation (they later behaved the same way when presented with their photographs).

Carpenter reasoned: 'The notion that man possesses, in addition to a physical self, a symbolic self is widespread, perhaps universal.... A mirror corroborates this. It does more: it reveals the symbolic self outside the physical self. The symbolic self is suddenly explicit, public, vulnerable. Man's initial response to this is probably always traumatic.'[15]

And photography was the *best* kind of mirror ever invented. The illustrator George Cruikshank made this belief clear in a ditty he composed for the opening of London's first-ever public photography studio: 'Your image reversed will minutely appear/So delicate, forcible, brilliant and clear/So small, full and round, with a life so profound/As none ever wore/In a mirror before.'[16]

The daguerreotype was therefore a mirror in a double sense: *literally*, a polished silver-coated metal plate ('it is nature herself which reproduces herself as reflection'), and *figuratively*, a 'mirror with a memory', a 'mirror of nature', 'a permanent mirror', even a 'magic mirror'. Photography therefore represented a double novelty: a chance for many people to see what they actually looked like, coupled with the opportunity of recording their appearance for posterity, albeit in miniature form (Cruikshank had observed how portraits 'would minutely appear', and accounts of the day often refer to the microscopic sense of the camera's scrutiny: photography should aim for 'a microscopic fidelity to nature'.[17] It is perhaps fitting therefore that, according to photohistorian Helmut Gernsheim, the first-ever portrait was made by a microscopist.[18]) Small wonder that early portraiture did not immediately set out either to enhance beauty or to capture the soul of the subject.

'Likeness' was all, the goal of faithful reproduction of features paramount. While one critic celebrated the artistic accomplishment in portraits made by the French sculptor-turned-photographer Adam-Salomon, he also acknowledged that 'the merit of exact resemblance is of course there in all its superiority'.[19] In fact, it never occurred to most writers that photography could do anything *but* faithfully record what was in front of the lens. If the person depicted wasn't beautiful, one photographer explained, 'the art is not to blame. It cannot render what does not exist.'[20] Even the evil queen in Snow White counted on an honest answer from her magic mirror when she demanded to be told 'who was the fairest of them all' (a fairy tale, which, incidentally, coincides more or less with the arrival of photography).

But people *did* begin to absorb the lessons of photography, even if it meant a blow to their vanity. Confronted with his first-ever portrait, the American writer Nathaniel Hawthorne admitted, 'I was really a little startled at recognizing myself apart from myself.'[21] An anonymous old lady, speechless at the sight of her first portraits, is reported to have quoted Shakespeare to express her feelings: 'This is no flattery; these are counsellors that feelingly persuade me what I am.'[22] Emerson called daguerreotypes 'grim things', but admitted that 'a great engine had been invented'.[23]

And an army of portraitists was waiting to drive Emerson's 'great engine' forward: 'amateurs old and young, male and female, gentle and simple, educated and uneducated, professionals high and low, in broad thoroughfares and up back courts; paper men and glass-positive men; stereoscopists; artist photographers; composition photographers; positive

printers; portrait colourists; print mounters; photo lithographers; stoppers and plate cleaners; albumenizers, & Etc....'[24] This was Darwinian progress made manifest! 'With savages, the better the likeness, the worse it is for the sitter [i.e., the soul has been stolen],' one writer explained. 'It is the reverse for civilized folk: the better the likeness, the better for the sitter.' And he concluded triumphantly, 'A love of portraits may be regarded as an index of civilization itself.'[25]

So entrenched today is the idea that the best portraits reveal the soul, or inner being, or essence, of the sitter, that it may come as a surprise to find that this rhetoric by no means dominated mainstream discourse during the nineteenth century. People were too busy making money, or mugging for the camera, to worry about metaphysics. Tobacconists, hatters, opticians, all manner of tradesmen added quick and cheap portraiture to their regular services; barbers might throw in a portrait with a shave. Portraits were a vibrant new industry, and clients lined up by 'the million'.[26] For the most part, acknowledges Gernsheim, 'There was no attempt at characterization, no endeavour to record what Julia Margaret Cameron called "the greatness of the inner as well as the features of the outer man".'[27] There were advocates, certainly, of a portraiture that would capture and reveal the soul: physiognomy and phrenology were hugely popular and resonant pseudo-sciences throughout the nineteenth century – and it would have been surprising if there hadn't been some echo in portrait photography – but as historian Alan Trachtenberg has observed, the rhetoric was really about conforming to social types rather than a celebration of individuality. The subtle codes with which photographers guided

their sitters really counselled 'the *imitation* of inwardness', resulting in 'stereotyped poses and in caricature, the underside of the bourgeois fetish of "character"'.[28] While everyone paid lip-service to high-minded ideals when they visited the studio (a step up from the barber's shop!), the real goal was to arrange oneself to look like what one was *supposed* to look like. Indeed, the face was a small part of the overall effort. Most portraits were full-figure or three-quarter-length, and 'harmonious rendering of all parts of the body' was considered an essential requirement of a portrait.[29] Clothing, props (flowers for a woman, a book for a gentleman, marble columns for both), painted backgrounds (a sylvan glade or a hint of a park, or the 'chateau of a French marquis') were indispensable elements.[30] Dignity and decorum were fundamental to the pose, and it was more important to be seen as belonging to a particular social stratum than it was to be marked by individuality of any description. A 'good' portrait of a lady, for instance, was meant to show her as she would have made herself up for her acquaintances: prim, gloved and properly attired.

When André Adolphe Eugène Disdéri patented the brilliant idea of making tiny, cheap portraits the size of visiting cards in 1854, millions of people of limited means flocked to the studios – often called 'Temples' and 'Palaces' – that sprang up in every town and city in the industrialized world. The uniformity of poses and expressions characteristic of these hastily produced prints is stultifying to modern observers, but the universal rage for these *carte de visite* portraits – hundreds of millions were made each year – attests to the profound need people felt at this moment in history to *see themselves* as

others saw them. 'The portrait is no longer the privilege of the rich,' noted *The Photographic News* in 1858.[31] But, like all fads, cartomania rapidly faded, and by the 1870s clients were demanding more from the tiny images than they could possibly deliver. Critics began to complain that most portraits conveyed little individuality, that the faces themselves were minuscule in comparison with the figures, and that the human countenance, when it could be read, 'appeared anything but divine'.[32] The 'pleasant look' that photographers had advised sitters to adopt had now 'lapsed far too often into a fatuous simper', while 'the easy and unconstrained position has become so strange and forced an attitude that it communicates a feeling of discomfort even to the casual spectator'.[33] Photographers found that bigger formats had greater appeal for clients, and gave them alluring names like 'the Promenade', 'the Boudoir' and 'the Imperial'. *The Photographic News* reported on a dramatic development evident in the typical family album: 'The face … continued to grow with enormous rapidity, and in a short time the head filled up the whole of the album aperture, and the body disappeared altogether.'[34]

Now that the face was becoming *the* prime and only focus of the portrait, the defects peculiar to an individual face were glaring. Technical limitations added to these woes. The uneven sensitivity of emulsions meant that freckles came out as black spots, and smallpox-marked faces looked 'alarmingly like the portraits made on a coarse-grained canvas'.[35] Blondes always 'came off badly', with hair that appeared dirty because of the differentiated sensitivities of the plate. Though there was at least one photographer who liked the effect of isochromatic plates, which he thought made his

portraits look more like Pre-Raphaelite paintings, in general the lack of naturalistic colour was an obvious complaint, and arguments raged about the validity of adding tints. *The Photographic News* warned against excess: 'In tinting photographs, too much care cannot be observed in preserving the fidelity of the likeness, the one thing to which all else should be subservient.'[36] All things considered, however, who could, in cases where mirrors lied, be so cruel as to take issue with the retoucher's art?

Much was written on the pros and cons of flattery. One wag noted that it was in the interests of a gentleman to 'pour the delicious drug of well-chosen flattery into the ears of his vain and self-satisfied hearer'. But men were also chastised for vanity. In New York, it was said, all male sitters stuffed cotton wool in their mouths to give their cheeks 'a pleasant rotundity'. A certain A.W. from Dundee argued in a letter to *The Photographic News* in 1880 that flattery should not make people look better than they are, but could and should allow them to look their best. How that juggling act was supposed to be effected, he or she did not say. Still, the writer warned, 'thoughtful men and women care nothing for a portrait unless it is a telling likeness'.[37] Retouching, the argument went, was fine if it respected the mirror principle.

It was obvious to many photographers, moreover, that bland, unretouched photographic portraits could never hope to equal portraits painted in oils. One painter recalled how, as the photographic portrait was first introduced, 'We were all fascinated by the marvellous accuracy … and with the newborn wonder of children, we forgot the absolutes of higher truth.'[38] It also began to dawn on professional photographers

that portraiture made with more artistry might well justify higher prices. Retouchers were henceforth given two mandates: prettify the subject, and enhance artistic effect. The new dogma was summarized thus: 'Without artistic knowledge to correct its blemishes, photography is not entirely truthful.'[39]

And so it was a small step to straightening eyes and covering bald patches; '… plain women were made pretty and pretty women were made beautiful, and in all cases looks were vastly improved.' Thus, more and more retouched photographs were sent out 'unblushingly to friends as likenesses', leading one critic to explode: 'Retouchers! Oh what ethical sins have you not to answer for! … You do not believe that the man or woman exists who in his or her heart endorses the sentiment of Old Oliver Cromwell about being painted with wrinkles and warts.' Nevertheless, the critic had to concede defeat in the face of such widespread vanity, concluding, ' … and you are right'.[40]

It would be a mistake, however, to assume that vanity and technical limitations alone drove the art of retouching to greater heights. There was (and is) a fundamental difference between looking directly at a person's face and looking at his or her face in a photograph. We seldom allow ourselves to scrutinize other faces in the flesh (the exceptions being the faces of our families and those we love) but we can, and do, scrutinize faces in photographs, confident that the subject is not 'seeing' us back. A portrait puts a head in a vise, and clamps it tightly for scrutiny by others. So it is only natural that (from bitter experience!) we insist that a photograph presents us in the best possible light. Thus, while a blemish on

"A portrait! What could be more simple and more complex, more obvious and more profound?" Charles Baudelaire, 1859

a real face may be a passing embarrassment, in a photograph it remains an eternal humiliation. Naturally enough, we would rather a temporary defect (the 'not really me!') be concealed. This would have been especially true of people who only expected to have one or two portraits in a lifetime. Therefore, once nineteenth-century subjects had gotten over the simple thrill of seeing their own instant likenesses and participating in the great democratic collector's game that the *cartes de visites* entailed, it was understandable that they would become more sophisticated, and more demanding, in their requirements.

The rise of the celebrity photograph helped fuel this new sophistication. Actresses were the first to demand that their portraits live up to their stage mystique – an impossibility, in most cases, without subtle enhancement. After all, actresses and dancers had become accustomed to seeing highly idealized representations of themselves in popular lithographs. One photographer noted that actresses knew how to adopt and hold an expression for the camera, whereas members of the general public 'assumed pinched, unattractive expressions'.[41]

Royalty also got in on the act, learning to pose and gesture for the camera.[42] A portrait of the Prince and Princess of

Wales was 'doubtless intended to represent an affectionate attitude,' complained one critic, 'but the impression produced on the non-artistic eye is that she is taking his measure for a coat.'[43] Disdéri photographed every royal court in Europe as well as that of the Emperor of Mexico (in 1855 he was also selling up to 2,400 photographs a day). As for the luckless Prince of Wales, who apparently had a deformed hand that he tried to hide, 'the anxiety of the spectators to make out [its shape] is quite typical of the interest which anything concerning royalty – no matter how insignificant – creates'.[44]

The anxiety of the spectators'…. Clearly, nineteenth-century portraits had a lot riding on them. There was much social confusion in the mix, leading one writer to acknowledge, albeit grudgingly, 'that democratic disregard of rank which prevails in our National Portrait Gallery of the present day – the stationer's shop window – where such discordant elements of the social fabric as Lord Napier and Lillie Langtry' rubbed shoulders jarringly.[45]

There are portraits by the million in nineteenth-century photography, and then there are faces by the million, too: passport photographs (as early as the 1850s); photographs of criminals taken by the police; photographs of the insane taken by medical men; photographic studies of 'the passions' as etched on men's faces; those new faces of celebrities; faces as seen in the street. 'Character' and 'soul' did not fare well in these genres. Francis Galton was alarmed to discover that his composite portraits of criminals did not unmask the 'criminal type', as he had been convinced it would, but instead miraculously produced handsome and honest-looking men, as respectable in appearance as bankers and merchants!

No, despite the nineteenth-century predilection for dark tales, witches and fairies, the prevailing attitude – as far as photography of the face was concerned – was surprisingly matter-of-fact. It wanted information, and it wanted affirmation. It wanted bigger and better (not unlike current demand for 'high definition') but contrary to conventional wisdom today, it did not want to strip away the veneer and reveal the tender soul within. Freud had not yet had his say.

By the century's end, however, there had been enough fact-gathering about faces, and people wanted something more expressive. The new century would see photography spread into every nook and cranny of people's lives. Portraits of many types proliferated. In the early years, there was the moral high ground occupied by the last of the great Pictorialist photographers, with their hymns to interiority and excessively painterly ambitions. Gertrude Kasebier, one of the foremost American practitioners, spoke for herself and the ethos of her fellows when she wrote, 'I have longed increasingly to make pictures of people that are biographies, to bring out in each photograph the essential personality that is variously called temperament, soul, humanity.'[46] Indeed, the most flattering comment a Pictorialist could hope to hear was that his or her portraits didn't look like photographs at all, but reminded the viewer of Rembrandt or Whistler.

At the other end of the spectrum, there were the informal snapshots of the family album, with their awkward angles, chance framings and badly timed exposures which had mushroomed since the arrival of small hand-held cameras. 'Twenty million Kodaks have clicked this summer on all the beaches

of the world,' noted the writer Carlo Rim in 1930. 'The family albums from now on will be peopled by silly grimaces and human hams.'[47] The vivid distinction between the high and the low served well those photographers on top, for whom the unbridgeable chasm merely served to show off the summits of their artistic achievements.

Professional studio photographers (which we might imagine as a kind of middle class between the aristocrats and the common folk) did not have the time to produce Pictorialist masterpieces. Staying alive in an extremely competitive environment meant churning out work. Nevertheless, they found the high-minded language of their *artiste* colleagues most useful as a seductive stratagem. Studios quickly developed a kind of short-hand, appropriately middle-ground 'artistic' portraiture, which would satisfy everyone: the aristocrats weren't threatened (they could still garner their gold and silver medals at the international salons); the professionals earned a decent living; while the proletariat could, from time to time, have a particularly important *rite de passage* (a graduation day, a wedding, a Golden Anniversary) commemorated in official fashion in a proper studio. Unlike the casual snapshots taken by Mom or Dad, which might or might not make their way into an album, these solemn portraits *were* considered worthy of being framed and placed on the mantelpiece, and a family could be proud when a visitor commented favourably on the evident talents and strength of character 'revealed' in the study. It was very possible that such an admirer had in the back of his or her mind *the* popular standard of the day: Yousuf Karsh's histrionic portraiture of the world's most famous twentieth-century men and women, which, helped along by ingratiating prose, claimed to seize, yes, the very soul of his noble subjects. He convinced his readers that he had done this, not so much by expertly cloaking his subjects in myth, as by *re*cloaking them in the myths already irrevocably attached to their names: his Winston Churchill embodied the rock that had held England fast in the storm; his Ernest Hemingway *was* the Old Man and the Sea.

Karsh might be said to have been the last of the great Pictorialists. But in terms of developments in art photography, he was an anachronism. Half a century earlier, modernist photographers were admitting to scepticism as far as capturing souls was concerned. Photographers who identified with the New Photography, the New Vision, or even the New Objectivity of the 1920s and '30s, saw faces in a very different light. The first of these modernists argued that photography's future lay in distancing itself from painting, rather than hiding behind its coat-tails. The properties inherent to photography – its superb resolution, its impassive objectivity – were to be refined, promoted and celebrated. 'Photography does not need any kitschy "moods", and gladly leaves them to the garret walls of the kitsch-makers – and the same goes for sentimental, so-called artistic photography,' argued one Czech critic. 'But let's speak of art for a moment,' proposed the avant-garde poet Tristan Tzara. 'Yes, art. I know a gentleman who makes excellent portraits. This gentleman is a camera.'[48]

These modern photographers wanted something new in the way of portraiture – not only a new way of seeing, but a vision which would reflect the new modern world that was

coming into being. Even the diehard American Pictorialist William Mortensen had to admit, in 1948, that, 'Thoughts and emotions cannot be photographed, despite the protestations of some mystically minded portraitists. Physical fact is ultimately the sole pictorial material.'[49] First to be dispensed with, according to Karel Teige, a leading figure, were the old nineteenth-century photographs, with 'their affectation of grimaces, as the portrayed person flirts with some unknown spectator; the portraits of famous singers, actresses and honourable patricians – the perfectly repugnant, hallucinatory face of the grande and petite bourgeoisie of that time'; second, the pretentious new studio variety of portrait, which represented 'the real fall of photography – commercial portrait photography and of so-called "artistic photography", a parasite of painting....'[50]

The modernists fought hard and long for, as spokesman László Moholy-Nagy put it, 'a biological way of looking at man, where every pore, every wrinkle and every freckle is of importance' (or what one dissenter called 'its appalling exactness in rendering the geography of the face').[51] There was no room for 'soul' in this New Vision; then again, if someone wanted to see 'the inner' man or woman, it was suggested, why not make use of the newly harnessed X-rays?

Although proponents of the New Vision made great strides stylistically, changing the look of photography in dramatic ways, the idea that a 'good' portrait could and should reveal the character and soul proved remarkably resilient in the popular imagination throughout the century. If tenacious even in the twenty-first century, the notion is nevertheless now waning. The studios still exist, though there are fewer and fewer of them, as ordinary people absorb more and more of the original functions. The further the studios are from big cities, the more they tend to retain an essence of the old Pictorialist style. To this day, a Western tourist travelling in countries of the old Soviet bloc, for example, can have a portrait taken that will make him wonder if he isn't actually looking back in time at the face of his father. But such intriguing relics aside, the conventional poses, lighting and stereotyped expressions of the twentieth-century portrait studio now seem passé. Paradoxically, it is the lowly amateur snapshot, with its undisciplined exuberance, which has triumphed. Faces in these unguarded moments seem far more real to intimates, and the accumulation of the moments is seen as adding up to a richer portrait of an individual than a single studio product could ever convey.

Furthermore, too many doubts about faciality have accumulated. Passport photos, supermarket check-out photos, identity photographs of every kind – no one expects these simple documents to count for much, other than help us cash a cheque somewhere or cross a border unmolested. Certainly no one believes today that they betray *anything* of the inner being. Who hasn't clowned around in a photobooth, trying on expressions and demeanours – the sultry actress, the mafia hoodlum, the goofball? Real character, personality? We have all seen too many newspaper photographs of well-groomed, sensitive-looking men and women who, we then learn, have just gone on serial-killing sprees. And after all, physical face change is only a cut or a gene away.

The sweet lies of the advertising world have also contributed to this doubt about the credibility of a portrait.

postFACE

By the time most of us have arrived at adulthood, we have learned just how deceitful the beautiful faces that inhabit the mediascape really are. The happiness and well-being they have so often proffered us so convincingly from billboards and glossy pages have turned out to be just so many cheap beads and trinkets. Even the *subjects* of such photographs can't recognize themselves. Carla Bruni, a top model of the 1990s, discussing her covergirl image with journalist Mary Blume, observed: 'I have 250 covers, and there is not one of them that I recognize as me.' Picking up an issue of *Elle*, she said to Blume, 'You're not going to tell me that this is me.' To which Blume had to reply, 'No.'[52]

Small wonder that contemporary photographers are filled with doubt. 'Most of the photos we come across today aren't really authentic anymore,' notes Thomas Ruff. 'They have the authenticity of a manipulated and prearranged reality.'[53] What option other than nihilism can there be, faced with the machinations of the 'imagineers', as evidenced in this account of a star in formation: 'The staff addressed the subject of "imaging" Cherie – what kind of look the subject should affect.... [The art director] said that in examining the images of current pop stars, he had noticed that there was a middle ground somewhere between Britney Spears and Shania Twain, which no one was trying to fill.... *The danger was that in trying to strike a balance between those extremes you might end up with nothing at all*' [author's italics].[54]

Nothing at all ... a true 'loss of face' – for Cherie, and for us.... Andy Warhol said it all splendidly as the last century waned, holding the mirror up to modern society so it could study its own vacuous, if glittering, reflections.

There has been a positive side to all this vacuity, this loss of faith, this loss of face. The fundamental questioning of twentieth-century portraiture's inflated claims has offered photographers an opportunity to profoundly rethink the genre. At the end of a long career of 'making faces' for clients who very *much* subscribed to those claims, Richard Avedon arrived at the conclusion that a portrait wasn't 'a fact', but 'only an opinion'. Stop asking us for the inner being/ essence/soul, he pleaded: 'The surface is all you've got.'[55] Alan Trachtenberg, looking at the new face photography more generally, concurred: 'Now we distrust depths, interiors, hidden truths. Meanings lie on surfaces, artefacts of an occasion rather than truths about persons.'[56]

The house of physiognomy should have been condemned for its shoddy foundations a long time ago. Happily, the truly interesting photographers of the face moved out a few years back and have been hard at work constructing new sites. It's an exciting moment but, rather than being an entirely new situation, it's actually a return to a more magical time in photography – those early decades when people marvelled at the face in the silvered mirror, and the psychoanalytic pretensions of photography had not yet gained the upper hand. The photographers in this book are confronting that Warholian nihilism, working their way through it, and helping in myriad creative ways to restore some of the old magic to the mirror.

William A. Ewing

FACING UP
FACING DOWN

GAZES

"Our current taste has veered once more toward the pattern and away from the character. Maybe, in our particular decades, humanity has become slightly unbearable."
Ben Maddow, 1977

Facing up...facing down. With photographs, these expressions can of course be taken literally, as in the sense of: *this person is looking up*, or *that person is looking down*. But in common speech we are far more likely to use the expressions in the figurative sense. We face up to difficult situations; we face down adversaries. What happens, then, when we apply these concepts to photography?

There are several different ways to define the first of the phrases, 'facing up'. Take the conventional portrait. In the confrontation between the photographer and the subject, which always involves something of a test of wills, just who can be said to be doing the facing up? The photographer? The sitter? Both parties? Professional portrait photographers know from experience that most of their sitters are not ready to face up to the reality of their features – that double chin, that bulbous nose, those crooked teeth, those shameful pimples. Clients expect to emerge from the studio with their flaws magically effaced. Even the lowly passport photograph, as often as not made by an impersonal machine and destined to be glanced at by bored border guards, seldom meets the inflated expectations of its proprietor. Studio photographers know that flattery is the name of this game (after all, who is paying?), and what can't be disguised in the scrutiny of the camera's eye by shadow or careful pose can always be rectified afterwards by a little (or even a lot of) judicious retouching

– photography's own version of cosmetic surgery. If there is any real 'facing up' to be done, therefore, such photographers would say, it is facing up to the universal vanity of their clients!

Today much 'portraiture' is made not for a single client, but for public consumption on a grand scale. The editors of mainstream magazines, and their advertising clients, know that the faces they want us to admire, envy and *believe* have to be enhanced if they are to grab our interest. To adapt the old military maxim, this kind of portraiture is too important to be left in the hands of the photographers. Troops of professional retouchers are therefore recruited to give portraits the necessary degree of attractiveness. If professional photographers don't face up to this simple fact, their careers will be short-lived indeed.

If photographers make portraits of others for themselves, however, they are probably paying their sitters, rather than the other way around, and flattery is no longer an obligation. But does this mean that these photographers are therefore ready to fully 'face up' to the reality before their lens? Not necessarily, judging by the torrent of hackneyed portraits produced over the last hundred years. Let's say a photographer is about to photograph a famous writer. He may have an idealized vision of 'what a famous writer looks like', and therefore unconsciously suppresses or downplays features or expressions that don't conform to this preconceived image. Serious writers, for example, judging from most portraits, have never learned to smile; singers, apparently, never open their eyes or take the pained expression off their face. What often passes in art photography for 'sensitive portraiture' is really imagery that conforms to the most banal stereotypes.

Only the truly independent photographer has the freedom to make a warts-and-all study of a face, not caring whether it displeases the subject or those who gaze upon the finished print. Happily, as the selection of this chapter makes clear, there are a good many photographers ready to reinvest the face with a new vitality.

It is one thing, however, to have bold photographers. But then are we, the viewers, ready to accept what they present us, especially if these faces do not conform to established conventions? What happens when a face is ravaged by disease, or hideously wounded, or simply decrepit with age? When an anatomical photographer literally strips the face from its moorings? When anxieties etched into faces are painful to behold? When that famous writer looks less like a sage than a frightened rabbit caught in headlights? Although photographers may face up to unpleasant truths, do we have the courage to do so too? If photographed faces are indeed to have potency, clearly the most deeply satisfying arrangement is for the three parties – photographer, subject and viewer – to all face up together.

'Facing down', meanwhile, has very different connotations. We face down the opposition, often relying on willpower and righteousness to triumph over brawn. Photographic portraiture has a syntax and grammar of its own, and here again we may ask: just who is doing the 'facing down'? The photographer, the subject, both parties? And just how is it to be accomplished?

Power is not always in the hands of the photographer, even if the camera most definitely is. Two human beings facing each other always involves a degree of psychological give-and-take. Sometimes the game takes the form of a face-off, as in certain sports, where both sides are equally balanced. Sometimes the photographer tries to dominate the exchange – after all, he wants people to admire *his* portrayal, rather than the actual man or woman portrayed. Sometimes it's the subject who tries to get the upper hand: closed eyes, a face turned away at the last second, a fierce stare, looking down at the lens rather than up. The more experienced the sitter, the more adept they are at imagining the resulting image and fixing their expressions accordingly. But then again, experienced photographers know how to bend such behaviour to their own ends.

For years, studio photographers had the upper hand, the equipment and the ambience having a certain intimidating effect on their clientele. Nowadays, portraits are more likely to be taken in more neutral territory. Some set up their cameras in unlikely environments – a busy street, a supermarket, a locker-room – hoping that the instant of psychological dislocation will give them an advantage. Others intentionally level the playing field, even handing the camera to their subjects and submitting to the uncomfortable operation themselves. And still other photographers face their own lens, peering *into it* as a mirror of their own doubts and torments, and *out of it* as through a window onto the world, meeting our gaze head-on and challenging us to summon up the courage to confront our own insecurities.

"A photographic portrait is a picture of someone who knows he is being photographed." Richard Avedon, 1993

i Facing Up

Early twenty-first-century man lives in troubled times. Fears and terrors abound, and threats to humankind and Planet Earth appear of a larger magnitude than ever before.

Judith Joy Ross's portrait of Private Maria Leon suggests that our young soldiers, whether men or women, feel no differently about the world. There is no bombast here, no heroic defiance, no imperial certitudes. The soldier faces an uncertain future, knows it and shares it with us, though whether she does this knowingly or has been captured in an unguarded moment is open to question – until we remember that portraying people precisely in those moments is Ross's particular skill.

The observers overleaf left, faces craned to the heavens, appear to be taking in some celestial event unfolding above their heads. But for one person present – the photographer, Frank Fournier – the real event is what transpires on the faces in the stands. And what a disparate cluster of facial expressions he captures. But only one face fully registers the horror of the moment being commemorated – that of the wife of the doomed shuttle's commander. For an instant, that face takes on the exact form of the Ancient Greek mask of tragedy, befitting of her loss of a modern Icarus.

"Flattery is unwholesome. It is contrary to truth." The Photographic News, London, 1870

Judith Joy Ross *P.F.C. Maria I. Leon, U.S. Army Reserve, On Red Alert, Gulf War* 1990

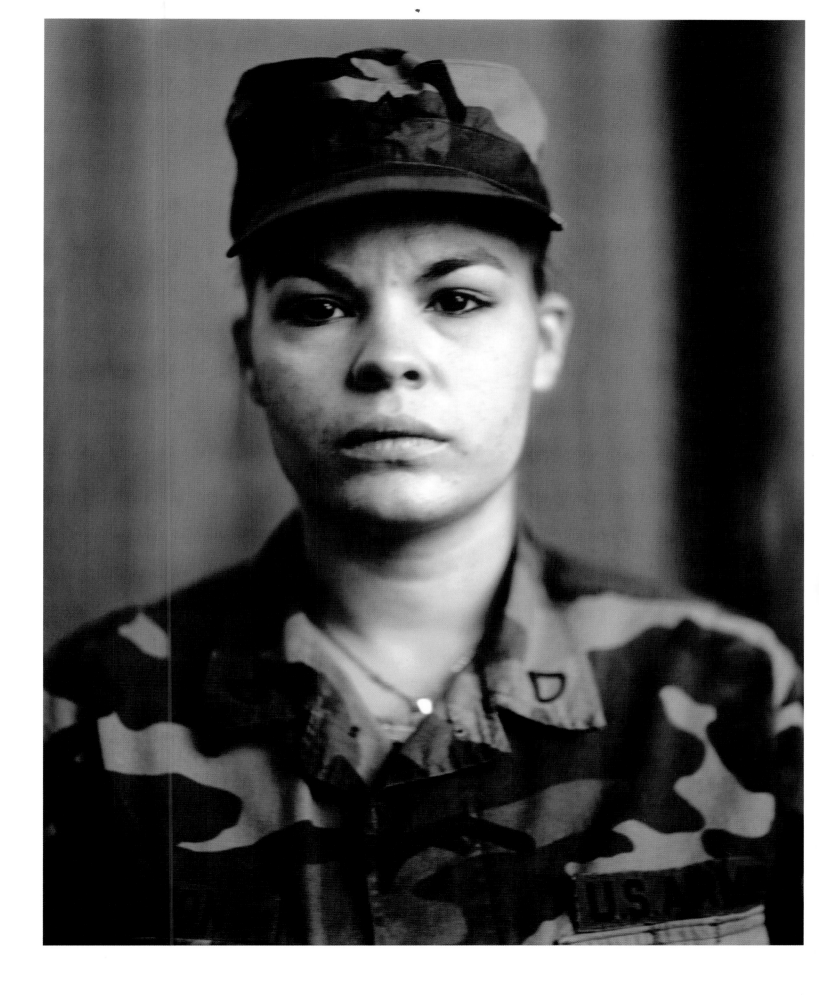

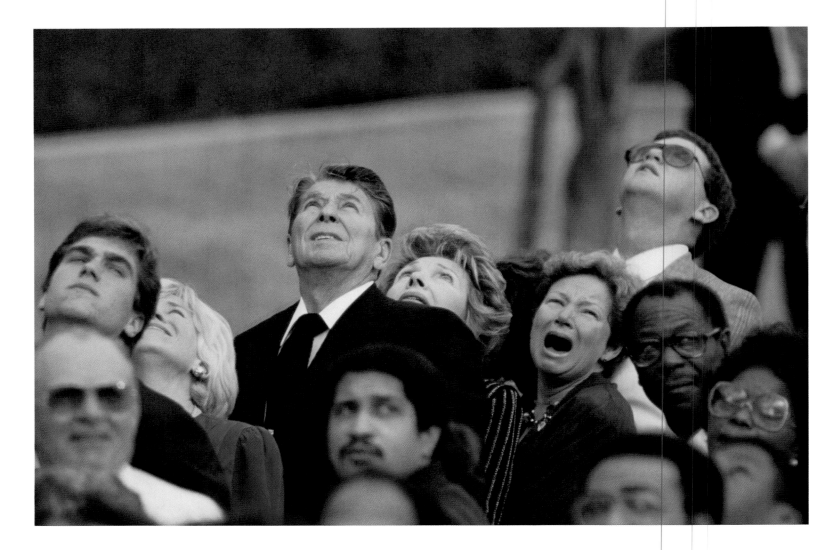

Frank Fournier *President Ronald Reagan and his wife Nancy Reagan*
next to Ms Scobee (wife of Francis Scobee, spacecraft commander of
the space shuttle Challenger that exploded 73 seconds after launch)
and Mr McNair (father of Ronald McNair, mission specialist). Challenger
disaster memorial. Houston, Texas, USA January 31, 1986

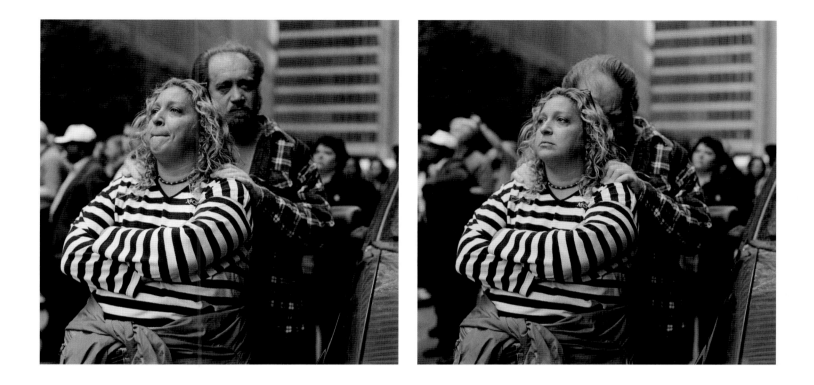

Kevin Bubriski *Portrait #21 World Trade Center, NYC* September 27, 2001
Kevin Bubriski *Portrait #22 World Trade Center, NYC* September 27, 2001

A couple strive to come to terms with the horror of 9/11. In the left-hand image, the man is the strong one; in the right-hand image, the woman rallies while her partner lets slip his stoic mask. What a difference a fraction of a second makes. How could we ever expect a single image to tell all there is to tell of the human face's liquid emotional field?

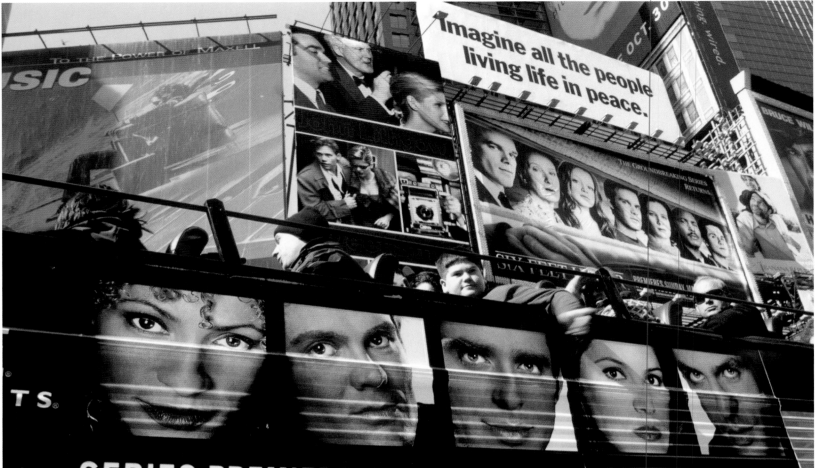

"The technology that lifted man out of both his environment and his body, allowing him to enter and leave limbo at will, has now become so casual, so environmental, we make that trip with the numbness of commuters, our eyes unseeing, the mystery of self-confrontation and self-discovery gone."
Edmund Snow Carpenter, 1972

Robert Walker *Times Square, New York* 2002

Swamped by giant billboards featuring the overly famil-iar faces beamed night and day into American homes, a group of tourists is quickly bused through the dazzling electronic emporium known to all the world as Times Square. The puny faces of the 'real' people in this mas-querade are crammed into a narrow band (the deck of the bus), unable to compete in the attractiveness sweep-stakes with the panorama of superglamorous faces squeezing them from above and below. How odd these real faces appear to our eyes, already accustomed to the new standard of face. New! Improved! Homogenized!

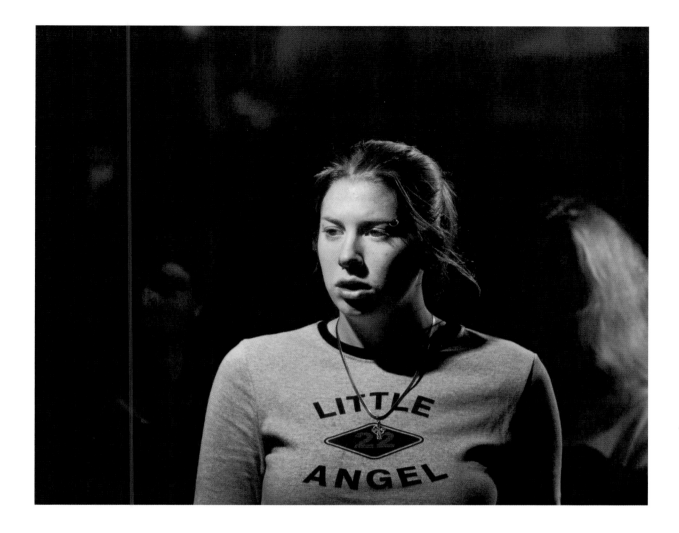

Philip-Lorca diCorcia *Head #8* 2000

Meanwhile, a lone urbanite, a fallen little angel, emerges for an instant into the pool of light shed by a hidden strobe as she negotiates the dark canyons of the city. As the photographer releases his shutter twenty feet away, his prey becomes, unawares, the cinematic star of a sad urban tale of isolation and anomie.

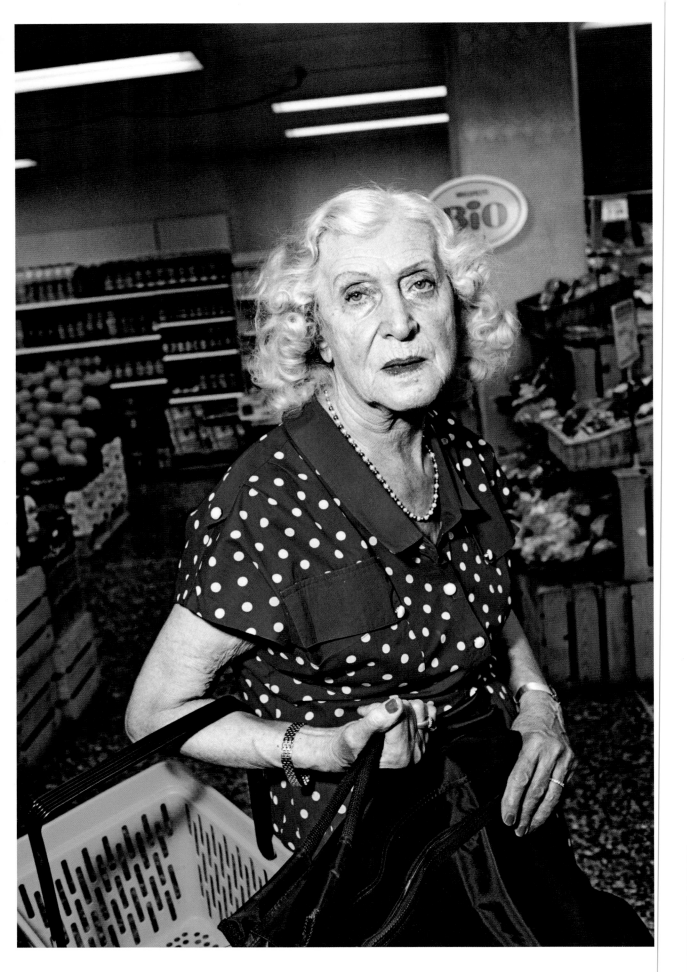

Yves Leresche *Migros Métropole, Renens*, from the series 'Vaudois' 2003
René Zurcher *Ophthalmic Portrait, Lausanne, Switzerland* 1990–91

"It is only when the photographer shows that he knows at once what to do under the varied circumstances with which he is surrounded, that the (client) begins to feel that confidence which allows them to put full trust in his effort, and to bend to his desires without opposition."
The Photographic News, London, 1870

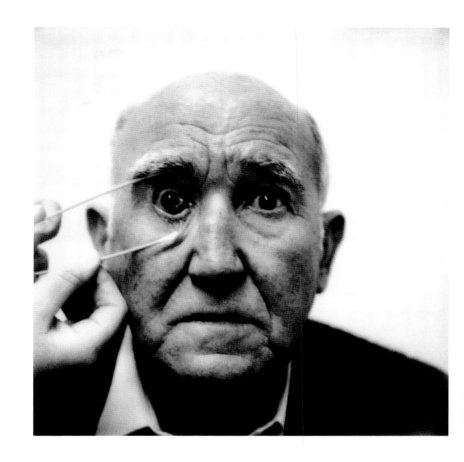

Who would expect to be confronted with a photographer in a supermarket? Especially by a photographer requesting a portrait? One leaves one's persona at the door of such a place, to be picked up again on leaving. But such discomfort was exactly what Yves Leresche was counting upon. By giving his subjects only an instant to compose themselves, he catches them in an unstable and revealing state, somewhere between their public personas and private lives.

Can a portrait be a portrait if the subject does not define it as such? René Zurcher's subjects were certainly aware of the camera, but they were posing for purely medical documentation. As a result, they betray far more of their torment than the 'mask' of a conventional portrait would have allowed.

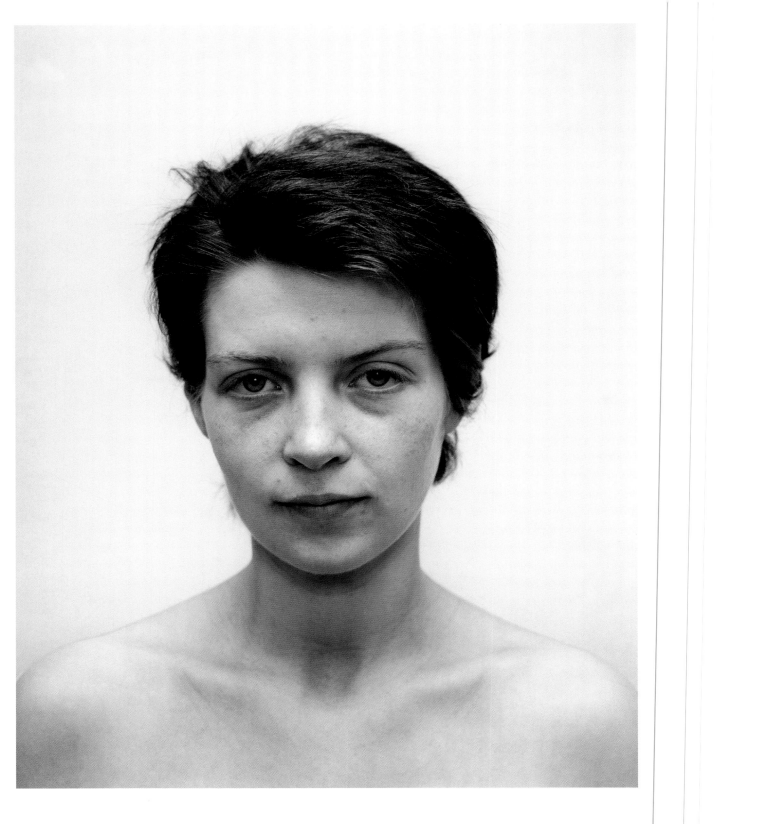

A young mother, photographed by Rineke Dijkstra, three weeks and then again six months after giving birth. The change in her is subtle, though immediately perceptible. The older Tia seems younger, as if the experience of motherhood has been rejuvenating, with hollow-eyed exhaustion giving way to profound satisfaction. The calm,

Rineke Dijkstra *Tia, Amsterdam* June 23, 1994

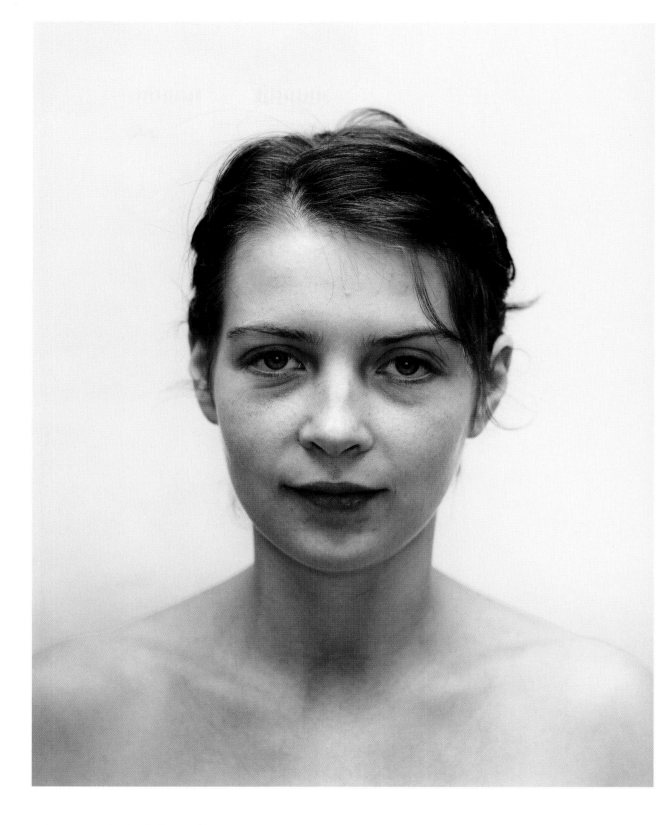

blank background allows us to concentrate fully on the sitter. We take in her nudity, which implies a privileged relationship with the photographer based on trust: this intimacy makes us feel privileged in turn. The dual portrayal seems all the more truthful for this reminder of still photography's basic limitation: the tyranny of the instant.

Rineke Dijkstra *Tia, Amsterdam* November 14, 1994

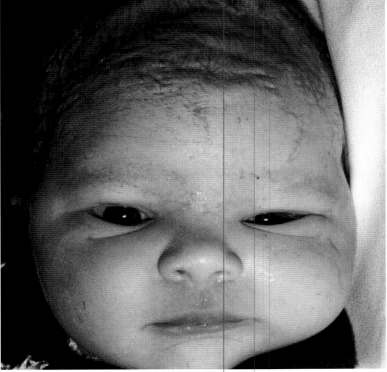

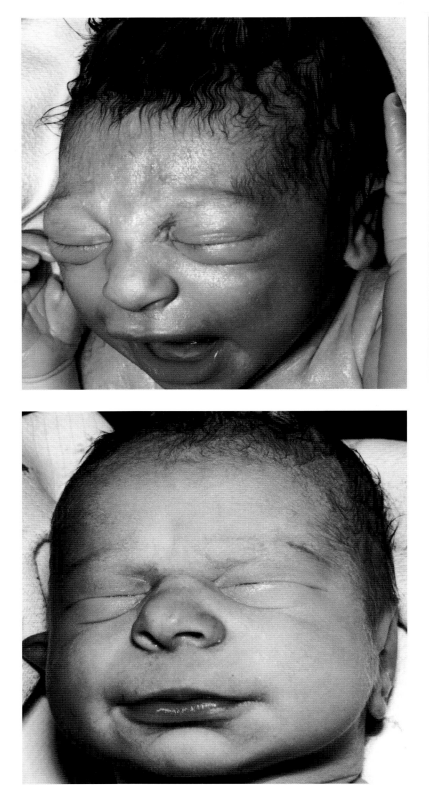

Philippe Bazin From the series 'Nés' 1998-99

The babies on this page have just arrived on Planet Earth, individuals all, still bearing the traces of their turbulent passage. We might make out on their newborn faces universal expressions of distress, alert curiosity or dreamy bliss. Utterly guileless before the camera's lens, the infants let their faces do what they will.

But what of the old men opposite? With their unfocussed but penetrating stares and their ultimately enigmatic expressions – equally curious, no closer to resolving the great mystery of 'why' – they evince a tenacity just as powerful as the babies', though theirs is grim as the journey ends. One senses that, caught in the grip, they also have no choice but to let their facial features drift where they will.

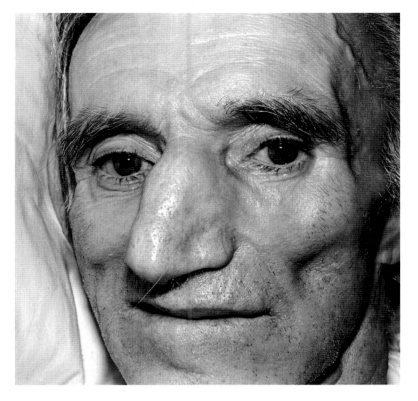

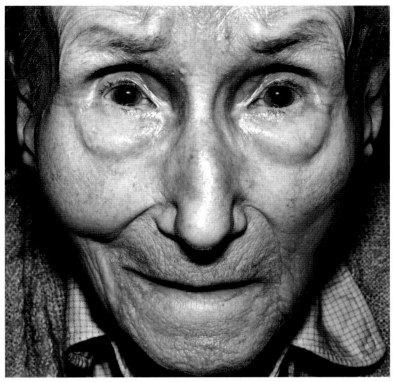

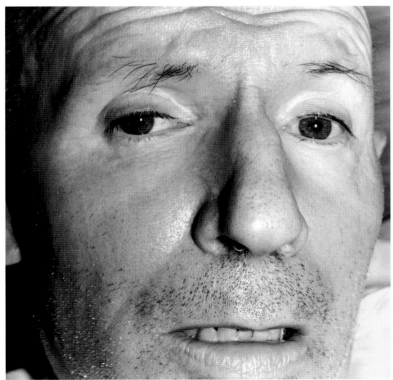

"All these portraits are given with a truthfulness free from flattery which makes the Human face appear anything but divine."
The Photographic News, London, 1858

Philippe Bazin From the series 'Faces (*vieillards*)' 1985-86

"When I look at your little photo, I am always astonished by the force which ties us together. Behind all there is to contemplate, behind the cherished face … act forces which are so near and dear and so indispensable to me, all of it is a real mystery in which the tiny creatures that we are must collapse in total submission…."
Franz Kafka, 1912

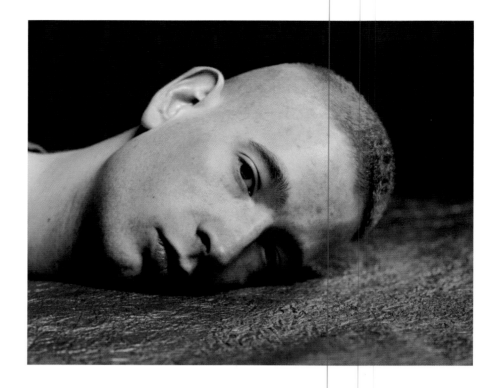

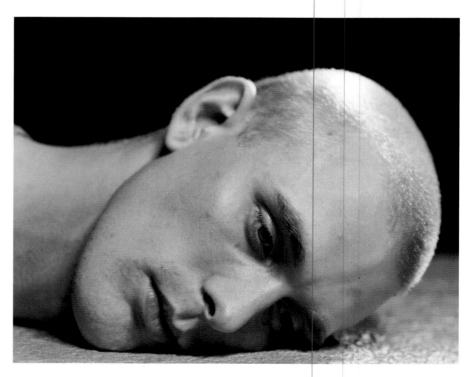

(clockwise from top left) **Suzanne Opton** *Soldier: Conklin* 2005; *Soldier: Claxton* 2004; *Soldier: Jefferson* 2005; *Soldier: Birkholz* 2004

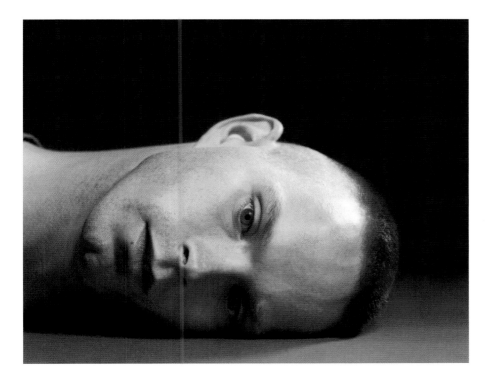

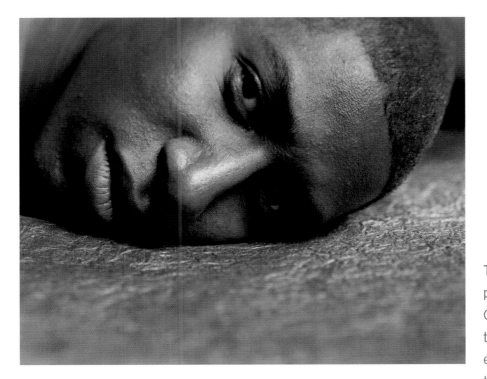

These American soldiers volunteered to be photographed, but had photographer Suzanne Opton posed them conventionally, or upright, their psychological defences would be engaged. As it is, she has successfully disarmed them. Suddenly these young men, trained to kill, seem heartbreakingly vulnerable and defenceless ... sacrificial lambs in their own right.

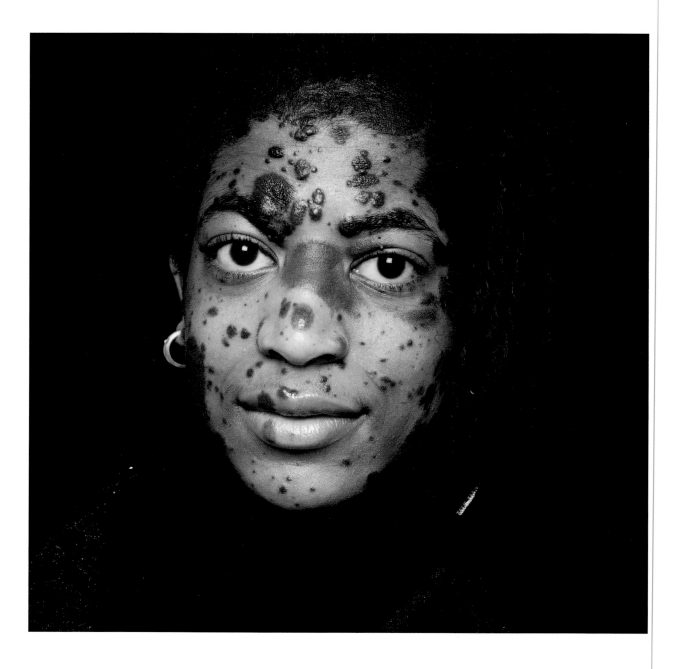

Adriënne M. Norman *Naomi Oron*, from the series 'Skin Portraits' 2000–02

Adriënne M. Norman coaxes her subjects – all of whom have severe skin conditions – out of the shadows to which they generally retreat. Were we to come face to face with this young woman, we would probably feel the impulse to avert our eyes, but the one-way mirror of the photograph gives us licence to stare. And as we scrutinize her face, a strange beauty manifests itself: less a person 'maimed' than a person simply and intriguingly 'marked'. Photography, often criticized for being a great invader of human privacy, can sometimes enable us to break down barriers.

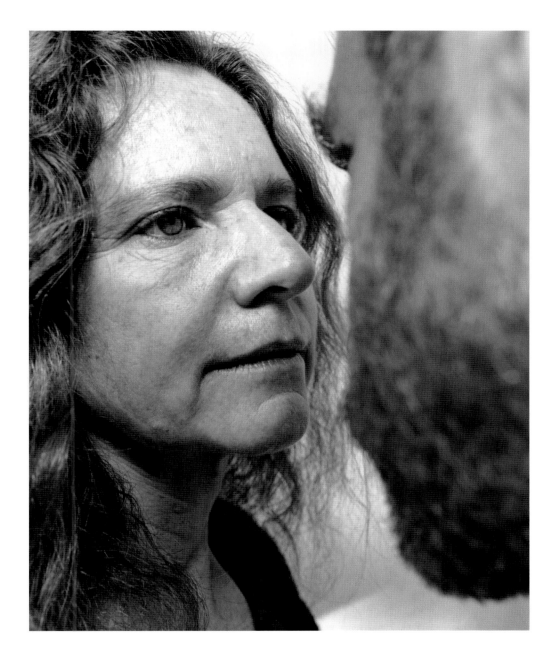

Nicholas Nixon *Bebe and I, Lexington* 1997

This couple, one of whom is the photographer, look into each other's eyes and beyond, seeing a lifetime of shared experiences: joys, trials, tribulations. Long gone are the days of masks and flirtation; ahead, the slow decline. Despite Nicholas Nixon's invitation to us to share this intimate moment, are we viewers not a little discomfited by our proximity? Three is a crowd....

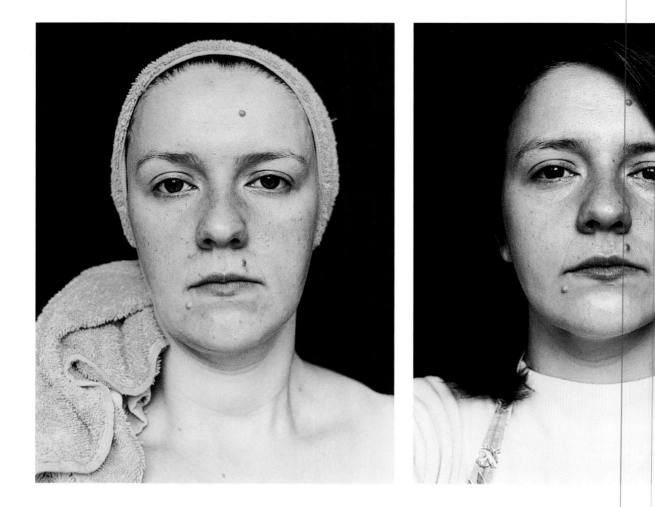

"I dream of a mirror. I see myself with a mask, or I see in the mirror somebody who is me but whom I do not recognize as myself." Jorge Luis Borges, 1985

Andrée Chaluleau From the series 'L'envers du miroir' 1999

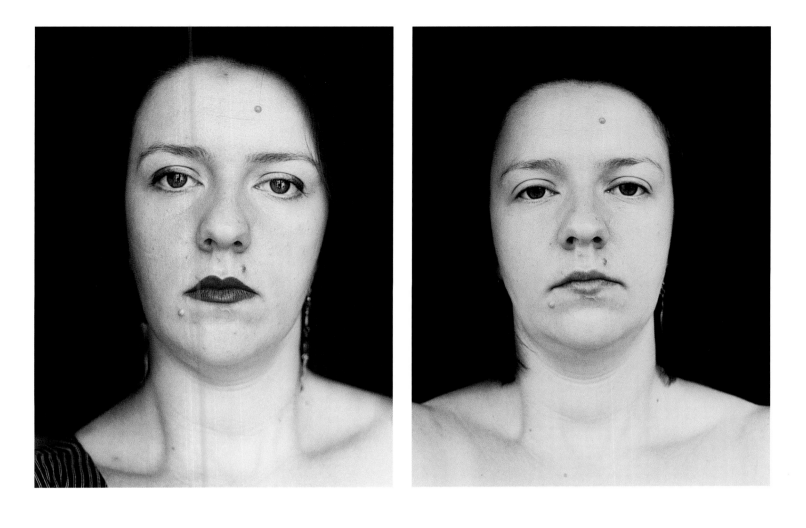

Looking at herself every day in the mirror of photography, Andrée Chaluleau dispassionately takes stock of her myriad personas, each of which is as real and valid as the next: 'I am myself and another, myself and my sister, myself ten years ago, myself in twenty years, myself tired, myself depressed: day after day, emotions and anxieties model my face....' This singular multitude allows her, on the one hand, to be and become a kind of family unto herself, a composite being, and on the other, to stand outside herself, like a stranger, wondering, 'Just who, really, is this/that woman?'

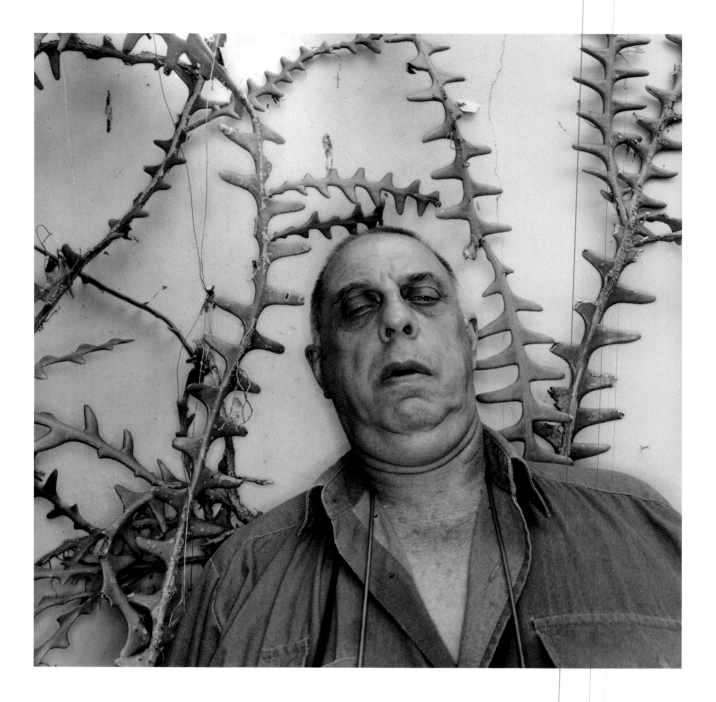

Lee Friedlander *Oaxaca, Mexico* 1995
Lee Friedlander *Anza-Borrego State Park, California* 1997

Self-portraits of photographers are usually arrogant affairs, representations of confident, prescient artists, often seen seamlessly wedded to their mechanical 'eye'. Rare indeed is the self-portrait in which the photographer admits to a decline in his powers with age, or lays bare his fatigue with the world. Here, however, Lee Friedlander faces up to his imminent demise, a weary soul resigned to a slow dissolution back into nature.

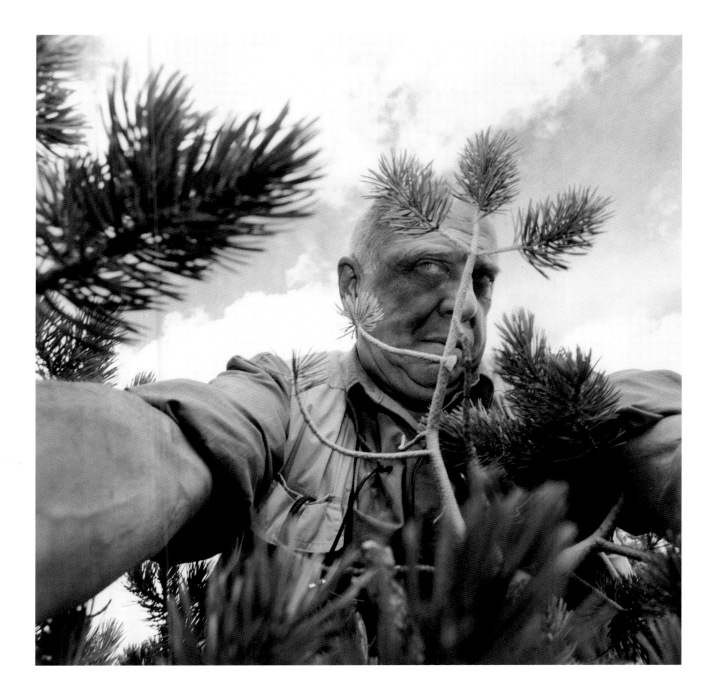

"Man cannot bear his own portrait. The image of his limits and his own determinacy exasperates him, drives him mad." Paul Valéry

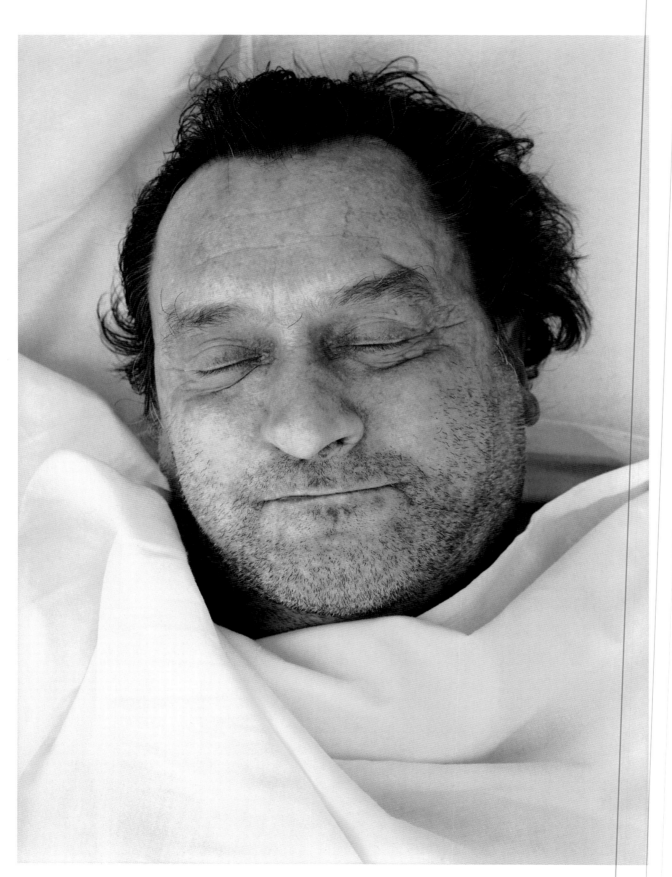

Rudolf Schäfer *Untitled*, from the series 'Dead Faces' 1986
Ralph T. Hutchings *Coronal section of the head* 1996

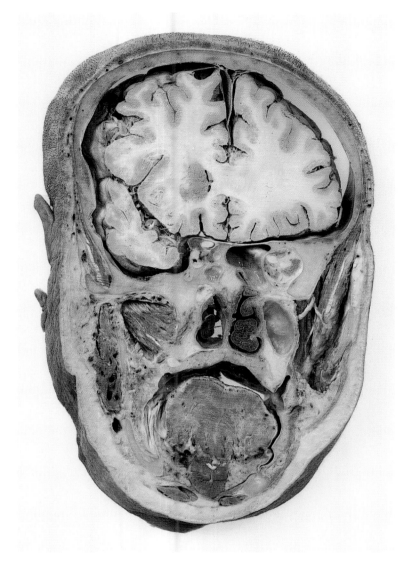

"The woman sat up, frightened, she pulled out of herself, too quickly, too violently, so that her face was left in her two hands. I could see it lying there: its hollow form. It cost me an indescribable effort to stay with those two hands, not to look at what had been torn out of them. I shuddered to see a face from the inside, but I was much more afraid of that bare flayed head waiting there faceless."
Rainer Maria Rilke, 1910

Whereas nineteenth-century photographers commonly depicted death, twentieth-century practitioners have generally shied away from the subject (except in its violent forms, where they have produced a surplus of macabre images). Such is the contentment on the face of Rudolf Schäfer's morgue subject that we have trouble believing that he has left our world – indeed, it would seem that 'life' on the other side of the River Styx holds its fair share of pleasures. The sense of a person merely asleep is enhanced by the comfortable, rumpled sheets. Would we read the face this way had the subject been depicted lying in a coffin?

The anatomical photographer Ralph T. Hutchings has a literal take on the phrase 'slice of life'. This is what we all look like within, millimetres below the surface of the face. There is little encouragement here for musings about character and 'inner being'. But, quietly, science has slowly been unravelling the mysteries of the face. And without advances in medical photography – a vital tool for surgeons – the promise of face transplants would still be a conceit of science fiction instead of a valid (if controversial) option.

ii Facing Down

In Désirée Dolron's striking portrait – inspired by Petrus Christus's *Portrait of a Young Woman* and reminiscent of artists as different as the Flemish primitives, Rembrandt and Italian masters like Bronzino – a girl turns partly towards us, with a look that could kill. Is she a real person, a porcelain doll, or mere image – some new species of electronic avatar? The beauty of the face is breathtaking, hyper- rather than sur-real, but the cold gaze finally does convince us that she is indeed human, if haughty and headstrong. She is only willing to share the instant with us, but not a shred of her feelings. Indeed, it seems that even X-rays would fail to penetrate the hard, ceramic shell.

"There is, in the human face, an infinity of twists and turns and escape routes." Georges Bataille, 1944

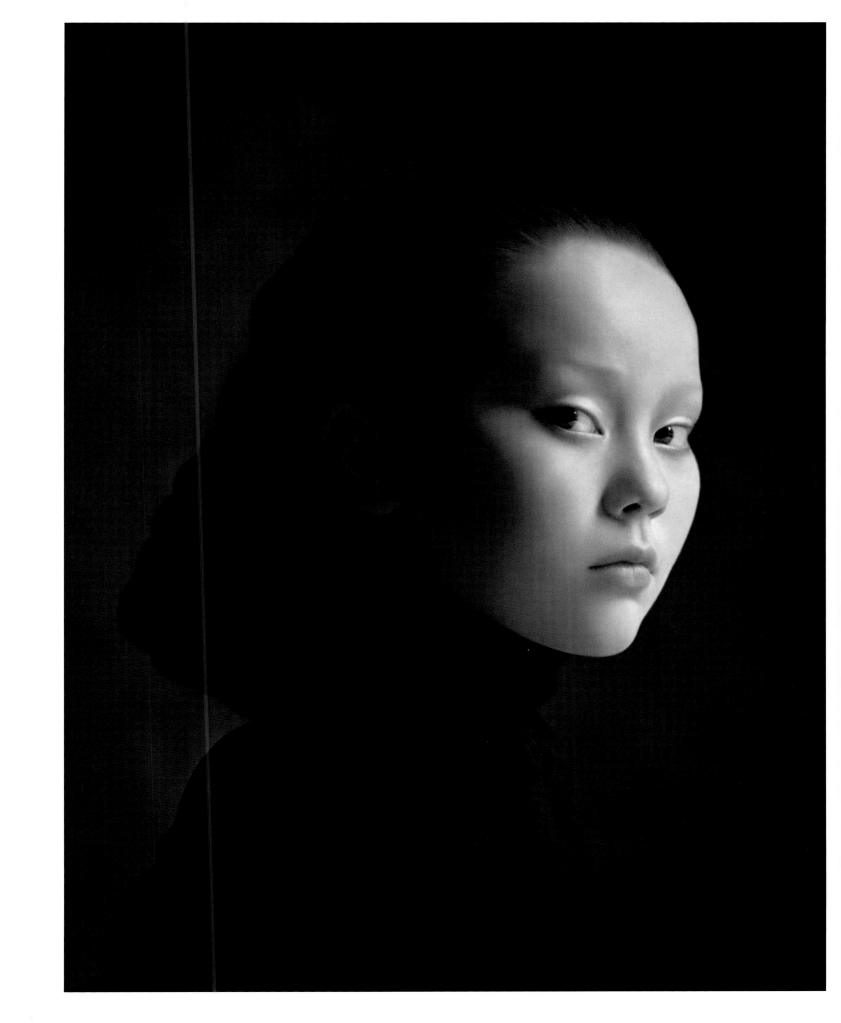

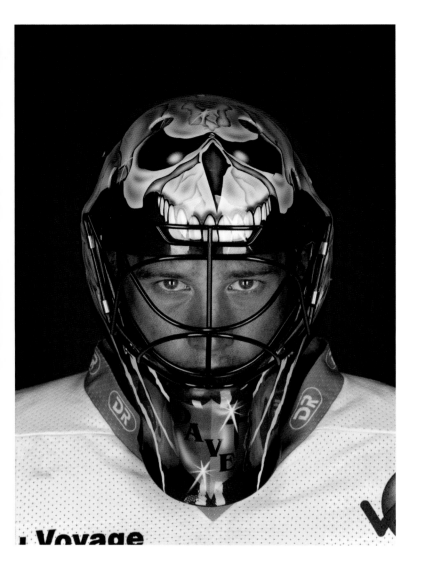
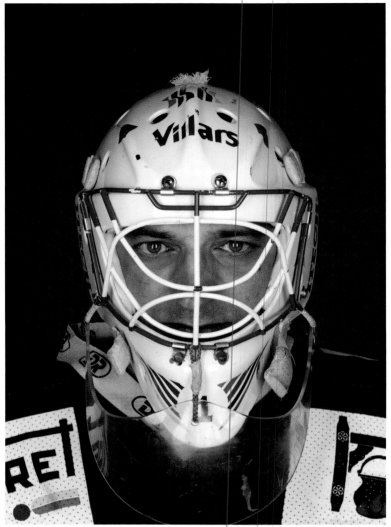

(from left to right) **Pierre Fantys**
Mask III, *Mask IV*, *Mask V*, *Mask II* 1999

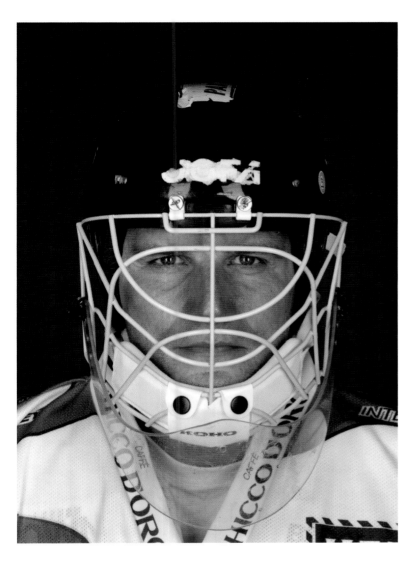

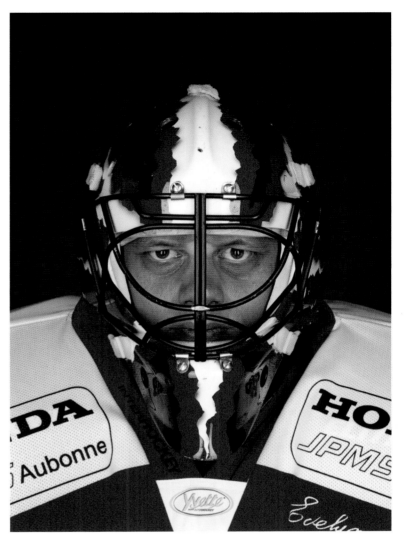

Hockey goalies, photographed on their own terrain, in the stadium, in the moments before a match. Had they visited the studio, the photographer would have had the psychological advantage. But Pierre Fantys has agreed to level the playing field, thus making the sitting a test of wills. Sport is sublimated warfare, and if the mask is there essentially to protect the face, full advantage is taken of its decorative potential in order to intimidate the 'offensive' players. Jagged forms, brilliant colours – neotribal masks to distract opposing warriors.

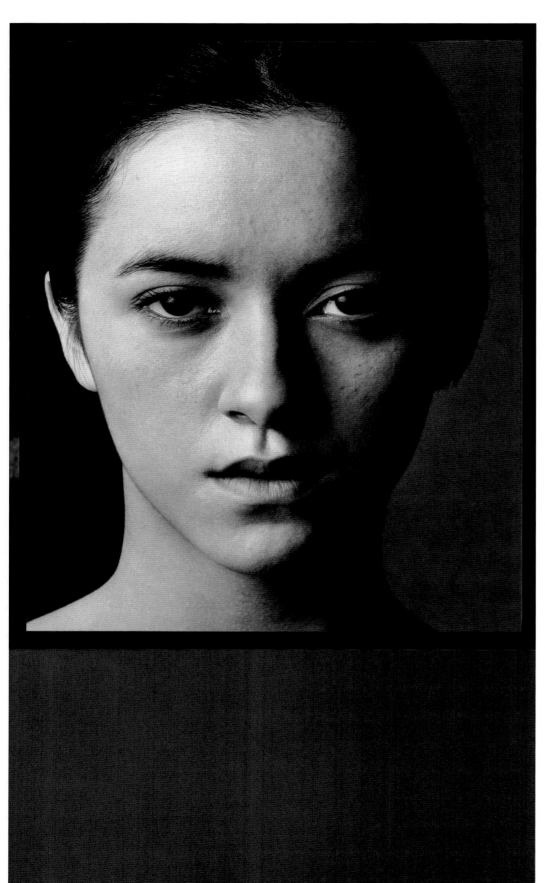

"Once I feel myself observed by the lens, everything changes: I constitute myself in the process of 'posing', I instantaneously make another body for myself, I transform myself in advance into an image."
Roland Barthes, 1981

Marie-Jo Lafontaine *Savoir, retenir et fixer ce qui est sublime #10* 1989

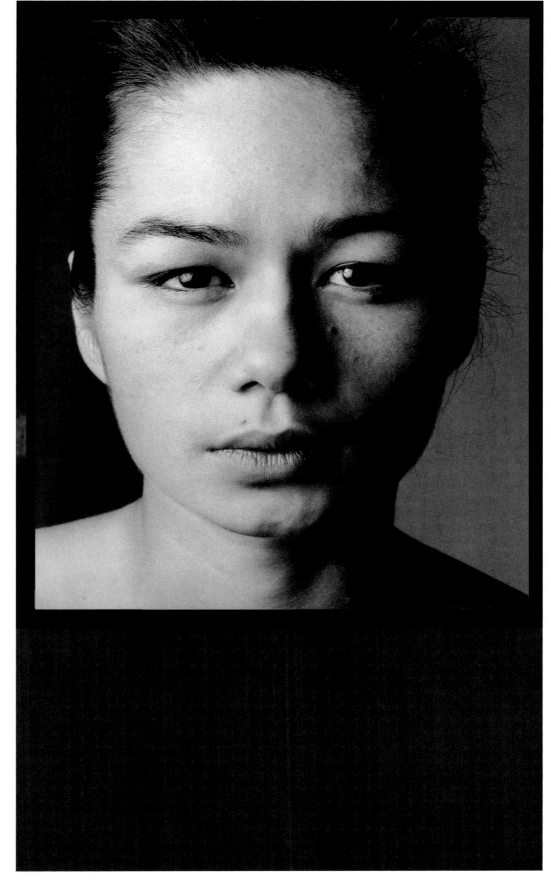

We sense that the strong women on these pages are present of their own accord, and we learn that it is true. They have responded to an advertisement placed by the photographer, Marie-Jo Lafontaine, who had asked women who felt that their mixed-race origins were evident to come forward and have their portraits made. Lafontaine cleverly allows them to fill the frame, a metaphor for their evident confidence and pride. By placing the monumental heads on 'pedestals' (the colour of which evokes blood, with all its connotations, both negative and positive, of ancestry), she invests the women with a sense of nobility.

Marie-Jo Lafontaine *Savoir, retenir et fixer ce qui est sublime #9* 1989

"My work is over when I have managed to get beyond the mirror." Jorge Molder

Pope Innocent X, looking at Velázquez's portrait of him in 1650, famously complained, 'Troppo vero' (too truthful)' – hence Jorge Molder's title 'T.V.' His self-portraits are 'too real, too truthful', for comfort, partly because the gaze is so close and so intense, and partly because his face gives away nothing, other than a kind of naked animal fear. 'Recognition and rejection' is how Molder characterizes his existential struggle: 'For the portrait we must absolutely learn to work with them.' But this is no private battle. By sharing his mirror with us, we are also forced to confront our demons.

Jorge Molder From the series 'T.V.' 1996

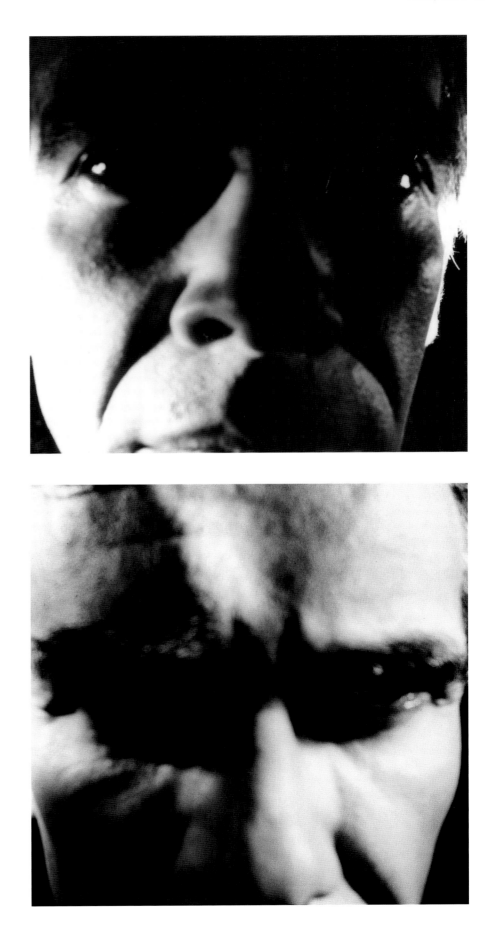

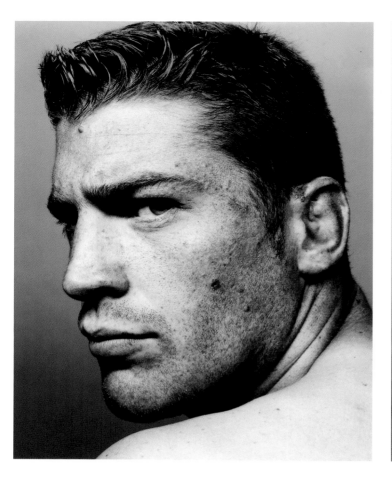
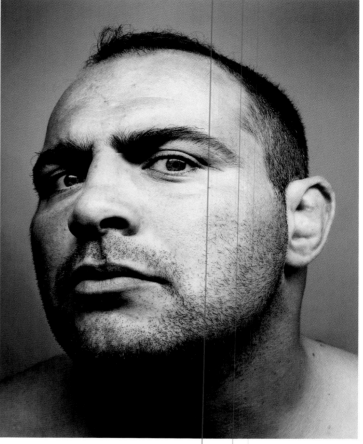

"I thought that the picture would bring out my feminine side but it's going to make my mother burst into tears. If I encountered this bloke in the street, I would ask him how his criminal rehabilitation was coming along."
Raphaël Ibanez (above right)

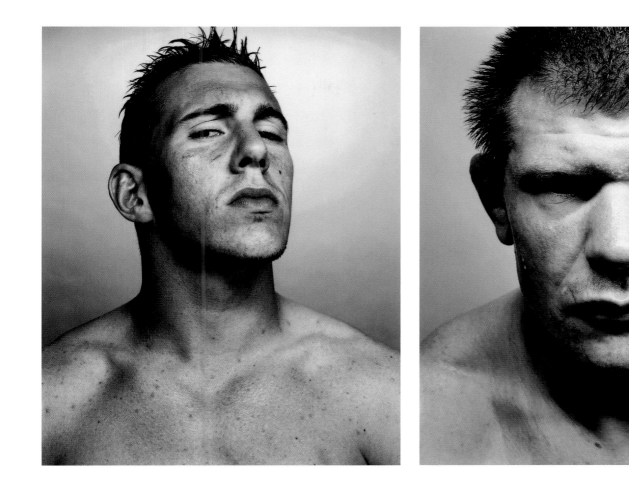

(from left to right) **Denis Rouvre** *Jérôme Thion*; *Raphaël Ibanez*; *Imanol Harinordoquy*; *Olivier Milloud*, from the series 'Broken Faces, le XV de France de rugby' 2003

Denis Rouvre took photographs of French international rugby players with the idea of challenging them afterwards to comment on the success of their portraits. He did not impose his own expressions, but allowed his subjects to present themselves as they would like to be seen. Well aware of the high value placed on machismo by their fans, the players act the part while subtly mocking the ludicrous script they are obliged to adopt by a celebrity-obsessed sporting culture.

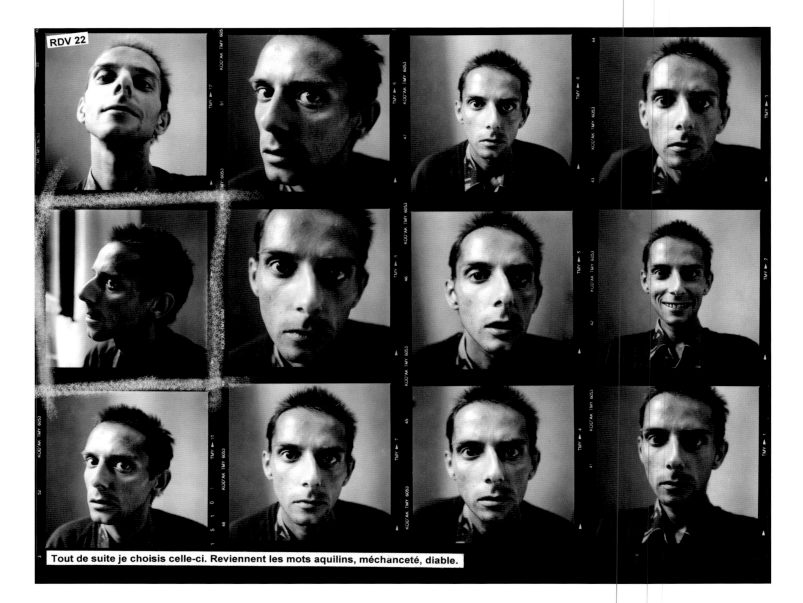

RDV 22

Tout de suite je choisis celle-ci. Reviennent les mots aquilins, méchanceté, diable.

"Immediately, I choose this one. It brings to mind the words aquiline, malice, devil."
Xavier

Steeve Iuncker's three-year project with Xavier, a young man slowly dying of AIDS, is highly unusual in that, after photographing his subject, Iuncker allowed the camera to be turned back on himself. By letting Xavier subject him to the same scrutiny, Iuncker equalized the relationship. At the same time he found a way to disarm his subject, making it likely that Xavier would be willing to give more of himself in Iuncker's own photographs. Moreover, with Xavier's growing experience as a photographed subject came a growing awareness of how to present himself. Iuncker, a news photographer, here played the part not of an impartial observer in a piece of reportage, but a partner in a moving social drama.

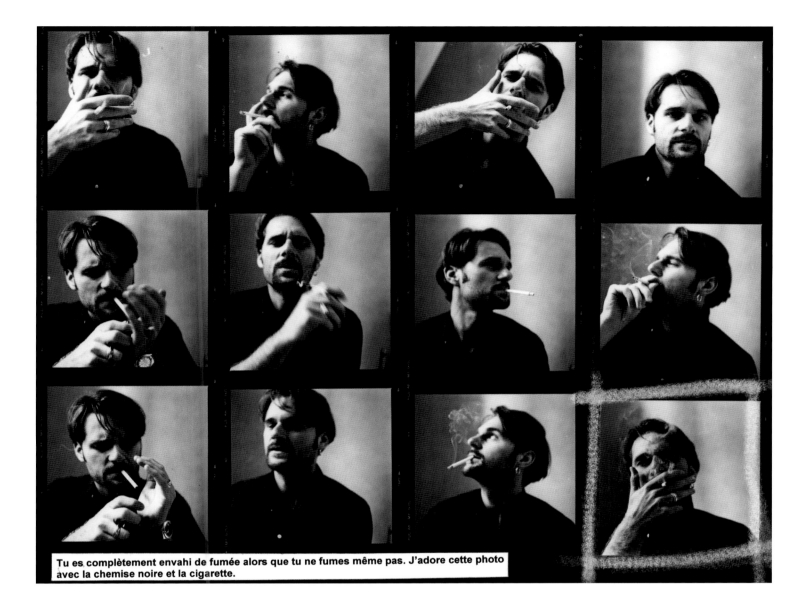

Tu es complètement envahi de fumée alors que tu ne fumes même pas. J'adore cette photo avec la chemise noire et la cigarette.

"You are completely enveloped in smoke, although you don't even smoke. I love this photo with the black shirt and the cigarette." Xavier

Steeve luncker *Rendez-vous 22*, from the series 'Xavier' 1996–98

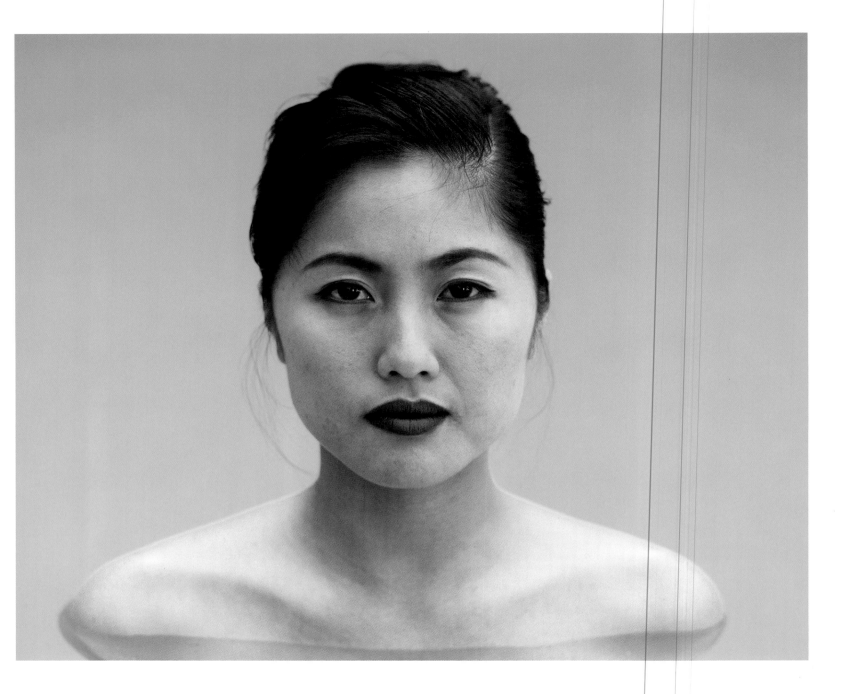

Roland Fischer *Untitled*, from the series 'Los Angeles Portraits' 1994
Roland Fischer *Untitled*, from the series 'Los Angeles Portraits' 1993

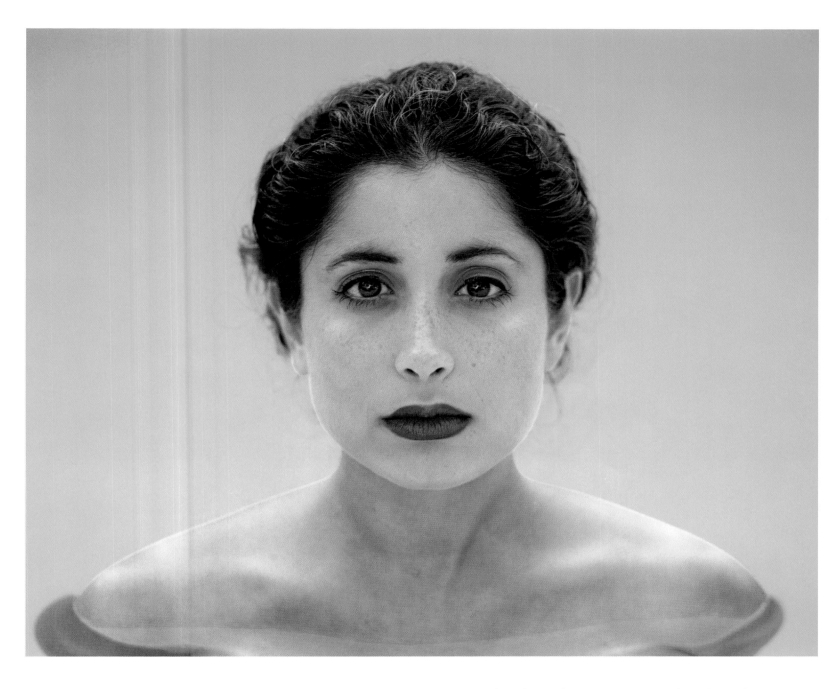

Women's bodies float in suspended animation, like lethargic fish in an aquarium. Beyond the evidently high-maintenance faces and bodies, there are no material signs of social status or occupation. No indication is given as to individual identity either; the subjects are identified simply as a group, 'Los Angeles Portraits'. Character, personality, idiosyncracy – all seem irrelevant, entirely outdated concepts. A *Degree Zero* of emotional expressivity, a total disengagement with the real world, seems to have been achieved.

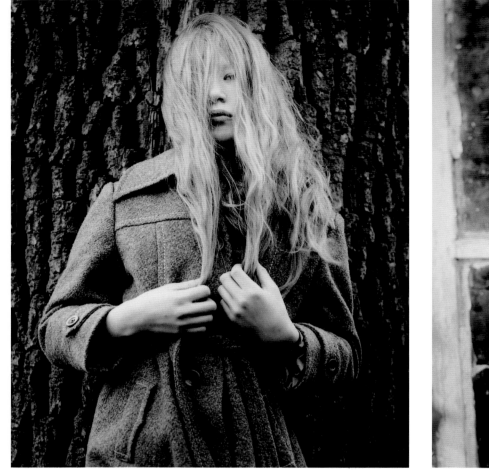
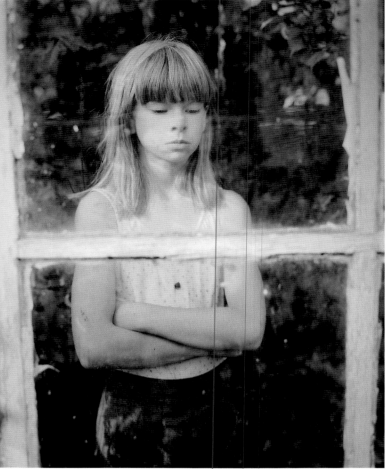

"Faces in the everyday impress us as hives of subtlety. That impression must be sharpened in photography, which discloses only a microsecond of the face's behaviour, immersed in a social process." Max Kozloff, 2000

(from left to right) **Ingar Krauss** *Untitled (Hannah), Zechin* 2001;
Untitled (Nico), Zechin 2001; *Untitled (Hannah), Ediger-Eller* 2001;
Untitled (Hannah), Zechin 2000

For generations photographers imposed their concept of the portrait on their subjects and were trusted to know best, just as a father, a teacher or a priest was an unassailable authority. No longer. Ingar Krauss's truculent children refuse to engage us. The adult world obliges them to be present, their body language seems to say, but clearly that is the limit of their collaboration. Still, it would be wrong to read these faces as neutral or affectless. Behind the clearly etched masks of defiance are strong personas ready for perennial intergenerational combat.

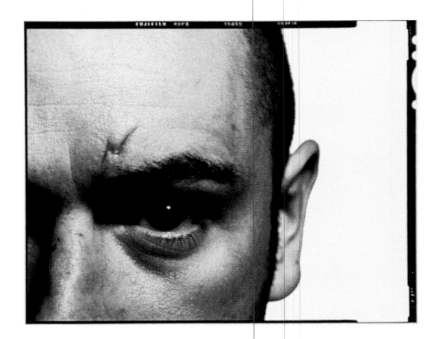

"Photography is our exorcism. Primitive society had its masks, bourgeois society its mirrors. We have our images." Jean Baudrillard, 1998

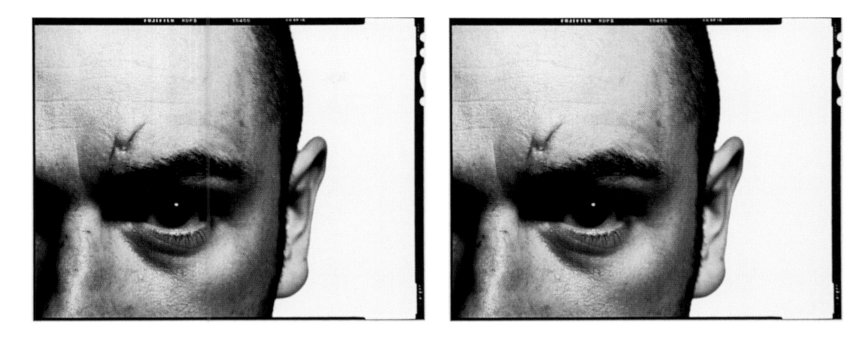

(from left to right) **Douglas Gordon** *Say 'yes'; Say 'no'; Say 'maybe'*,
from the series 'Punishment Exercise' 2001

There is marked hostility in this face and there can be no doubt at all that it is directed at us, the viewer. We are being interrogated, without mercy. The window's tight framing suffocates and its staccato repetition magnifies our discomfort. It is as if *our* heads are in a vice, and the face of the torturer swims in and out of our vision. What answer must we give him to stop our torment? *Yes? No? Maybe?*

MASKS
MERGERS

²LOOKS

Language is rich in words and phrases that speak of faces – faces *seen*, and faces that *see*. The thesaurus reminds us how words we commonly use for faces are often associated with other domains: façades (architecture); veneer (carpentry); reading someone's face (literature); a feast for the eyes (food); and play of expressions (theatre). Take the multi-faceted word 'looks', which sums up the concepts above and evokes many more. On the one hand there are the looks that can be thrown like daggers across a room – *if looks could kill*, or *you should have seen the dirty look she gave me*. On the other hand there are those of appearance: *good-looking*, *odd-looking*, and so on.

We are assigned our faces in the womb, with no say in the matter, but our looks are to some degree malleable. Those dissatisfied with their lot – most of us, it would seem – gradually learn to make adjustments as we grow, hiding perceived flaws with arrangements of hair and make-up, enhancing perceived assets with jewelry and decoration, and learning procedures to keep our faces fresh, youthful and blemish-free – all of which practices are inflected by culture, class and the whims of current fashion.

People also learn to animate their faces attractively. Young children 'make faces' in the mirror, pushing expressions to extremes – and it's not just a game, but a way of arriving at socially acceptable norms. Adolescents in our society commonly go through a phase of practising more subtle expressions in the mirror, narrowing looks down to those that seem the most flattering or seductive. Adults buy glossy magazines and scrutinize faces for strategies they can adopt. Lastly, for those who feel that such face-shaping techniques are not quite sufficient to give them the looks to which they feel entitled, there is always recourse to the surgeon's knife, ever more skilful with time. ('The nose-job look is gone,' runs one advertisement for cosmetic surgery, implicitly suggesting that clients had best keep coming back if they want their faces to remain fashionably up to date.) And just as clothed bodies end up seeming more natural than naked bodies, so artfully made-up faces end up seeming more natural than the raw material underneath. In the future, of course, the desired looks (at least those desired by parents) will be genetically programmed: the mask will be provided at birth.

The word 'masks' also suggests myriad meanings: a covering, a screen, a disguise, a veil, camouflage…. On the one hand, all that is deceitful in human beings; on the other hand, simple fun and games, pleasure, escape from the humdrum,

make-believe. 'Mergers', too, evokes numerous possibilities: combinations, mixtures, minglings, interweavings, amalgams, fusions, hybrids....

It is fair to say that good photographers are more comfortable with the thesaurus model than with the dictionary definition. They approach 'the face' as if it were the terrain of a foreign planet, curious and wary of what (and who) they may find there. Photographers are used to close scrutiny of visible surfaces, yet extremely conscious of just how thin these surfaces can be. One moment they might read a particular face one way – as, say, a stone wall that *conceals* something – and the next instant as a porous membrane that *reveals* something. Or photographers may decide that penetrating duplicitous surfaces requires the mixing and matching of different faces.

There is no limit to the techniques photographers may employ. Some choose to weave their magic in the studio, others in the darkroom, and still others in the electronic ether. Some use combinations of these techniques – for example, film to capture images and then the computer to mix them. The rapid mutation in the digital realm means that the possibilities change virtually by the day. The horizon now seems limitless: if contemporary photographers have abandoned the parched ground of conventional portraiture, they have more than made up for it tilling the fertile slopes of the digital terrain.

Perhaps photographers are drawn to faces because photographs and faces share something in common: although both are instantly engaging, first appearances can be very misleading.

"I wrote with light, and the model was transformed into all the figures of my imagination: a Napoleon, a beggar, a medieval monk, a knight, a modern technician, a religious fanatic, a gothic statue, a death mask."
Helmar Lerski, 1953

iii Masks

The subject of Inez van Lamsweerde and Vinoodh Matadin's portrait (a questionable term, given the theatricality of the staging) conjures up a world of transgressions. Exuding an elegant, refined, Versailles-like decadence, this delicate waif of a woman fixes the viewer with a look of absolute command, hinting at erotic pleasures. The apparent graphic simplicity of the image belies its complexity: note the downward tilt of the head, the massive coiffure, the bow (the male gaze imagines the untying of the bow, the cascading hair and inevitable 'surrender'), and the sensuous play of curves throughout (note also the subtle mirroring of the breasts in the hair at the nape of the neck). But, above all, there is suggested transgression in the 'mask' itself: black/white, male/female, adult/child. And is the mask a mask, or a painted face? On scrutiny, it seems the latter. Perhaps, then, the mask is yet another's face – the face, in fact, of the desiring male, which would mean that there is no female present at all, only a mirror reflecting male lust.

Overleaf are two minimalist portraits from Valérie Belin's series of black African women. They face us as still and polished as carved ebony. This sculptural effect is cleverly reinforced by the partial covering of the shoulders, thus suggesting a 'base' for the sculpted head. Belin thus pays homage both to a rich tradition of African sculpture, with its coherent mix of figuration and abstraction, and to the real flesh and blood women who have posed for her. Her work reminds us that great pleasure is to be derived from photography's inherent ambiguity, throwing into doubt Regis Debray's claim that 'the face can never have the calm existence of an object'.

Inez van Lamsweerde and Vinoodh Matadin *Anastasia* 1994/2001

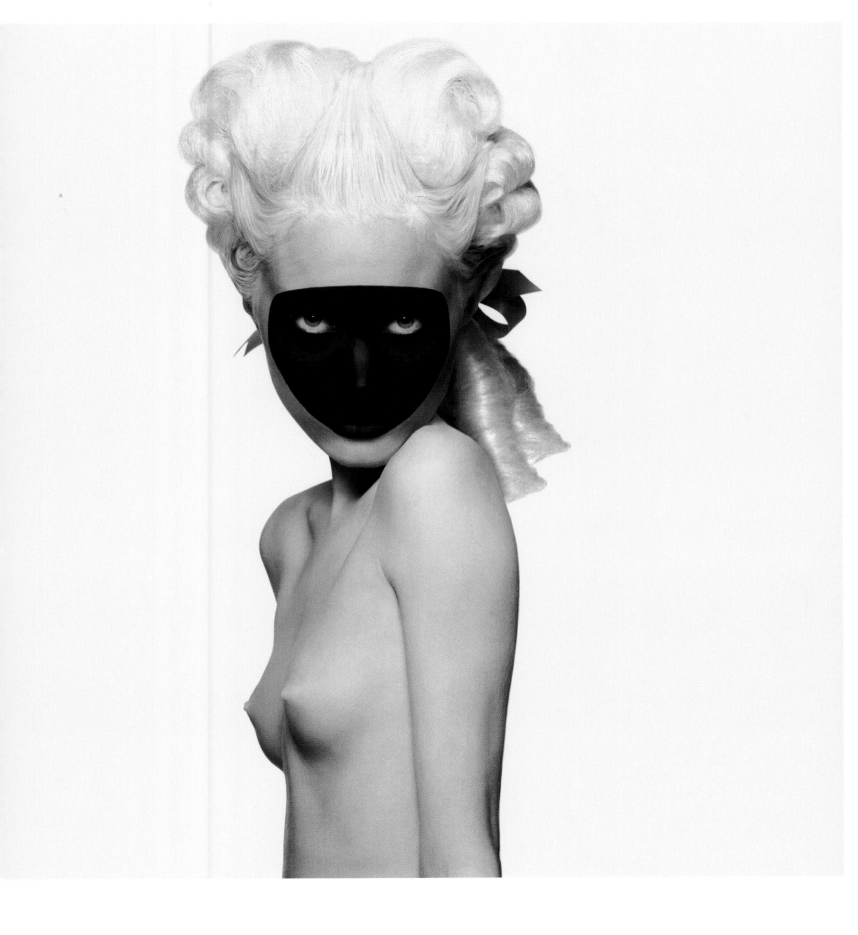

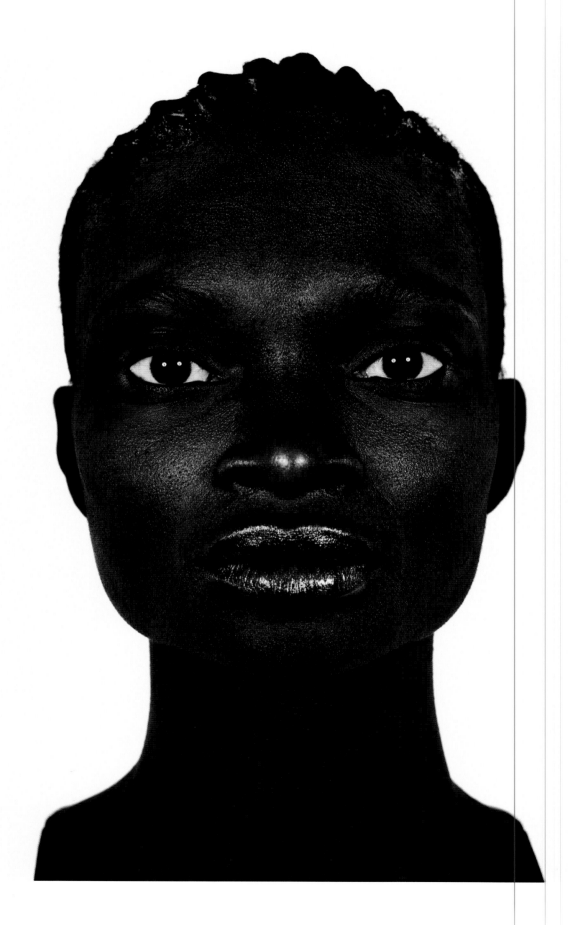

Valérie Belin *Untitled* 2001

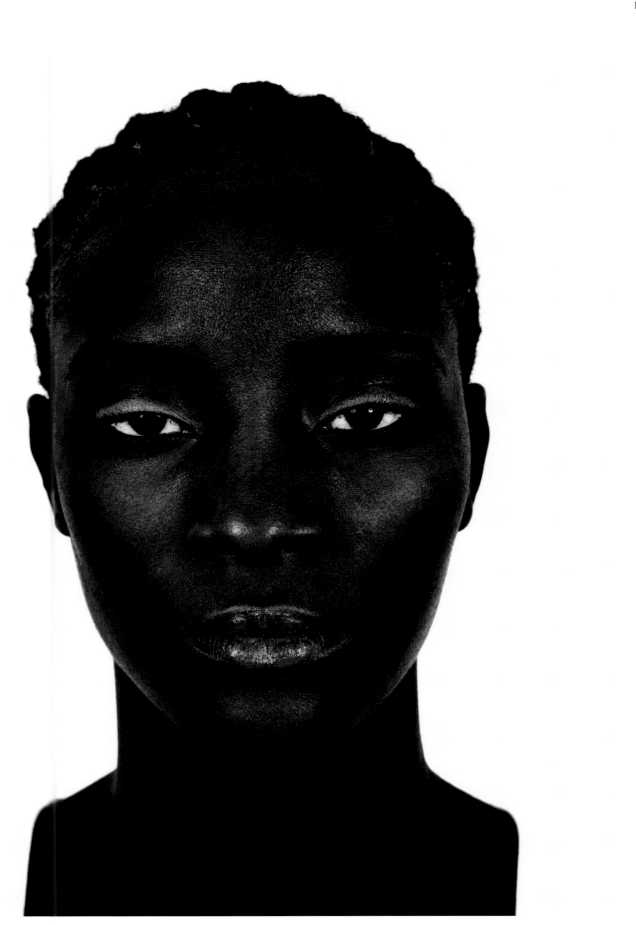

Valérie Belin *Untitled* 2001

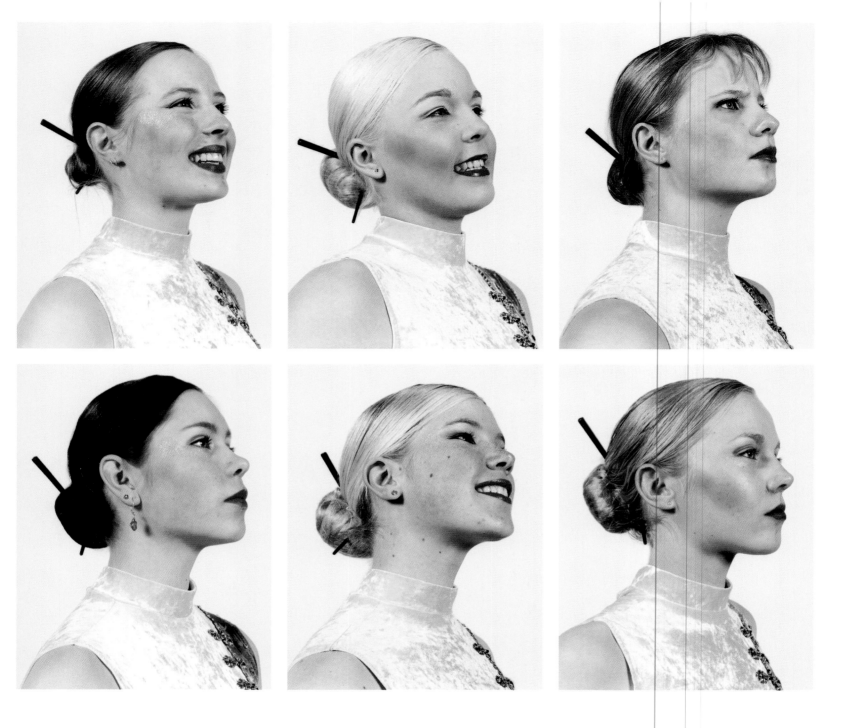

(clockwise from top left) **Charles Fréger** *Winner Face 14; Winner Face 11; Winner Face 6; Winner Face 1; Winner Face 12; Winner Face 4*, from the series 'Steps' 2001-02

Charles Fréger's synchronized skaters are shown posing with their chins held high, putting on the expression known as the 'winner face' – a requirement of the skating routine. Conformity is all, and individuality is seen as an unwelcome intruder. The smile itself is pure performance, simply another acquired skill. But because the smile (as well as the frown of determination, necessary sides of the same coin) is usually observed at a considerable distance, Fréger's too-close camera provides a discomfiting intrusion.

"Thank you, Dr Lewis, for giving me something so priceless – my smile! You are the one who truly deserves a Gold Medal." Shannon Miller, Olympic Gold Medallist

overleaf ▶ It might take a moment for us to realize that the face photographed overleaf left is that of a doll. Our gaze is so habituated to idealized advertising imagery that it is easy for us to read life into it. What drove Mona Schweizer to commemorate the life of this being, photographically speaking as real as any other face in this book? The ubiquitous imagery of Eternal Youth in the public sphere? A model for genetic engineers to emulate? A comment on the lies and deceits practised by portrait photographers?

Inez van Lamsweerde and Vinoodh Matadin's portrait overleaf right is also replete with mixed messages. Doll? Child? Child-woman? 'Pretty Baby'? The glossy lips and closed eyes speak of sexual pleasure, but the youthfulness of the face cries out against this interpretation, mirroring the conflict inherent in the fashion industry's deployment of ever younger faces. Cleverly, the tight cropping of the subject's face denies us the information we crave to resolve the enigma and defuse the issue.

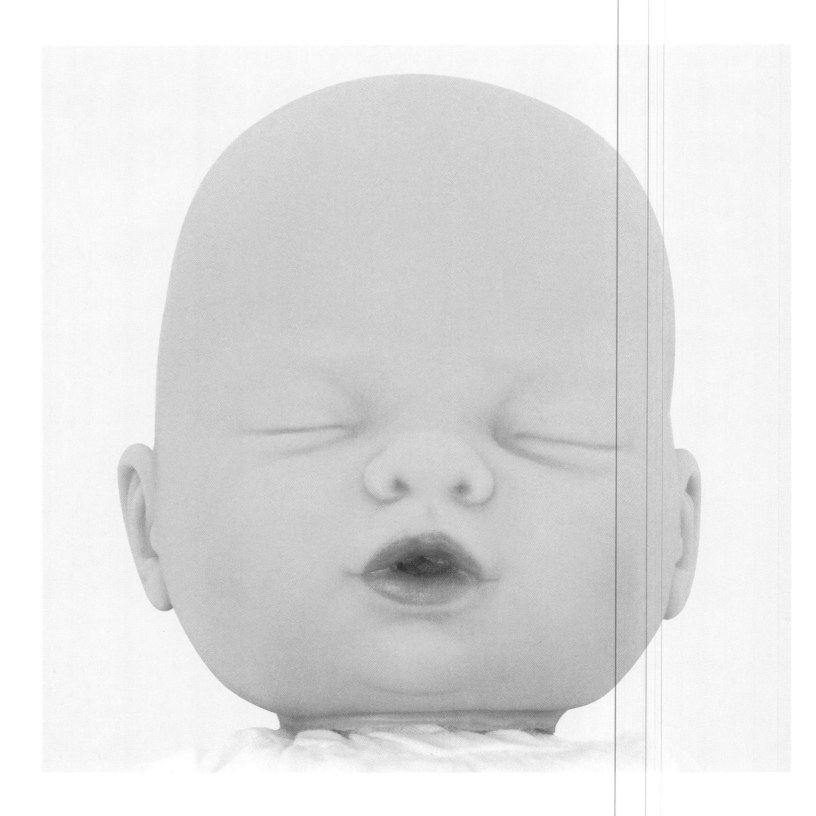

Mona Schweizer *A Portrait of a Doll* 2004

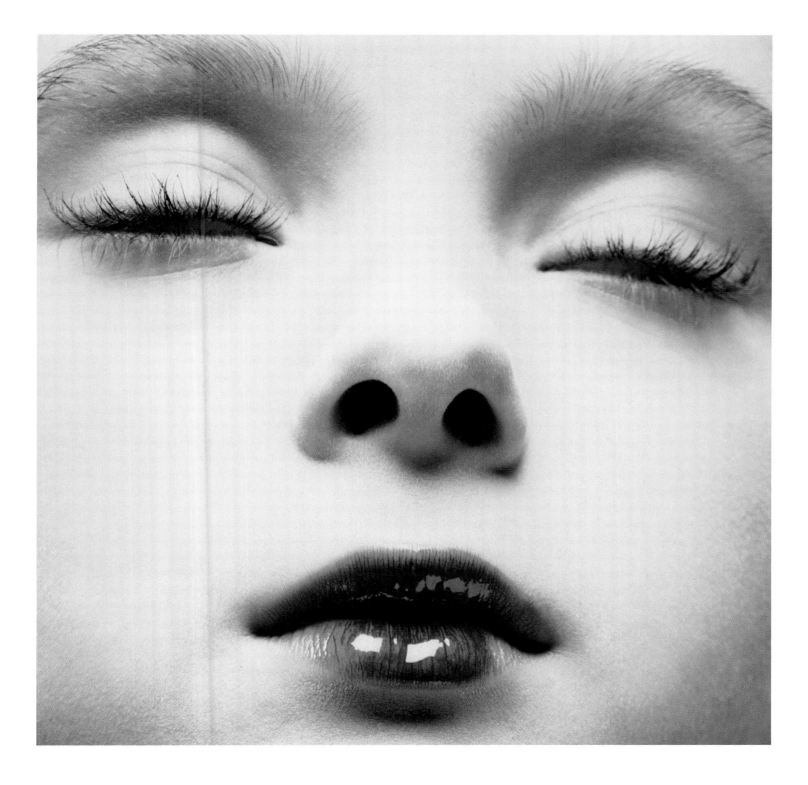

Inez van Lamsweerde and Vinoodh Matadin *Kirsten* 1997

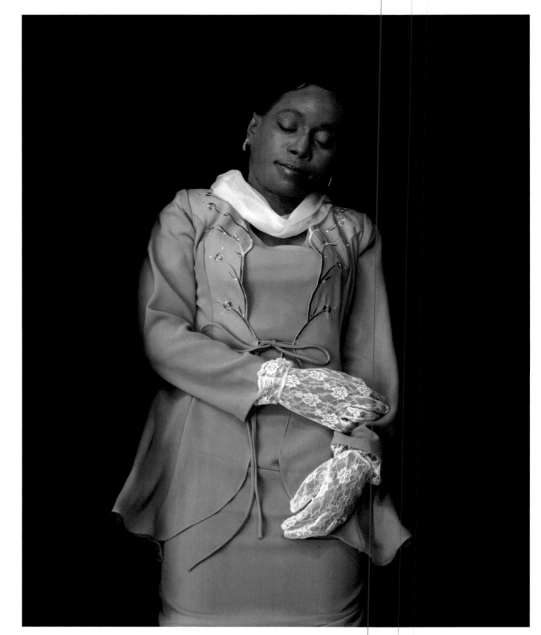

Elizabeth Heyert *Daphne Jones, Born August 1954, Harlem New York, Died January 2004, Harlem New York,* from the series 'The Travelers' 2004

"Thanks to the sublime art … much of the bitterness of separation amongst friends, and of that great and final separation which we have all at times experienced, is greatly alleviated." The Photographic News, London, 1865

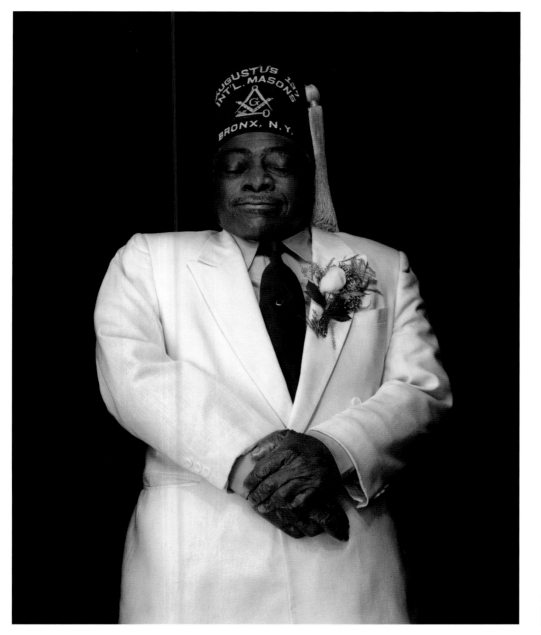

Elizabeth Heyert *Raymond E. Jones Sr., Born December 1928, Memphis Tennessee, Died January 2004, Harlem New York*, from the series 'The Travelers' 2004

Are they really dead, or are they only pretending? Is this a joke at our expense, some macabre pantomime? Elizabeth Heyert tells us that her subjects are well and truly dead, their faces, dress and postures composed by Harlem's famed mortician, Isaiah Owens, renowned for his ability to reinvest the faces of the dead – which often come to him abused and shattered – with the quality of life, and of a life worth having lived. Heyert depicts her subjects without coffins, in an enveloping, womblike black. Were we to uncritically accept Richard Avedon's definition of a portrait as 'a picture of someone who knows he is being photographed', we'd clearly have to rule out the dead. Luckily, no one has told Elizabeth Heyert of this photographic 'no man's land'.

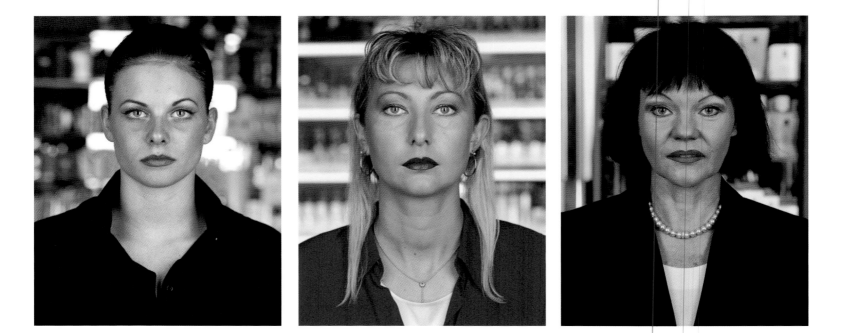

"There is no doubt a Dior woman, a Guerlain
Monique Sicard, 2002

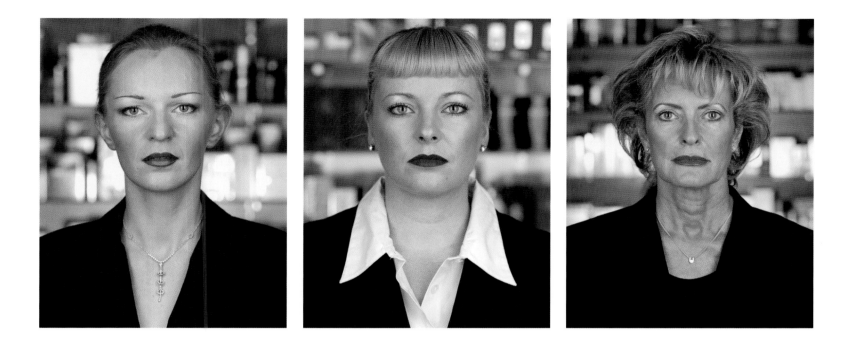

woman, a L'Oréal woman…."

Raphael Hefti's department-store sales forces stand stolidly before their famous brands of cosmetics, freshly arrayed before the workday shift. These are the made-up faces of front-line soldiers in the great, cease-less battle of consumerism, ready for hand-to-hand combat with their anxious clientele, but with the weapon of the seductive smile yet to be engaged. These are not the faces of the elite shock troops – the Cindys, Kates and Naomis, aka the Supermodels, whose images are cloned by the billion each month. The faces of the lowly soldiers photographed here will never grace the pages of the glamour magazines, being far too individu-alistic, expressive and *real*.

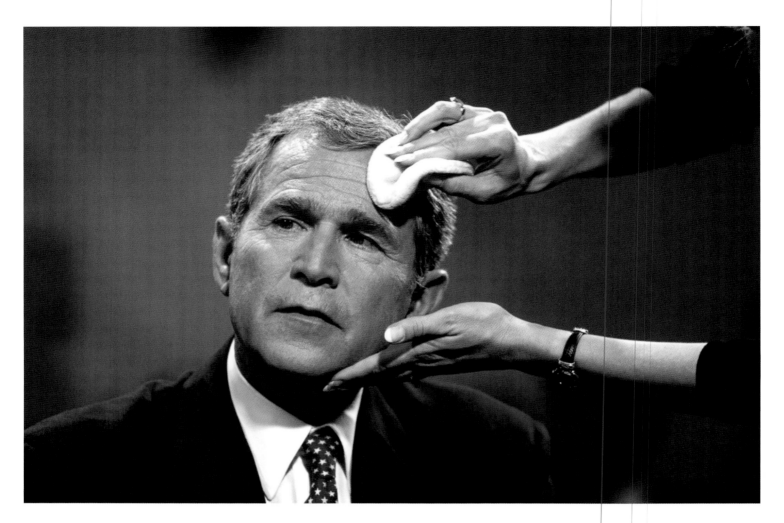

"To say that 'the camera cannot lie' is merely to underline the multiple deceits that are now practised in its name." Marshall McLuhan, 1964

Brooks Kraft *Candidate Bush* May, 2000

Josef von Sternberg explained that because the human head was monstrously expanded on the silver screen it therefore had to be treated like a landscape. Something similar can be said of the transformation of the face on television. Here, through the eyes of a photojournalist, we see George Bush before becoming president, being 'made-up' for television viewing. The soon-to-be most powerful man on earth submits to the delicate feminine touch of the cosmetician that will render him attractive in pixels. For anthropologists, faces are biological ornaments that signal valuable information to potential mates, and these ornaments must be polished to perfection if seduction is to occur.

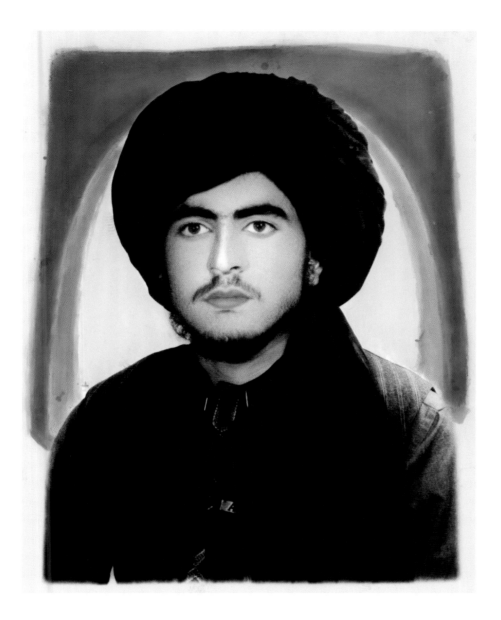

Thomas Dworzak *Taliban portrait, Kandahar, Afghanistan* 2002

While travelling in Afghanistan, photographer Thomas Dworzak discovered a cache of photographs of Taliban warriors that had been left behind in the chaos. It was an astonishing find, given that the Taliban's strict version of Islam forbids any depiction of a living being. More astonishing, given the reputation in the West for Taliban ferocity, not to mention proscription of homosexuality, the pictures had been heavily retouched, indeed feminized. But perhaps there is no contradiction here at all, merely a time-lag (it was, after all, only a few decades ago that Valentino was heavily made up for public consumption). Or perhaps this is yet again an indication of our failure to comprehend another complex culture.

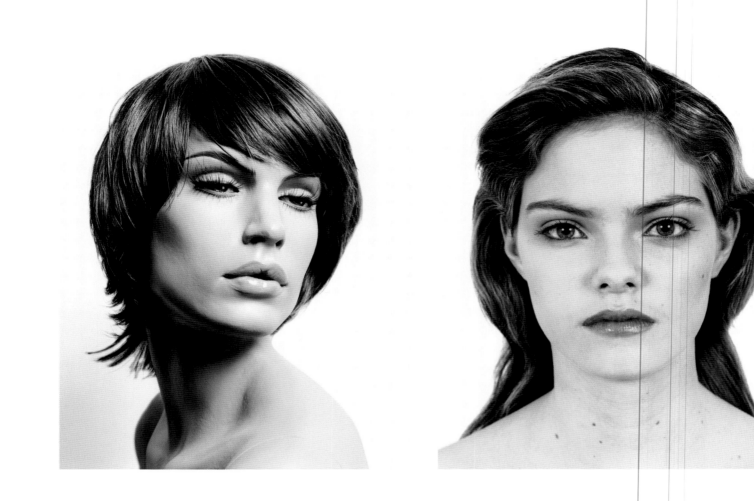

(from left to right) **Valérie Belin** *Untitled* 2003;
Untitled 2001; *Untitled* 2003; *Untitled* 2001

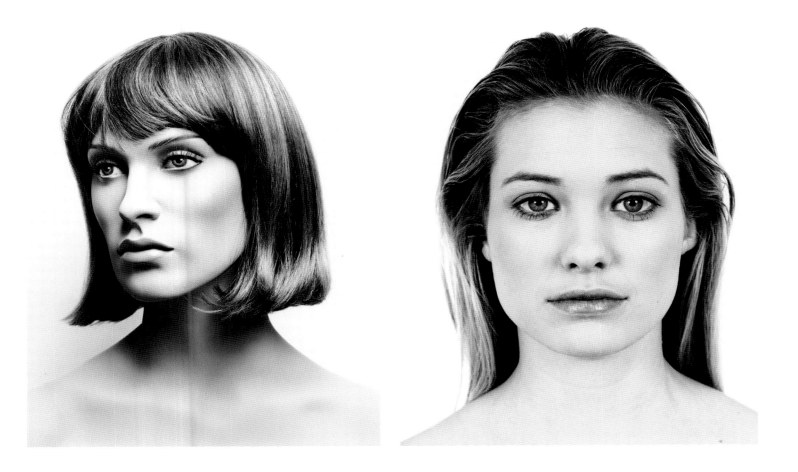

The French word for 'model' is *mannequin*, which in English refers to an inanimate object. With the current vogue for emaciated and inexperienced models, today's living, breathing exemplars do seem increasingly lifeless and inhuman, both in photographs and on the runway. Manufactured mannequins, on the other hand, are becoming more and more 'lifelike'. In these portraits, which capture a kind of look that has been labelled a 'morbid aesthetic', more expression seems to emanate from the artificial constructs than from the real women.

"Why, you've even stolen my face; you know it and I don't!" Jean-Paul Sartre, 1944

Anneè Olofsson *I put my foot deep in the tracks that you made* 2000

Paradoxically, Anneè Olofsson's portrait is a composite of two people, yet owes nothing to darkroom or computer manipulation. Indeed, it is a classically 'straight' photograph. The title offers a clue: but who is the 'I' and who is the 'you'? The 'I', we can assume, is the photographer; the 'you' another woman, probably her mother. But is this an homage to a strong woman, who has protected her daughter all her life? Or is it a complaint: does Olofsson feel that she has been effaced by a stronger personality? Or are the 'tracks' she is destined to follow a statement of resignation (i.e. to how she will eventually look), or else a grateful recognition that her mother has shown her 'the way'?

Gillian Wearing *Self Portrait* 2000

At first glance, the subject of Gillian Wearing's portrait appears to be simply a blandly attractive and thoroughly conventional young woman, with an ordinary face of the kind we might peremptorily dismiss, condescendingly, as that of 'a nice girl'. But then we note an oddness to the eyes and realize that the face is a mask. The tables are turned and we discover that we are the ones being spied upon, and that we can say nothing about the person within, only that we have allowed our prejudices to blind us. A 'self portrait', as the title reads? Rather an un-self-portrait....

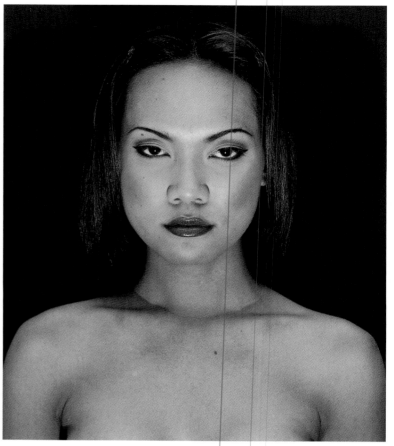

Thomas Weisskopf From the series 'Cut' 2002

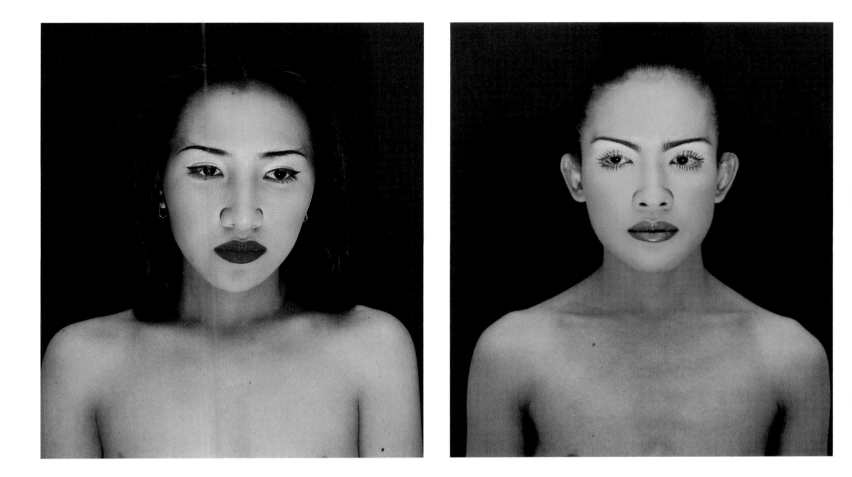

Thomas Weisskopf's portraits have the discomfiting feel of a police line-up. His subjects, Thai transsexuals and transvestites, give us the impression that they have no choice but to be here, which may well be the case in terms of economic survival. The painted lips, the plucked eyebrows, the meticulously applied eyeshadow – these are part of the dress code demanded of a business, the essence of which is the satisfaction of male erotic desires. It would be wrong to condemn Weisskopf's sitters for lacking individuality, as conformity to type is precisely what their clientele demand. One of photography's great flaws is that we forget that a photograph is only part of the picture, a theatrical staging: these (fe)males are not imprisoned in their ladyboy role, they have other lives as well – as cosmetic salesgirls, dancers and models.

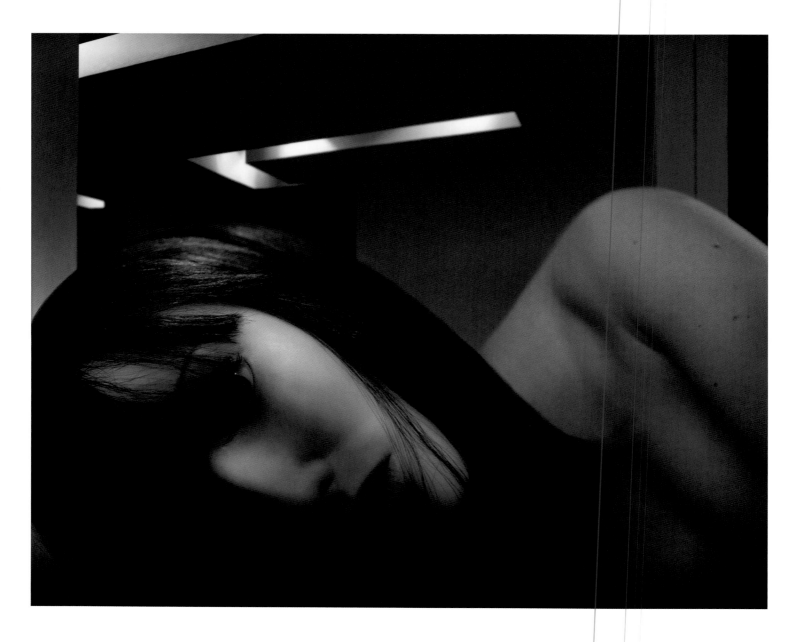

Jean-Pierre Khazem's imagery at first appears to be computer-generated. The body and face are too smooth, the 'Bladerunner' environment too schematic, to be real. But the space *is* real, and so is the body. Only the head of a mannequin has been substituted. And at second glance the environment starts to look disturbingly familiar – precisely because of its banal, soulless aspect. This is where in future, perhaps, replicants and cyborgs will be locked away at night.

As with Khazem's cyborg, the facial expression on Larry Sultan's *Woman in Curlers*, opposite, is equally vacant – and possibly more so. Sultan tells us that she is a pornographic film actress, but we might be forgiven if we professed to see instead a latter-day Botticelli Venus. She is being meticulously prepared for a shoot, and soon her body will be intimately entwined with those of her fellows. But for this precise moment she is not just a 'sex object' but a woman with a life of her own, who puts on a mask for her work and will soon take it off again.

Jean-Pierre Khazem *Pause 17* 2002

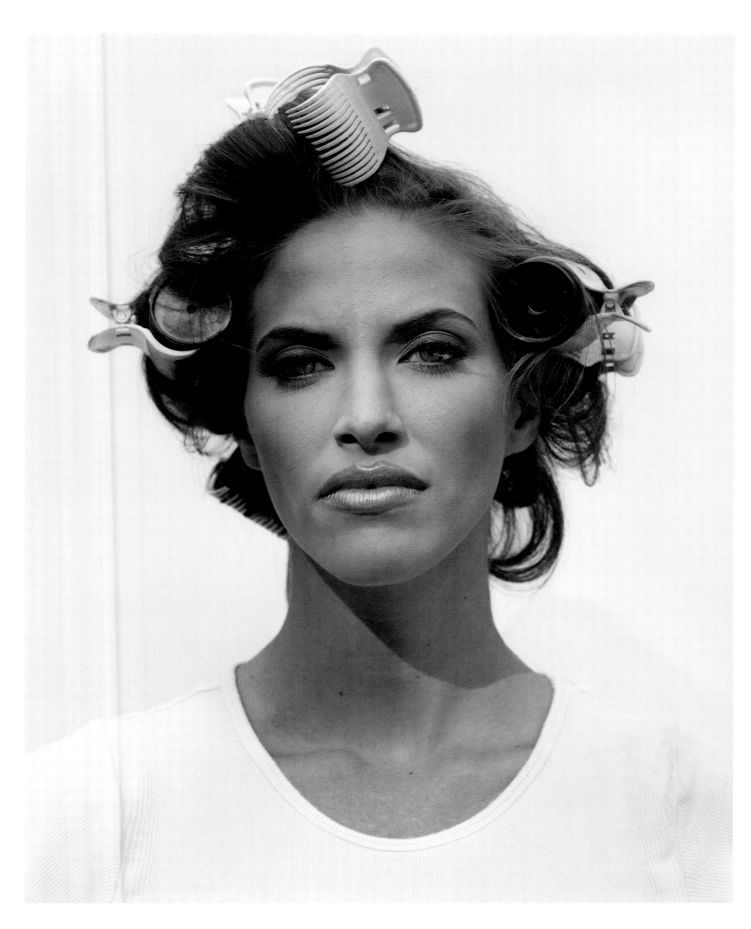

Larry Sultan *Woman in Curlers* 2002

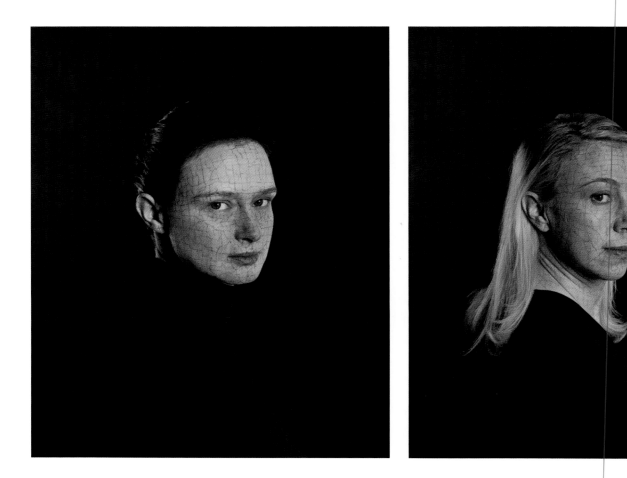

"We distrust depths, interiors, hidden 'truths'. Meanings lie on surfaces, artifacts of an occasion rather than truths about persons.... In place of persons with revealing faces we look for contingencies, signs of constructedness, cracks and fissures in façades which disclose the paint and wires." Alan Trachtenberg, 2000

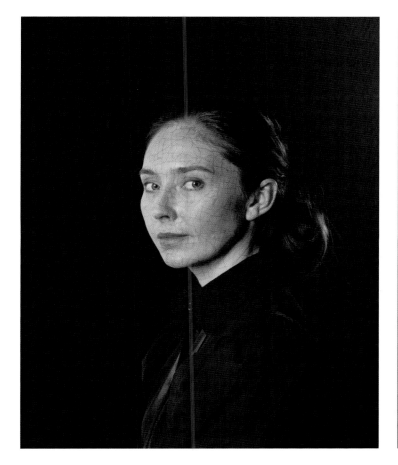

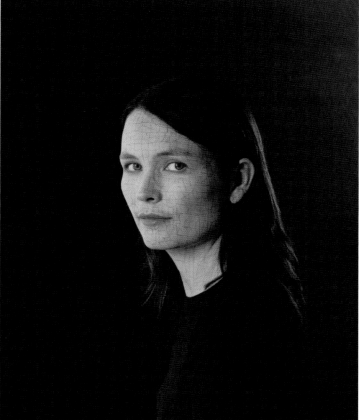

(from left to right) **Anneè Olofsson** *Uscha*; *Marianne*; *Kristina*; *Elisabeth*, from the series 'Will you still love me tomorrow' 2004

A cosmetics industry spokesman asks: does the feeling that we are ageing come before the real signs become apparent? Do we feel more wrinkled than we actually appear to others? Fashion and beauty magazines keep up a relentless barrage of dire warnings. The wrinkles are coming! Let battle commence! Botox, lotions, potions, surgery – every weapon in the arsenal must be engaged in the struggle to maintain the façade. Anneè Olofsson reminds us that our faces will crack and crumble despite the ceaseless 'war on terror' waged so earnestly by beauticians and their willing collaborators. These women are saying, 'To accept me now is to accept me as an old woman.'

iv Mergers

The current impulse, widely shared, is for 'self-improvement' in the literal sense. One young Swiss woman has submitted to thirty surgical operations to enhance her looks. 'I wanted a virginal face, smooth, childlike.... I am always searching for the ideal image I have forged of myself.'

The artist Keith Cottingham has dealt with the issue metaphorically. He uses anatomical drawings, wax and clay sculptures and digital montages to hybridize – and 'improve' – himself. Here he has modelled an adolescent head in clay, based on photographs of boys and of himself as a youth. Photographs of the head are then digitally attached to pencil drawings of adolescent bodies, which are then 'painted over' with skin. Cottingham has posed the figures to resemble a close family grouping, as might be depicted in a bourgeois painting, thus intimating how quickly a radical concept like cloning may settle into thoroughly banal and commonplace practice. As one critic has put it, Cottingham's clones could perfectly illustrate the eugenicist theme in Aldous Huxley's *Brave New World*.

"To make a portrait, it is not enough to reproduce the proportions and forms of the individual with mathematical accuracy; it is also, above all, necessary to understand and represent the intentions of nature manifest in that individual, saving and improving them...."
André Adolphe Eugène Disdéri, 1862

Keith Cottingham From the series 'Fictitious Portraits' 1992

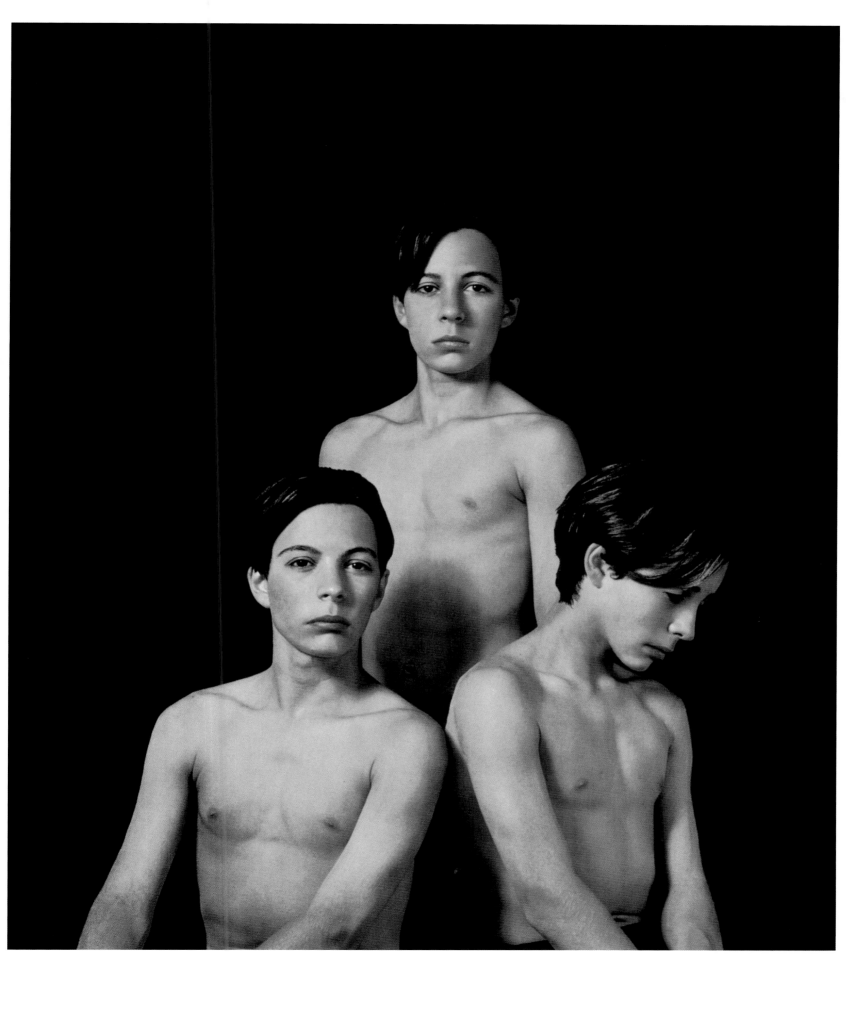

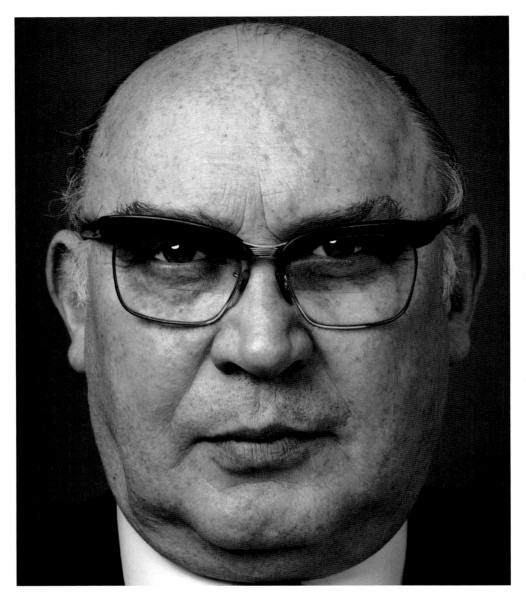
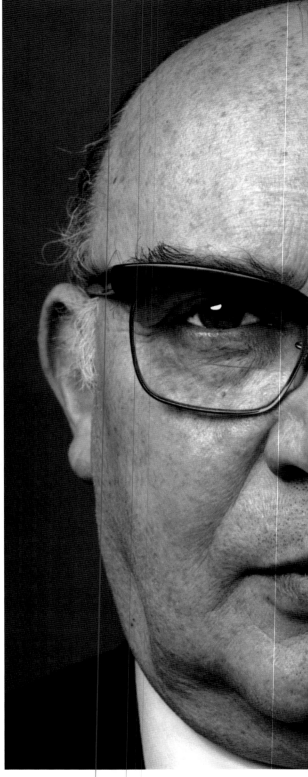

Pierre Radisic *Couple 8-5-82* 1982

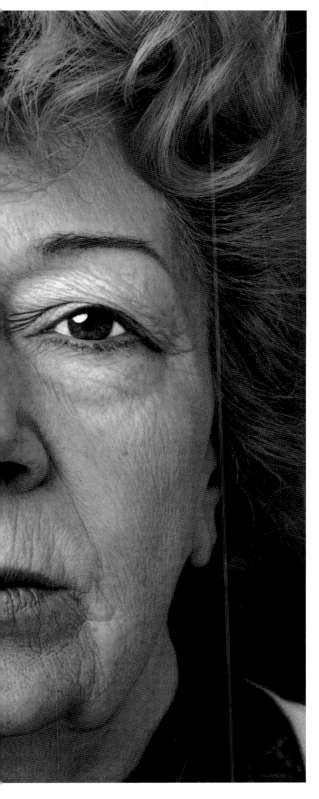

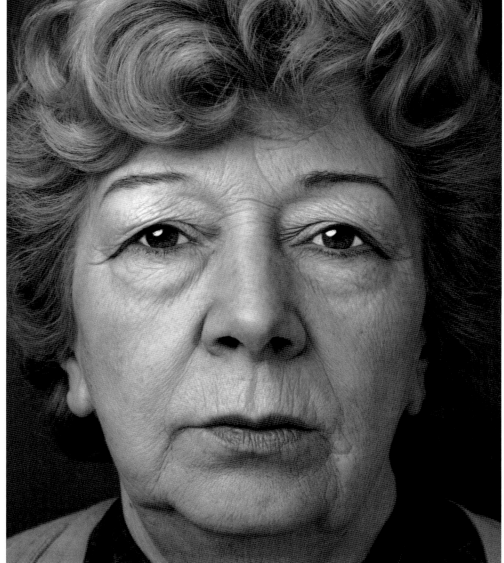

Photographer Pierre Radisic was fascinated by the old adage that couples who have lived together for years end up looking alike. His composite - an image that is in no way manipulated, neither in the darkroom nor on the computer - seems to prove the case, even to the point where the wrinkles on the woman's eyelid are mimicked by the metallic bridge of her partner's glasses.

Working in extreme and intimate close-up, Hee Jin Kang destabilizes our conventional notions of male and female faces, questioning the kinds of treatment and expression appropriate to each as seen in the domains of advertising and publicity. Thus men are repelled by the facial hair, women by the glossy lips. Doesn't the suggestive, slightly opened, pouting mouth belong rather to the nubile female siren? It certainly does not 'fit' the unshaven male face. In photography's commercial arena, male lips are either smiling or pressed determinedly together.

We are made similarly uncomfortable by Michèle Sylvander's s/he portrait, opposite, but here it is the 'manly' hair on the chest that disturbs: otherwise, we would not hesitate to categorize the face as female. Learning that Sylvander has cut his/her own hair and glued it to his/her chest does not make us any less anxious in his/her presence ... not that she avoids responsibility for the deception; she has clearly labelled the portrayal 'the culprit'.

Hee Jin Kang *Danny*, from the series 'Kissable' 2001

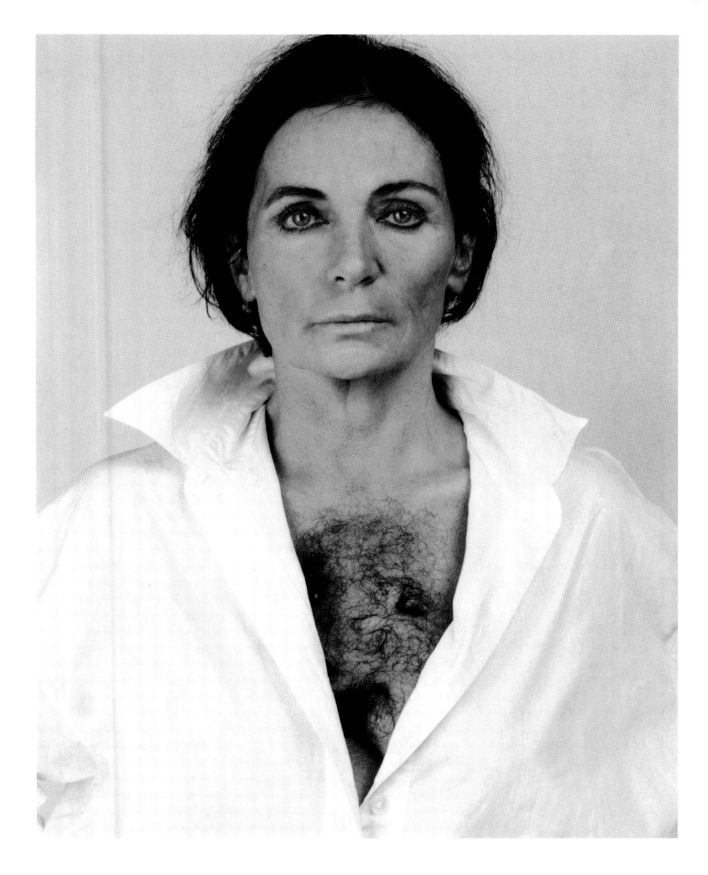

Michèle Sylvander *La fautive*, from the series 'Rencontres' 1995

"Photography pretends to show reality. With your technique you have to go as near to reality as possible in order to imitate reality. And when you come so close then you recognize that, at the same time, it is not." Thomas Ruff, 1993

Masculine and feminine traits are similarly confounded in Thomas Ruff's portrait of an unspecified 'other' (left). The black and white 'passport' quality, which makes one think of 'I.D.', lends credence to the reading of the photograph as that of a real person, whereas in fact there are four individuals present. Ruff has always believed that photographs are most effective when they engage reality, but pull back ever so slightly to expose its pat assumptions.

Friederike van Lawick and Hans Müller suggest that real faces are, in the digital age, only necessary as points of departure. Their multi-frame composites morph couples imperceptibly (the only real photographs are top left and bottom right; the others are graduated composites of the two). If there is departure from reality, however, there is no clear arrival. Any of the fourteen stations along the way is an equally valid, equally convincing portrait of a couple of working artists, the partners of which would themselves have great difficulty untangling their interwoven personas.

Thomas Ruff *Other Portrait #143/146* 1994-95
LawickMüller *La Folie à Deux. Portraits of artist duos: Muriel Olesen/Gérald Minkoff* 1996

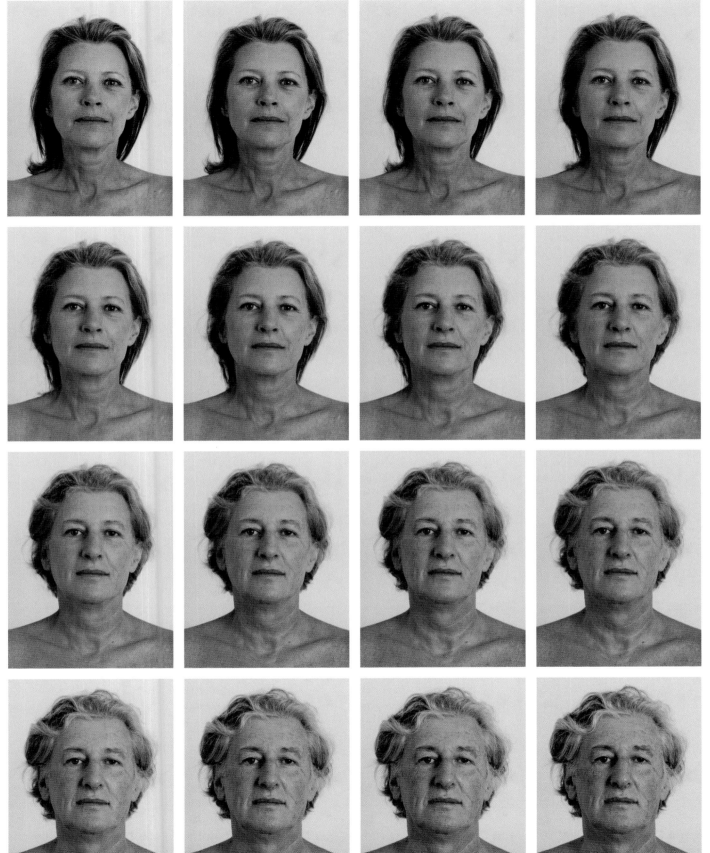

Berclaz de Sierre *Michelangelo Buonarroti; Andrea Mantegna; Sandro Botticelli;
Leonardo da Vinci*, from the series 'Gli Equivoci' 2002

"Our social personality is a creation of the minds of others." Marcel Proust, 1918

The artist Berclaz de Sierre has a great passion for names, and the people who come attached to them without having had any say in the matter. Sometimes those names are weighty baggage indeed, bringing to mind the imposing human monuments of art history – here brought solidly down to earth.

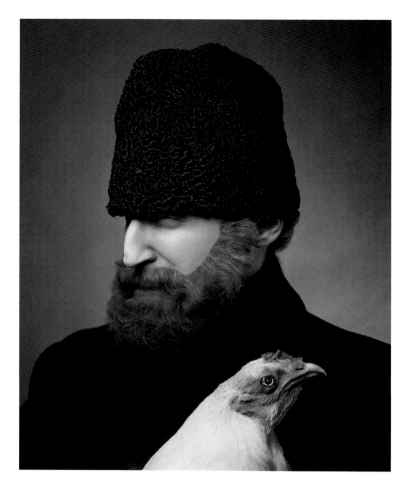

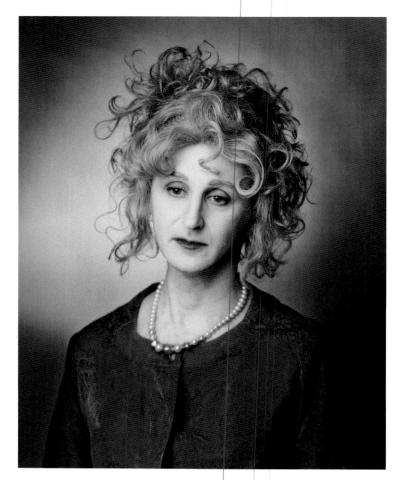

Rafael Goldchain *Self Portrait as Naftuli Goldszajn (Born Krasnik, Poland, early 1800s, Died Krasnik, Poland, late 1800s),* from the series 'Familial Ground' 1999-2001
Rafael Goldchain *Self Portrait as Reizl Goldszajn (Born Poland, 1905, Died Buenos Aires, Argentina, 1975),* from the series 'Familial Ground' 1999-2001

Rafael Goldchain works with digitally manipulated self-portraits to make autobiographical works that concern identity and a familial and cultural history that has been subject to much dislocation and erasure. Inspired by the birth of his son, which made him aware of his inheritance as a Jew and his lack of knowledge about his background, Goldchain decided to retrieve basic historical facts, but over and above that, to get to know the world of his forebears in a more profound and connected way. Using the conventions of family portraiture, he inserted himself into the history of his family. Ancestral figures now take on his face as they emerge into visibility. Through a subtext of mourning and loss, there is also a camp humour that offers vital critical distance and reminds us that this is also a game.

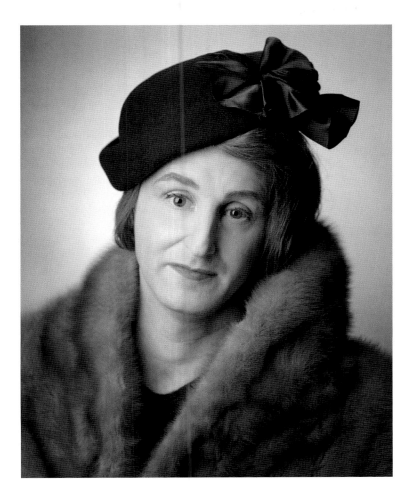

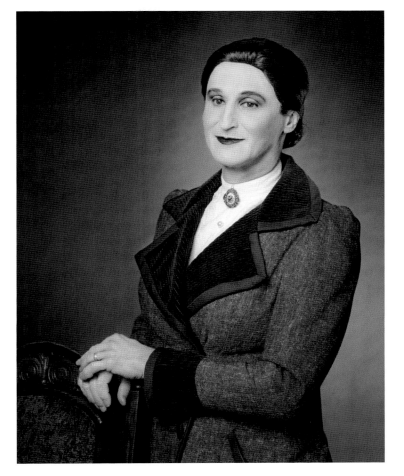

Rafael Goldchain *Self Portrait as Pola Baumfeld (Born Ostrowiec, Poland, Died Poland, early 1940s)*, from the series 'Familial Ground' 1999-2001
Rafael Goldchain *Self Portrait as Doña Balbina Baumfeld Szpiegel de Rubinstein (Born Ostrowiec, Poland, 1903, Died Santiago de Chile, 1964)*, from the series 'Familial Ground' 1999-2001

overleaf ▶ While the face has conventionally been read as the singular truth about an individual, Orlan maintains that any single face also tells us truths about the multitude - in other words, the civilization of which they are a part. Individual faces are sponges which soak up a culture in a figurative sense, but Orlan applies the metaphor literally. In the past she has submitted to facial surgery - giving herself, for example, the 'horns' visible in the photograph overleaf right - but here she uses the computer to help her travel across time and space, and blends her own face with representations of beauty from pre-Columbian America. In the (near) future, will we all want features that mimic our idealized notions of movie stars' faces? Or will we be more adventurous, adopting and adapting ideals from once vibrant cultures?

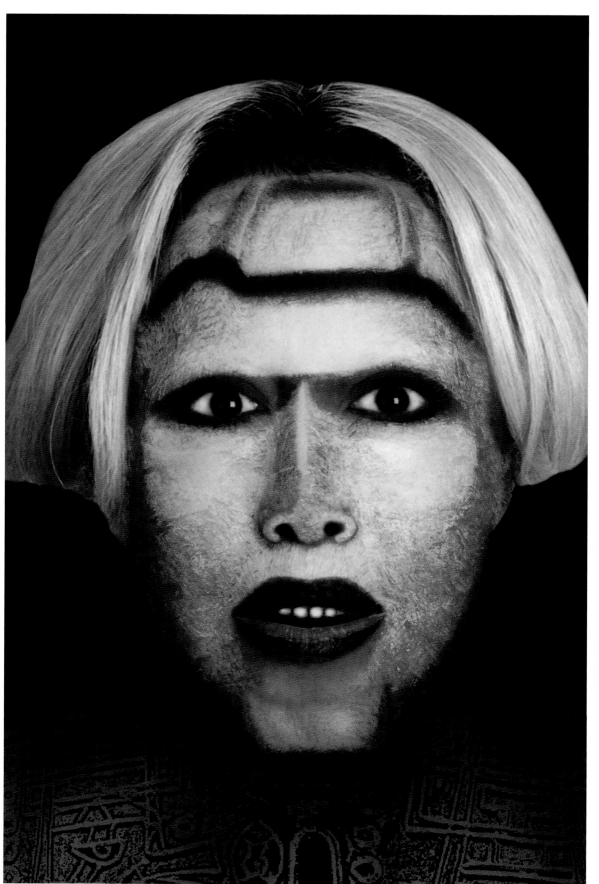

Orlan *Disfiguring-Refiguring: Pre-Columbian Hybridization No. 22* 1998

"In days gone by it was believed that our bodies belonged to us. But each era defines itself by the faces it produces. The face possesses something so special that the least breath, biographical or cultural, leaves its mark." Monique Sicard, 2002

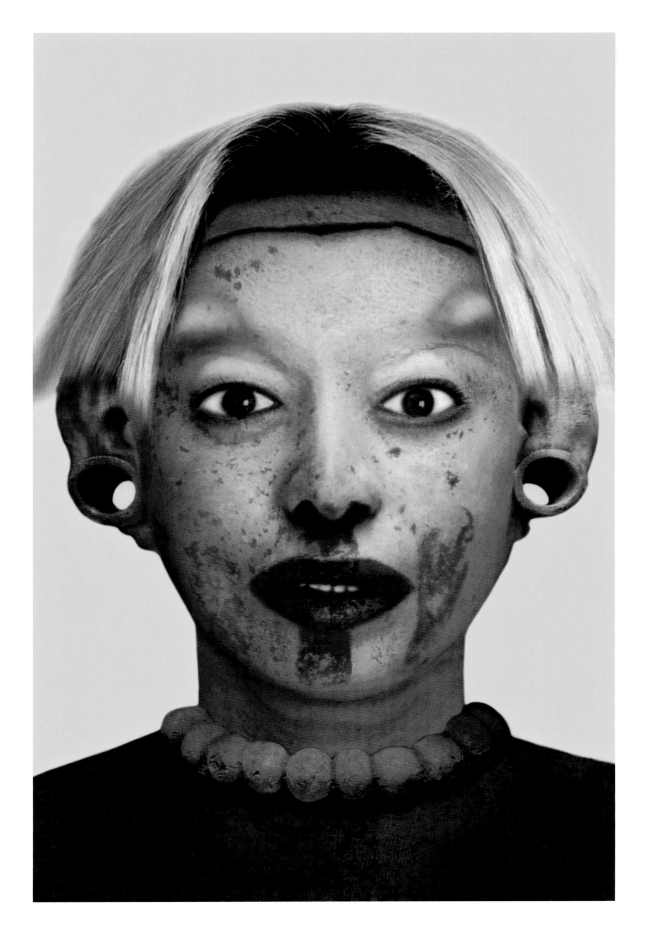

Orlan *Disfiguring-Refiguring: Pre-Columbian Hybridization No. 30* 1998

Cindy Sherman *Untitled* 2000
Cindy Sherman *Untitled* 2003

"But, sir, do you still doubt my identity? Then here is my photograph!"
German caricature, 1877

No portrait is ever really taken, but rather made. Here Cindy Sherman, who has tried on more faces and personas than any other living artist, invokes the classical portraiture of the modern twentieth-century photography studio – 'artistic' poses, theatrical lighting, blank backdrops. In this series of 'portraits', women well past their prime engage happily with the 'photographer', still hoping perhaps for that one last shot at fame. 'Still hot in her mind' is how Sherman characterizes one of 'her' subjects. As grotesque as they are – redolent of, as Wayne Koestenbaum lists it, 'shimmer, filth; wealth, decline; extravagance, dessication; sexual success; sexual failure' – their hopefulness and eagerness to please renders each desperate persona touchingly pathetic.

"The camera tends to turn people into things, and the photograph extends and multiplies the human image to the proportions of mass-produced merchandise. The movie stars and matinee idols are put into the public domain by photography. They become dreams that money can buy. They can be bought and thumbed more easily than public prostitutes." Marshall McLuhan, 1964

Piotr Uklanski *The Nazis* 1998 (detail). From left to right: Klaus Kinski in *Five into Hell*, directed by Frank Kramer, 1969; George Mikell in *Victory*, directed by John Huston, 1981; Jan Englert in *Zloto Dezerterow*, directed by Janusz Majewski, 1998; Robert Duvall in *The Eagle Has Landed*, directed by John Sturges, 1976; Hardy Krüger in *A Bridge Too Far*, directed by Richard Attenborough, 1977; Yul Brynner in *Triple Cross*, directed by Terence Young, 1966; Christopher Plummer in *The Scarlet and the Black*, directed by Jerry London, 1983; Cedric Hardwicke in *The Moon is Down*, directed by Irving Pichel, 1943

It takes but a flash to realize that Piotr Uklanski's arrogant and imposing Nazi officers bear certificates marked 'Made in Hollywood'. Niven, Duvall, Brynner … veritable legions of virile Hollywood leading men have spouted Fascist ideology in the service of art and entertainment. What is the enduring fascination of Nazism and its trappings for citizens of countries who fought a bloody war to defeat it, Uklanski asks? Is fascism a perennial subject of cinema because we came so close to it, and the movies serve as an 'it could still happen here' reminder and warning? Or is our fascination due to the fact that we haven't entirely excised these demons, and are actually attracted to these supremely confident authority figures, like moths to the flame, in a similar way to those who are attracted to today's icons – celebrity actors?

LOSING FACE
SAVING FACE

FAÇADES

"'Look: this shows what retouching can do,' said the photographer. 'But the retouched one does not look a bit like the woman who sat for it,' I exclaimed. 'Of course not,' replied the photographer. 'That's the beauty of it!'" The Photographic News, London, 1890

Perhaps we use the word 'façade' for the face because of, and not despite, its architectural connotations. The Oxford English Dictionary reminds us that the first meaning of façade is *the face of a building, especially the front*. It's a fitting concept, as personas – and faces – are at least partly designed, partly built structures. Like buildings, they also weather with time, their surfaces eroding imperceptibly. And as with private houses, many owners of faces turn to professionals for help in the maintenance, renovation and daily upkeep of their properties.

The second meaning of façade is the more conventional one: *a deceptive outward appearance*. Façades can be very beautiful, but they can hide banal or ugly things inside. They can also be shoddy affairs, superficially glamorous. What are most televised faces, for example, if not Potemkin visages?

Both readings of the term stimulate photographers, as the wide range of imagery and intent on the following pages makes clear. And as both of our architecturally minded definitions evoke a sense of the ephemeral nature of façades/faces, the concepts of loss and preservation make for an intriguing perspective. Does not the term 'face value' aptly suggest this inherent fluctuation in the fortunes of the face?

In a literal sense, faces can be lost and faces can be saved. We lose faces in horrific accidents, in fires and car crashes, in war and through disease. We count on our medical specialists to save those they can, or at least restore a modicum of faciality to the most unfortunate victims. Loss of face in this literal sense is extraordinarily traumatic for the person concerned, not to mention his or her circle of intimates. As for the reception of the face in public, many victims prefer not to risk the reactions of others and instead retire into themselves. The arrival of the first full face transplant in 2005 involved both a losing of face (the donor) and a saving (the recipient). It was unthinkable, of course, that a photographer would not be officially asked to commemorate this momentous event.

Faces can also be saved in another literal sense. As one observer of a face-lift operation mused, 'With each snip I imagined the ghosts of the myriad worries that furled this woman's forehead flying free: there the times she troubled over school exams; there the long waits for loved ones who were late; and there the years of confusion and doubt.'[1] As historian Wendy Doniger notes, the rationale for face-lifts is often 'to make you look like you "really are", i.e., who you were before you aged'.[2] Yet a critic of this ever-more widespread practice might well argue that surgery amounts to a loss. What is snipped away so thoughtlessly – and let us not forget, by an absolute stranger – are, first, features that

connect us with our ancestry and, second, features that reflect our own hard-won experiences. And all for, as Doniger notes, a 'quick fix' that can hardly stem the inevitable decay. Photographs, meanwhile, remind us that the violence inflicted on the face is indeed horrific.

On occasion, the loss of face can be both literal *and* figurative. In the past prisoners have been hooded to prevent them from establishing emotional bonds with their fellows: to be faceless is to be an outcast, even within a community of outcasts. Photographs bear eloquent witness to this injustice. Political prisoners and protestors have also damaged their faces to express disgust and disdain for those who oppose them. Paradoxically, physical loss is moral gain.

Willingly and unwillingly, human beings manage to 'lose face' in many ways - far too many to enumerate. At the petty end of the spectrum, we lose face in embarrassing situations. Models lose face, albeit temporarily, through sale or rent of their assets to business interests. All of us risk long-term loss through sloppy management of the precious family album (250 billion digital family photographs will be made this year, but how many will be preserved?). More ominously, through a desperate desire to suppress our idiosyncrasies in favour of a homogenized group identity, as dispensed liberally by magazines and advertisements, how soon will it be before we are carbon copies of one another: *groupface*, in an Orwellian world of *groupthink*?

Faces are also stolen from us. Facial recognition systems are increasingly powerful and efficient, and each of our faces has certainly been recorded and stored many times without our knowing it. Will they come back to haunt us?

Faces are saved in innumerable ways, too. Photography is as useful a tool as writing to stem the tide of loss. Photographs even show us facets of ourselves we didn't know existed: they are, in a sense, truly eyes in the back of the head. And if our culture seems obsessed with physical attractiveness, and uses photography to lure us with fantasies of eternal youth and perfect beauty, perhaps photographs can also help us reign in our most absurd impulses and locate a middle ground which serves factual reality and still allows for soaring imagination. *What if*...?

"If you stand in front of a customs officer, you try to make a face like the one in your passport. So why should my portraits be communicative at a time when you could be prosecuted for your sympathies?" Thomas Ruff, 1993

v Losing Face

Pierre Radisic's deaf and mute friends, or twin brothers, seem curiously resigned to their sensory deprivations; the one apparently unable to speak, the other, it would seem, unable to hear. And yet their postures suggest both an intimacy and an ability to communicate silently with each other. Their interrogatory gaze, however, suggests that the sensory deprivation is our problem, not theirs. Perhaps Radisic is speaking of photography's own limited sense organs. The cinema made faces in pictures talk long ago, but still photography remains curiously mute.

In order to construct new and convincing faces, some artists use composite techniques whereby features are imprinted one upon the other, but Jason Salavon (overleaf) prefers to erase traits, mocking our pretensions of individuality. Seen one, seen them all. His composites of graduating students, or marrying couples, speak of tedious conformity and petty vanities – rites of passage of ephemeral interest, even to one's intimates (despite obligatory protestations to the contrary).

" . . . people can tolerate their images in mirror or photo, but they are made uncomfortable by the recorded sound of their own voices. The photo and visual worlds are secure areas of anaesthesia." Marshall McLuhan, 1964

Pierre Radisic *Y & R* 1987

"These men resemble what I have described, but they are not the same. Nature does not feel obliged to make a face into a sign. Out of a physiognomy, it prefers to make a hiding place." Alfred Döblin, 1946

Jason Salavon *The Class of 1967* 1998
Jason Salavon *100 Special Moments (Newlyweds)* 2004

overleaf ► Maya Dickerhof's 'amateur' family portraits are a marvellous catalogue of technical and conceptual blunders – legs and elbows chopped off arbitrarily, a total obliviousness to the setting and, above all, obliteration through incompetent use of flash or timing. But then, although the urge to fill in the missing faces is almost automatic, Dickerhof seems to be asking, is there really any need to see them? Aren't they, after all, generic?

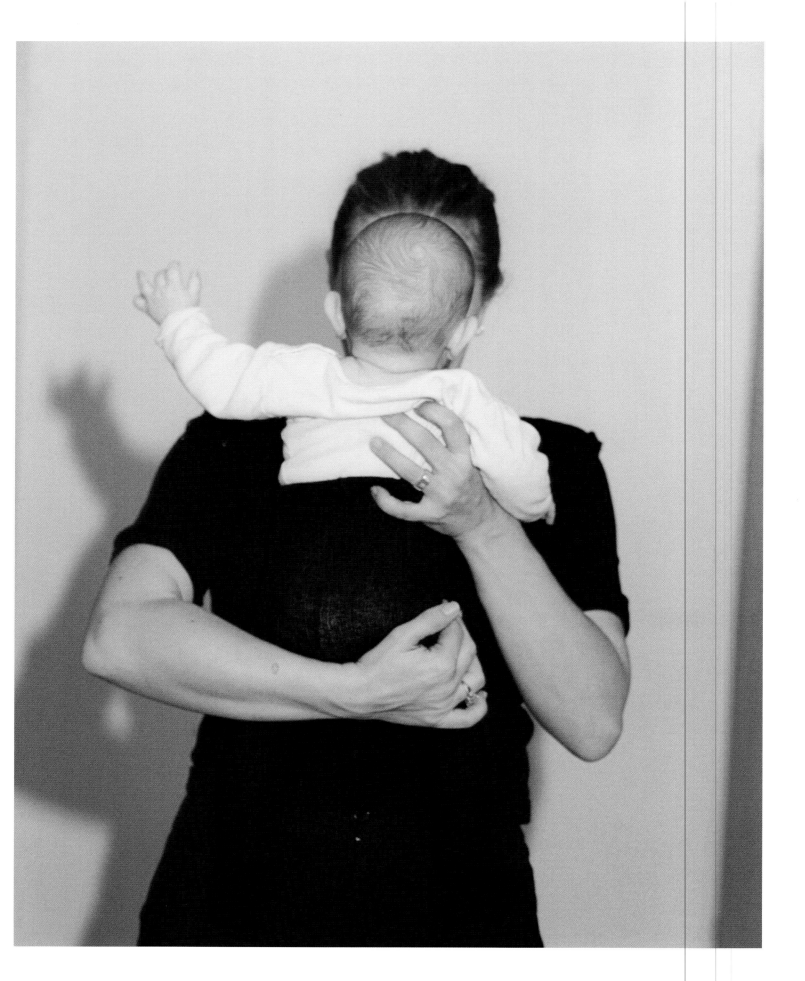

Maya Dickerhof From the series 'Memory' 2001

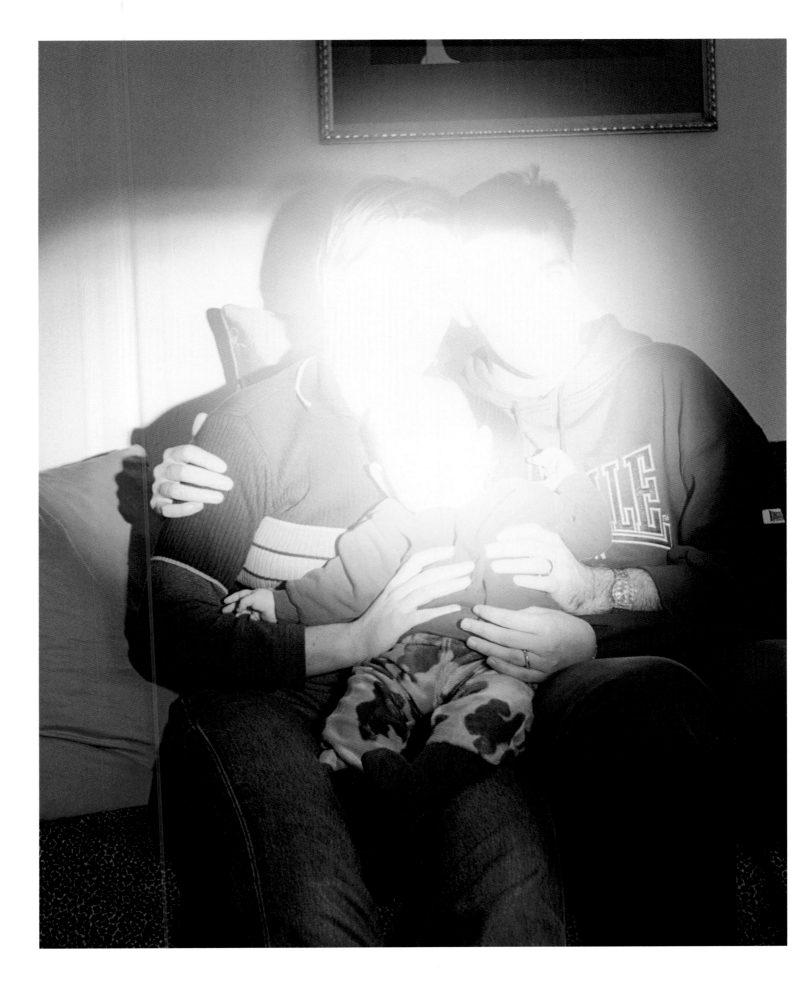

"I feel certain that the largest part of all photographs ever taken or being taken or ever to be taken, is and will continue to be, portraits. This is not only true, it is also necessary. We are not solitary mammals, like the elephant, the whale and the ape. What is most profoundly felt between us, even if hidden, will reappear in our own portraits of one another."
Ben Maddow, 1977

How naked these heads appear. How vulnerable. Eric Nehr has found these little birds in the street and coaxed them up to his studio. Stripping them of their natural habitat, they appear lost, dazed, confused. They look - but at nothing. Were August Sander alive, he would have identified these people by what work they did, anchoring them in society. Nehr gives us no social indicators whatsoever, only first names, which makes their isolation seem all the more poignant. Today's young men and women, the photographer seems to be saying, have no such anchoring - no stable jobs, no guarantees of secure futures, no extended families to count on, only rootlessness and alienation. Individuality has triumphed, but at what price?

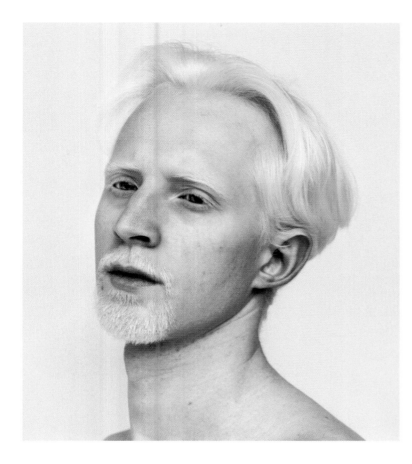

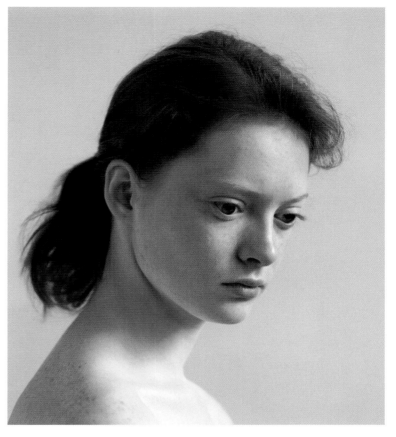

(from left to right) **Eric Nehr** *Arnaud* 2003;
Boubbatt 2000; *Stéphane* 2000; *Margaret* 2003

overleaf ▶ Carrie Levy invites her subjects to pose in their own homes, but asks them to hide their faces. In creating her anti-portraits, she forces her sitters to express their individuality solely through body language. Though naked, the bodies are ordinary (like those of most viewers), so that we identify with them rather than reify them, and this identification encourages us to 'fill in' the faces. Levy's proposition seems radical, but in *Discourses on Art* two centuries previously Sir Joshua Reynolds noted that Gainsborough's 'unfinished' or 'undetermined' manner of painting portraits was a brilliant ploy, as 'the imagination of the spectator supplies the rest, and perhaps more satisfactorily to himself, if not more exactly, than the artist, with all his care, could possibly have done'.

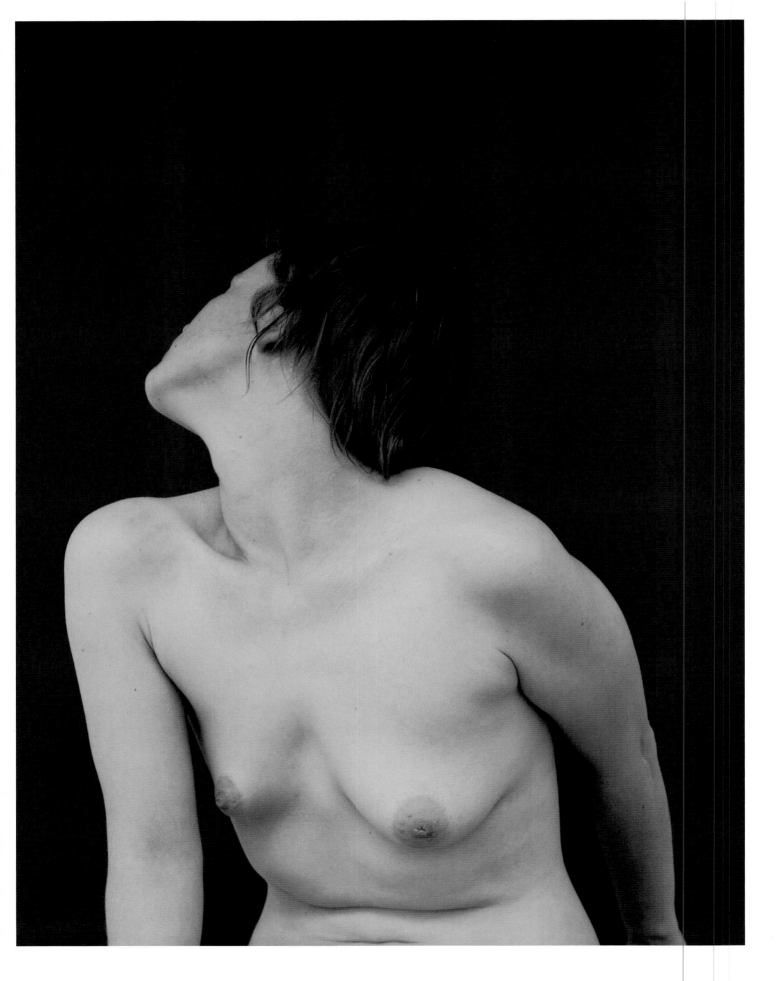

Carrie Levy *Untitled*, from the series 'Domestic Stages' 2004

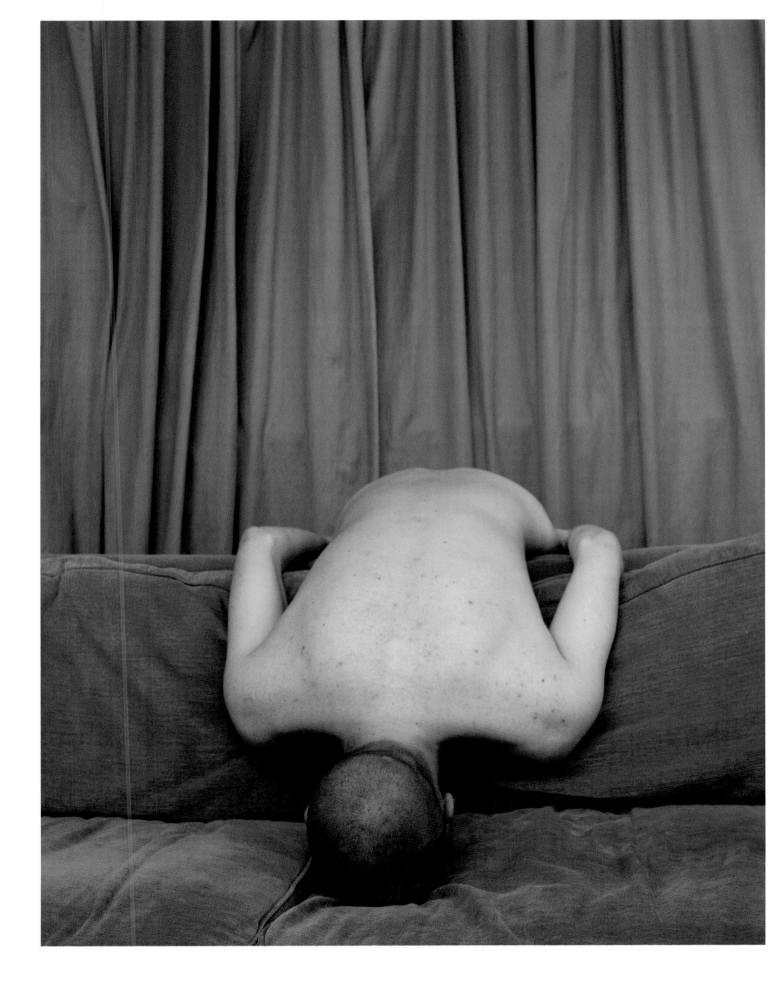

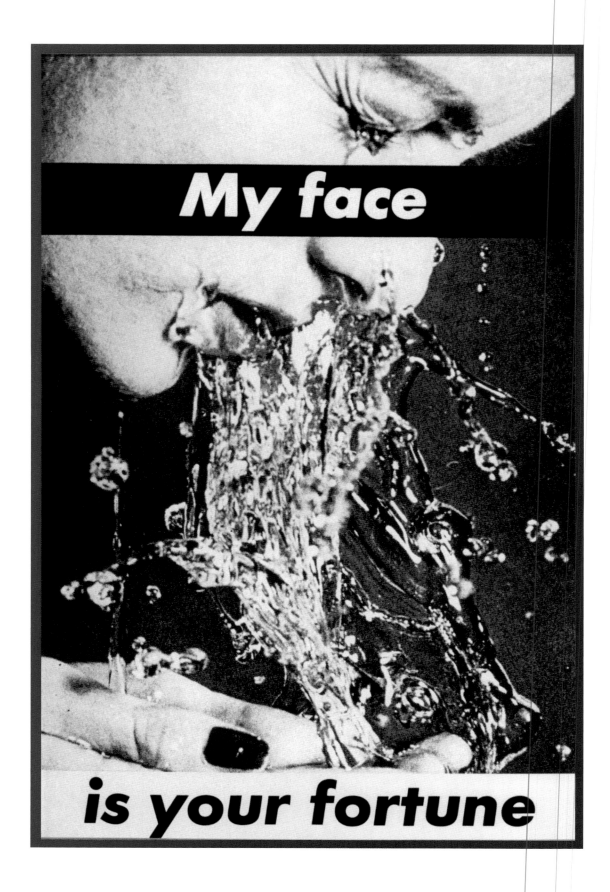

Barbara Kruger *(Untitled) My face is your fortune* 1982

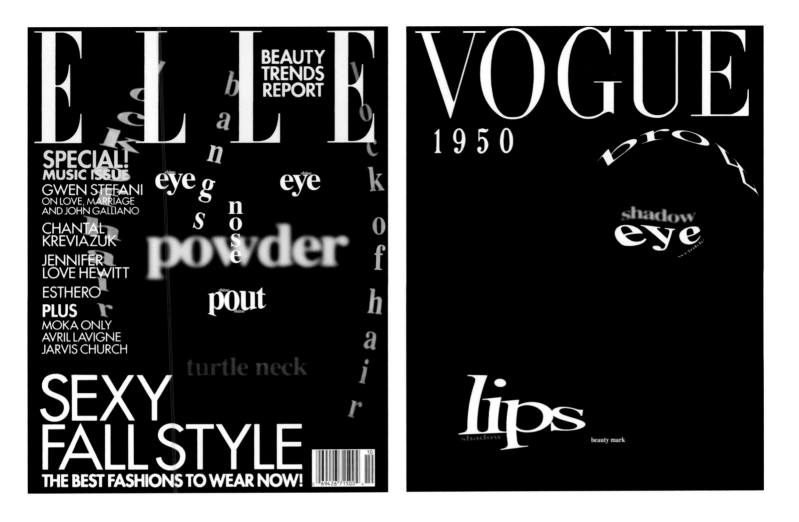

The pages of glossy fashion magazines are cornucopia of glamorous, constructed faces (often the models cannot recognize themselves in the finished pictures), and the covers, with their seamless weave of image and word, are the most meticulous constructions of all. Word with image, image with word: the amalgams serve to broadcast and amplify the same, simple message – that with the right purchases of goods and services this beautiful face can be yours. Moreover, the images themselves begin with words, as Susan Evans (above) reminds us: 'We need a Parisian look for our January issue, spare and elegant', or 'Let's do a Lolita-like cover for our sexy fall style'. Only then, when a concept has been clearly defined in word, are the legions of image-makers – the photographers, models, stylists, retouchers, etc., etc. – put to work building the corresponding face. The face has been colonized, warns Barbara Kruger (opposite), and will be mined as long as the veins of ore are rich and deep.

Susan Evans From the series 'Faces' 2005

"Article 159: Prisoners are not allowed, on any pretext, to see each other or to communicate among themselves by speaking, writing or gestures. Outside his cell, each prisoner will wear a hood over his face, which may only be removed on the walking grounds, at the chapel's amphitheatres, or in other places where no other prisoner is present." Provisory regulation of the Lisbon Penitentiary, 20 November 1884

José Luís Neto From the series '22474' 2000

The heavy grain of José Luís Neto's imagery suggests transmission from a distant planet. In fact these figures are prisoners of the Lisbon Penitentiary, photographed in 1913 and hooded to stifle all normal human interaction. Neto discovered Joshua Benoliel's original negative by chance, and enlarged each head individually. The prisoners had undergone a symbolic dispossession of the self, losing their name for a number and their face for a hood. Despite the cover-up, we feel a strange kind of empathy for these dog-like beings, with their mute, pleading eyes and tender paws. A second negative commemorates the moment when new legislation allowed the prisoners to remove their hoods (see p. 156).

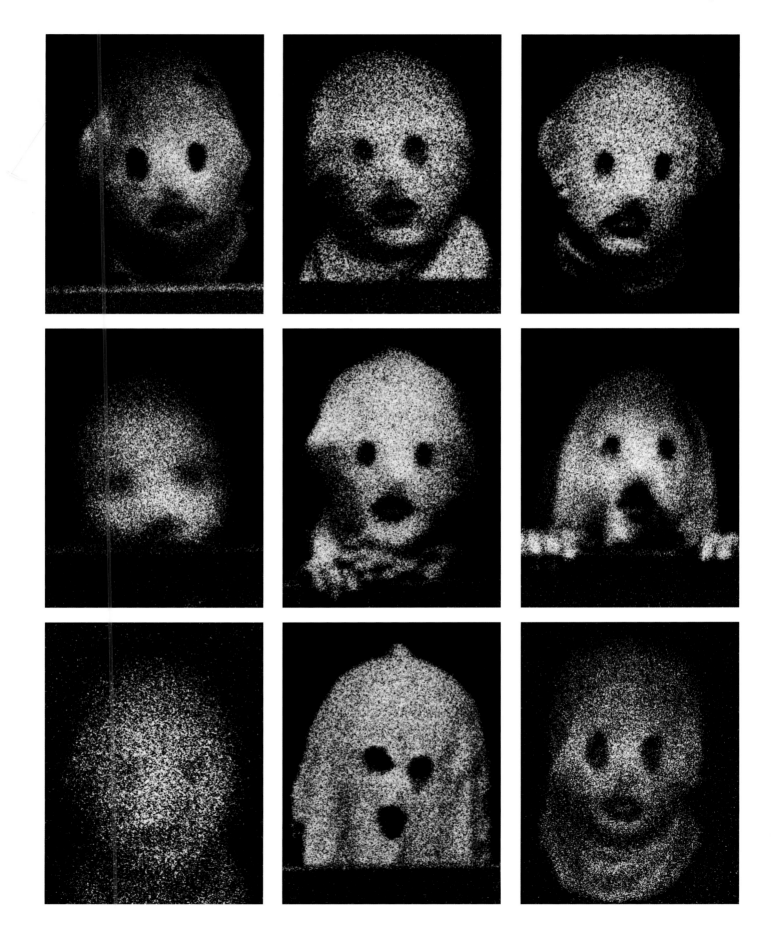

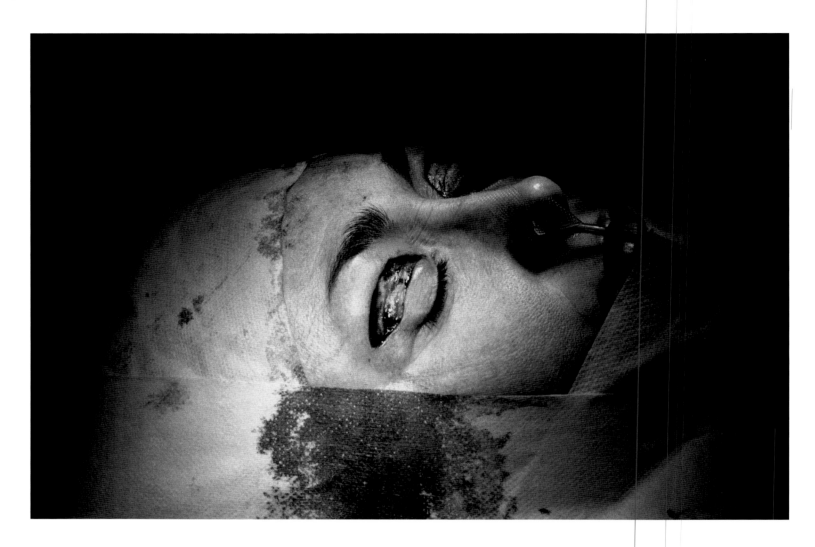

"The body, this sketch to be corrected…" David Le Breton, 1999

Valérie Rouyer From the series 'Still Life' 2001-02

The face, as with its attached body, is no longer one's destiny, but one's decision. The stigma of pure vanity attached to cosmetic surgery is giving way rapidly, as the fountain of youth moves from the realm of myth to a range of dazzling and affordable products. In modern capitalist society, the face is prime real-estate, and who isn't tempted to make at least a minimal number of home-improvements? Some buyers want to tear down the existing structure and start from scratch. Others are content with more modest renovations by an interior decorator. However, as Valérie Rouyer reminds us, no one really wants to see the building site before completion.

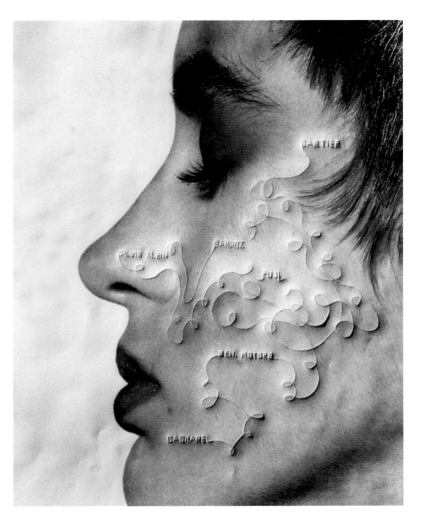

"The mythology of the face-lift imagines people who attempt to swim upstream against the current of time by changing their faces back in the other direction." Wendy Doniger, 2000

And if the face is prime real-estate, why not rent it out to the highest bidder? After all, Daniele Buetti reminds us, we already proudly trumpet the slogans of our favourite brand names on our clothing. Don't just buy the brand, become it!

Daniele Buetti From the series 'Looking for Love' 1996

This is the second of a suite of six photographs by Claudia Matzko, depicting human heads in various ambiguous states of vocalization. The ambiguity is maddening, and we search for precise meaning. Is the subject pressed against a window or door of frosted glass, screaming in pain as a result of torture, or shouting for help? Is he (something in the image tells us that the subject is male) merely singing boisterously in the shower, in which case the frosted glass is simply a given part of the environment and the event is commonplace? Matzko doesn't say, and we are left with a nagging sense that we are being spoken to in a language we do not understand. Richard Avedon might have been speaking about such an image when he said: 'In focus, known; out of focus, unknown.'

As for Axel Antas, the lack of disclosure is unthreatening, if unsettling. Our gaze seeks information, and quickly arrives at the casual shirt, suggesting a thoroughly ordinary inhabitant. It would seem that we are in the domain of the informal portrait – of the artless, head-on variety, which usually signals a frank and full disclosure on the part of the subject. But when we search for the human face – and Antas clearly wants us to, or he would have simply angled the camera down to fill the frame with the shirt – we find a void, an informational 'white-out'. It is as if Antas's subject is saying, 'I am not hiding from you; I have nothing to offer you.' He is suffering from Milan Kundera's postmodern ailment, 'the unbearable lightness of being'.

Axel Antas *White Portrait* 2002

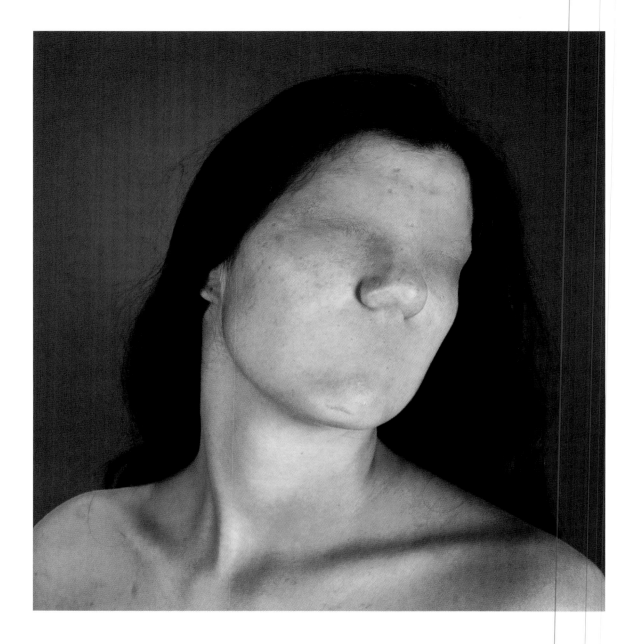

"Obviously there are a nose, two eyes and a mouth, but none of it makes sense, there is not even a human expression."
Jean-Paul Sartre, 1938

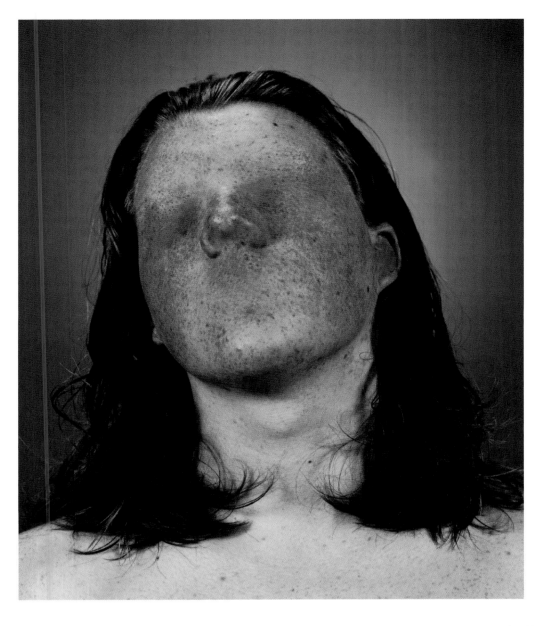

Aziz + Cucher *Maria* and *Rick*, from the series 'Dystopia' 1994

At the moment, cosmetic surgery is the path forward, but advocates of genetic engineering imagine a not-too-distant Golden Age, in which ugliness is banished and everyone enjoys the face of a star. Sceptics abound: which model of bland prettiness will triumph? How will we tell each other apart? Beauty is exceptional by definition: if everyone is beautiful, then no one is. And what of the inevitable genetic engineering accidents? The back-street cut-rate deals, the student pranks that got out of hand, the adolescent experiments in the garage? The artists Aziz + Cucher warn us of such dystopic possibilities, the resulting being imprisoned, senseless, in an envelope of flesh? Will we have special homes for such creatures, well out of sight?

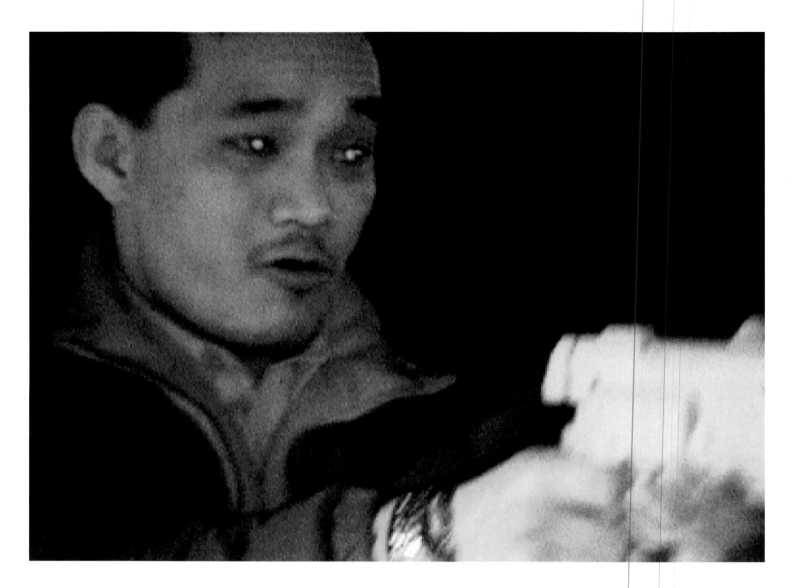

"Once we have surrendered our senses and nervous systems to the private manipulation of those who would try to benefit from taking a lease on our eyes and ears and nerves, we don't really have any rights left." Marshall McLuhan, 1964

The violence of the video arcade; murder for sale, or rather for rent. In the strange green light given off by the games – which immediately brings to mind the night-vision apparatus used by 'special forces' in night-fighting operations in wars here and there – we see faces contorted with murderous hate. It is said that war, fought remotely, is getting to be more and more like a video game, while video games are becoming more and more war-like. At what point will the two converge? Will future armies be adolescent conscripts, waging war from their bedrooms? The disembodiment and bodily disengagement implicit in the Electronic Revolution point to an inexorable erosion of our humanity.

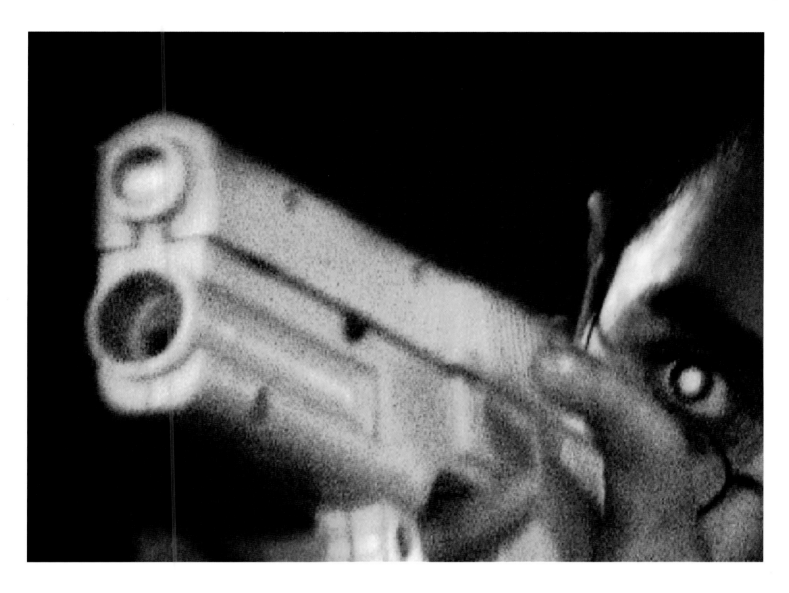

Stefan Walter *Virtual Killer #3* 2003
Stefan Walter *Virtual Killer #6* 2003

overleaf ► Initially, the reflections in Jorma Puranen's photographs of old painted portraits disturb. Obviously, a 'competent' professional photographer would have avoided them so that we'd believe we were looking at the paintings themselves. But Puranen wants us to look at the *photograph*. He reminds us that we are looking first at photographs, then at paintings of faces, and then at faces. Why should the reflections be censored? After all, the visitor to a gallery has to shift about to avoid them. Photography's capacity to register reflections is actually its singular gift. What other medium deals so expressively with the play of light and shadow? Furthermore, by veiling the faces in light, the photograph actually reinvests them with mystery.

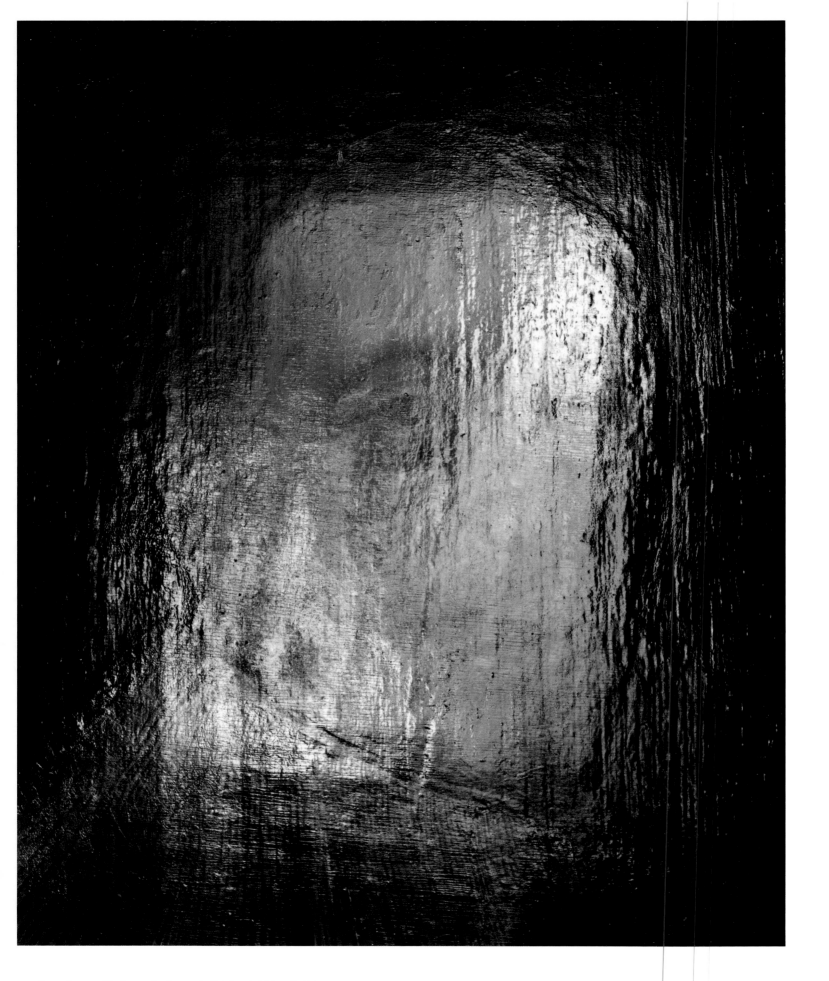

Jorma Puranen *Shadows, reflections and all that sort of thing #8* 2001

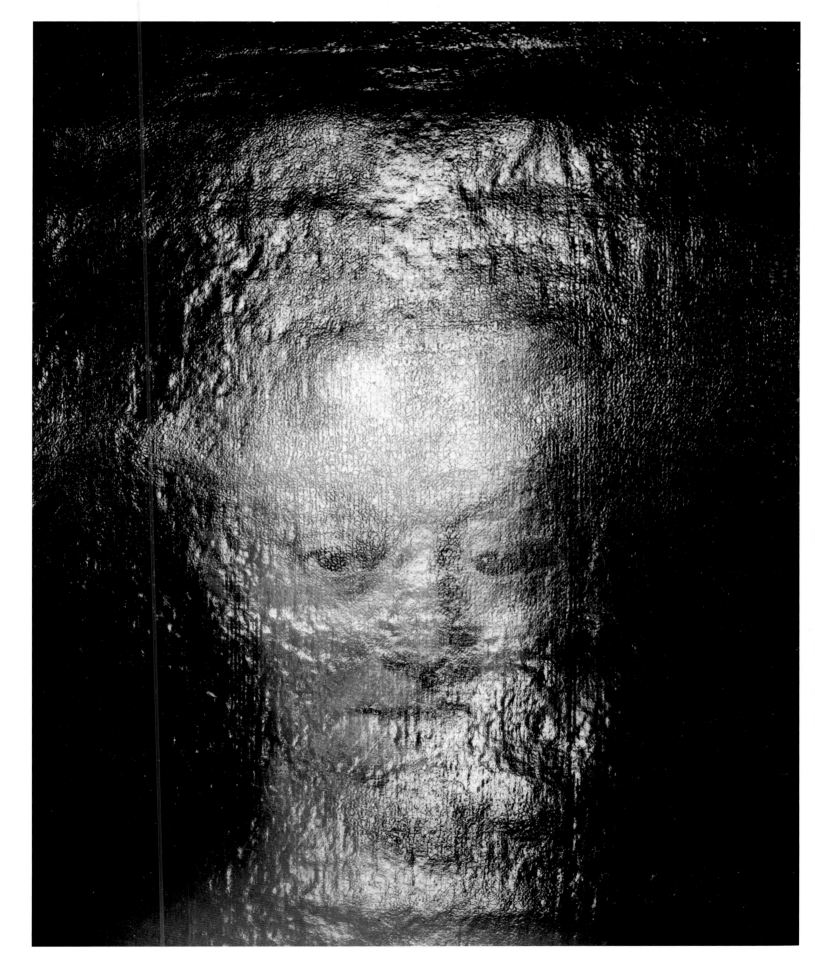

Jorma Puranen *Shadows, reflections and all that sort of thing #18* 2002

John Baldessari *The Studio* 1987

John Baldessari makes use of found photographs in order to disrupt our complacent viewing habits. Here he has used a picture of an artist's studio that has all the naïve artifice of a 1950s film set. The artist, and what looks like a group of wealthy collectors, have each had their faces replaced with differently coloured dots, which gives a rhythm to the composition, flattens the image and encourages the viewer to look at each 'player' in turn. Though personality and character have been effaced, we find ourselves trying to 'fill in the dots', sifting through the extensive stock of film faces stored since childhood in our minds.

John Waters *Liz Taylor's Hair and Feet* 1996

"**Whoever has followed the adventures of the image has, for ten, twenty or thirty years, witnessed the strange obliteration of the human face.**"
Serge Daney, 1991

The filmmaker John Waters is well placed to comment knowingly on the phenomenal impact of celebrity portraiture. Here he has taken found film footage from Elizabeth Taylor's movies and cropped the frames to remove her face, leaving us with images that have all the banality of amateur snapshot photography gone wrong. But who needs to see Taylor's face when it is already seared into our consciousness? In the middle of Waters's image is a great white void, open to multiple interpretations. It could be a place for us to project our mental images of the movie star; a reference to the empty movie screen, ready to reflect light; a symbol of our engulfing thirst for celebrity imagery; or a metaphor for the sheer futility of the whole enterprise.

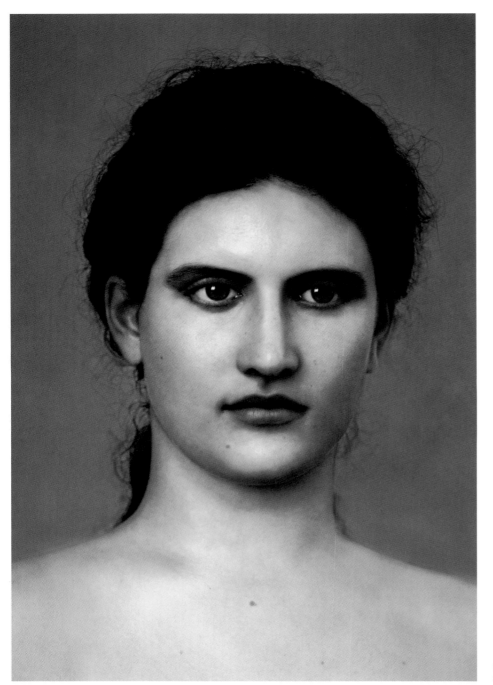

LawickMüller *Athena Velletri, Nina* and *Apollo from Olympia, Oliver* from the series 'PERFECTLY superNATURAL' 1999

" . . . mythological texts spanning many centuries and many cultures (from ancient India to Hollywood) have imagined what the consequences might be if those who wished for a new face were to get what they wished for. . . . And the myths, at least, demonstrate that this is a foolish, impossible, or even fatal desire."
Wendy Doniger, 2000

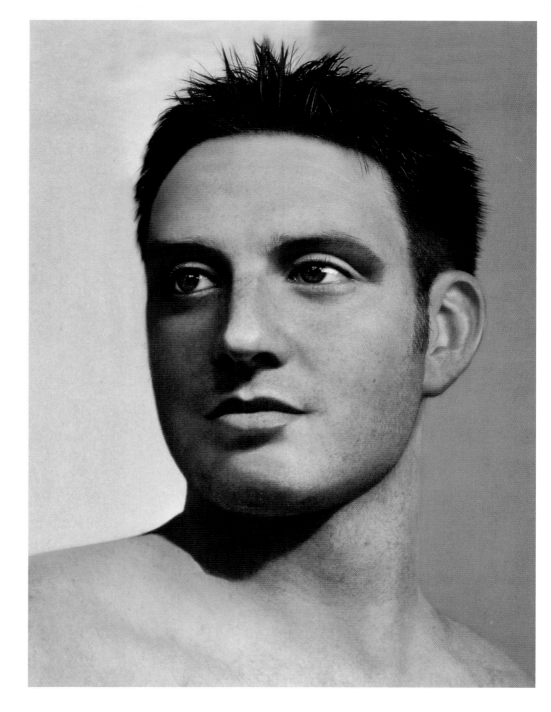

Western man has constantly imagined himself not as s/he is, but as s/he ought to be. And standing on the highest pedestal in the pantheon, to this day, is the Hellenistic model. It was always possible of course, both in art and photography, to pose people according to Ancient Greek models (as fashion photographer George Hoyningen-Huene did time and again in the 1920s and '30s), but with genetic engineering it will soon be possible to redesign humans to incorporate Ancient Greek prototypes. LawickMüller imagine this face of the near-future, merging real people with an Athena and an Apollo.

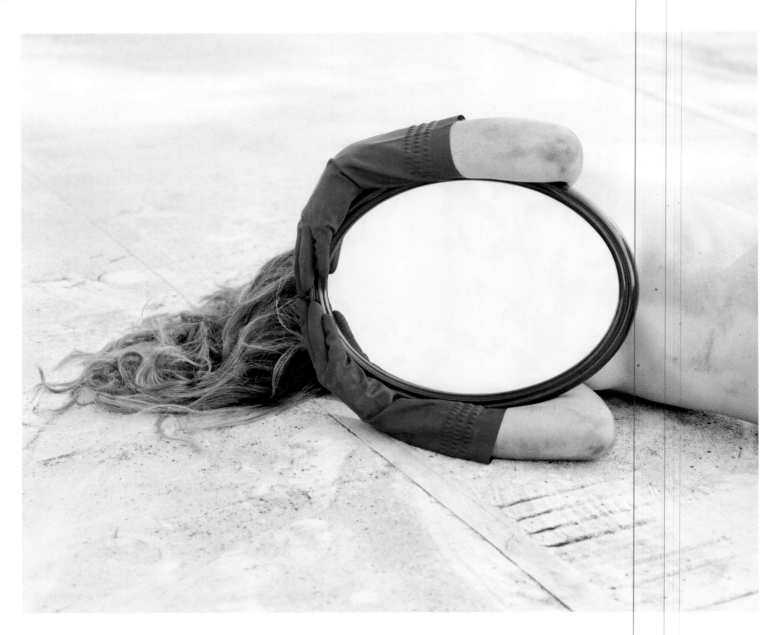

Dorothée Baumann *Face you* 2004

First impressions: a broken doll, a gaping void in its back, tossed into the street.... Then: a mirror, a face-like blank slate, reflecting nothing.... Slowly we work it out: a real body, a girl or a woman, holding a mirror to her face for protection. But protection from what? From us? From our gaze? We cling to the old adage that the face mirrors the soul. Give us your face, we demand. Bare your soul! She resists. Giving up the mirror would mean abandoning her dream.

"Since your face is not available to me, why should my face be available to you?" John M. Hull (blind), 1990

John Waters *Sophia Loren Decapitated* 1998

As the critic John Kelsey has commented, 'In fetish objects like *Sophia Loren Decapitated*, 1998, and *Farrah*, 2000 – two sequences of X-Actoknifed close-ups – [John] Waters stalks and slashes movie stars known for their impeccably controlled self-images.' When we look at Waters's work, we project our own image of the actress onto the void where her head has been excised.

vi Saving Face

Can any photograph of a face taken in a fraction of a second do justice to the complexity of that human being? 'Being', after all, connotes a continuous rather than fixed state, which would seem to rule out photography's narrow attention span.

Gary Schneider, inspired by the nineteenth-century working methods of Julia Margaret Cameron, eschews the 'decisive moment' in favour of a very long exposure, during which he paints the face with light. The subject lies prone in a darkened room, looking up at the lens of a large-format camera, while the photographer hovers above with his flashlight. Each brush of the flashlight leaves its trace on the film. Because the photographer works slowly on one area at a time, and because the subject moves involuntarily, the features are discombobulated, allowing for, as Schneider puts it, 'an accumulation of expressions', which register the flow of emotions undergone by the subject during the exchange. This calls for a high degree of trust on the part of the subject, in this instance fellow New Yorker Helen Gee, a curator and ex-gallery owner, and close friend of the photographer.

"Were you ever Daguerreotyped, O immortal man? ... unhappily the total expression escaped from the face and you held the portrait of a mask instead of a man. Could you not by grasping it very tight hold the stream of a river or of a small brook & prevent it from flowing?" Ralph Waldo Emerson, 1841

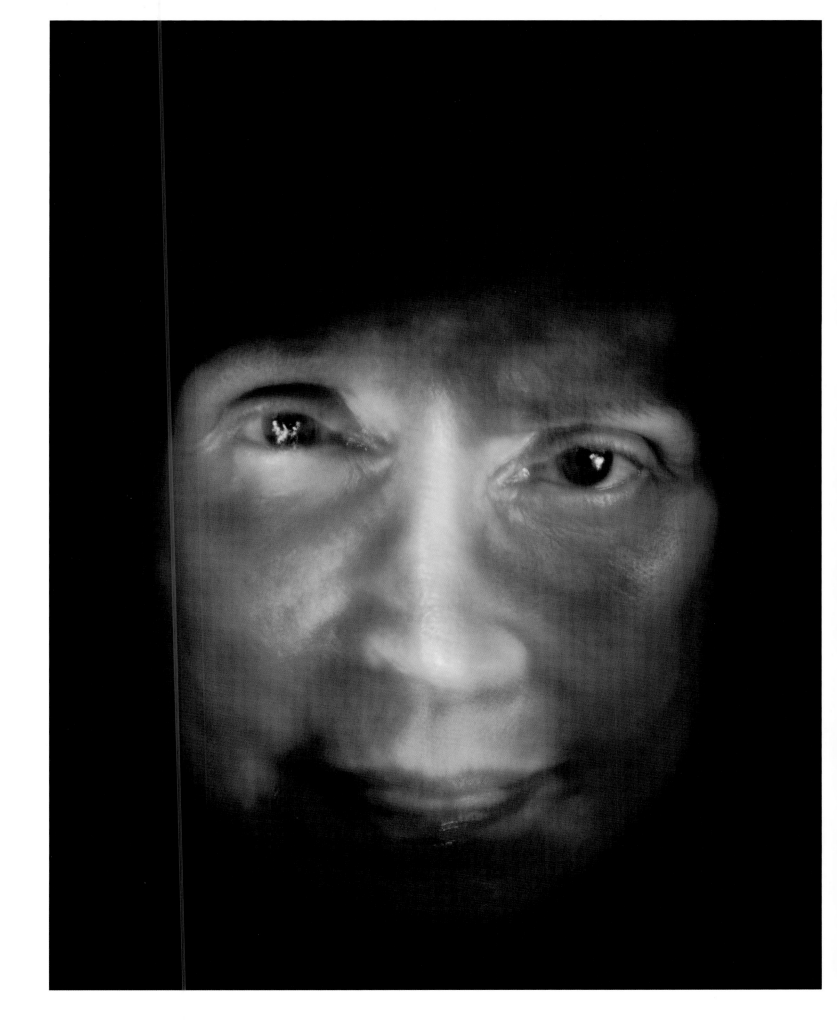

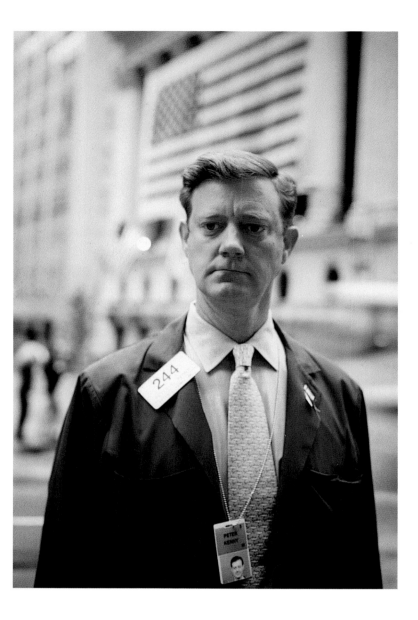

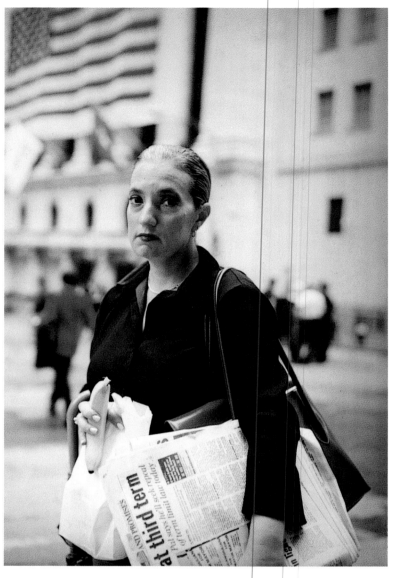

Suzanne Opton *Still Standing: Peter Kenny* September 17, 2001
Suzanne Opton *Still Standing: Wendi Caplan* September 24, 2001

Like several other New York-based photographers who are not photojournalists, Suzanne Opton needed some time to work out a suitable response to the events of 9/11. Not for her the smoke and ashes, the cathedral of twisted steel, at Ground Zero, nor the dust-covered faces of the heroic rescuers. She settled instead on the ordinary men and women who work at the Stock Exchange, and set up her camera outside the venerable institution on the very day of its reopening. The faces she depicts betray the shock and uncertainty of the time (New Yorkers still feared that more attacks were imminent), but also resignation: for better or worse, it was back to

"The human face never lies. It is the only map that records all the territories where we have lived." Luis Sepúlveda, 1998

work. Had Opton wanted to speak of 'the face' as a mirror of anxiety in a universal sense, she could have focused tightly on the faces to the exclusion of context, but she wanted to root them in the here-and-now, and so wisely pulls back to provide significant information – the flag, ultimate symbol of defiance and pride (for Americans, the anthem's ringing phrase, 'in the rocket's red glare', was suddenly literal, not figurative); the indispensable 'tools' of the trade (newspaper, coffee and perhaps most touchingly, a banana); and the newly ubiquitous security badge. It was those personal touches, Opton understood, that would give her portraits poignancy.

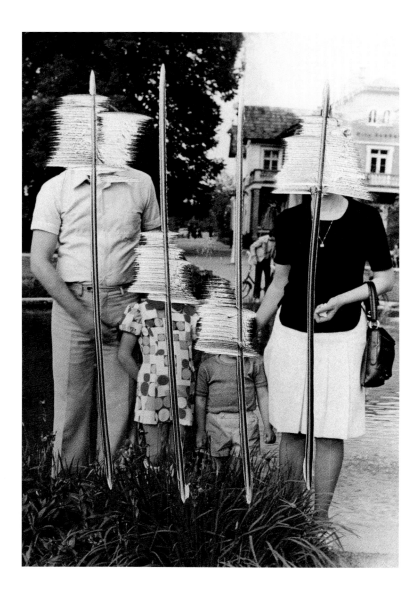

Ron Haviv *A defaced photograph found by a Bosnian family when they returned to their home in a Sarajevo suburb* Spring 1996

"The horror of being faceless. Of forgetting one's own appearance, of having no face. The face is the mirror image of the self." John M. Hull (blind), 1990

Photojournalist Ron Haviv accidentally discovered this defaced photograph while working in war-torn Yugoslavia. The Bosnian family depicted here had first been stripped of their home and possessions; then symbolically, viciously, of their identity – a virtual ethnic cleansing. When the Serbs finally abandoned the house, only the photograph was left behind. Was it guilt that drove the aggressors to this violent, voodoo-like act of defacement? Were the expressions on the faces of the parents and children (smiling, proud, responsible?) too much for them to face? Most likely it was a crude warning to all Bosnian families. By leaving the photograph where it would be found, its message is: we'll get rid of you, and we'll take everything you've got.

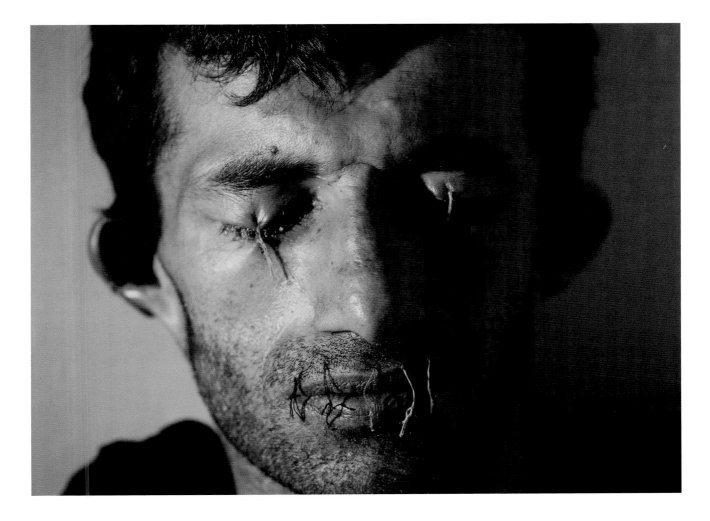

Darren Staples *Iranian asylum-seeker Abas Amini sits with his eyes,
mouth and ears sewn up at his home in Nottingham* May 27, 2003

Darren Staples's photograph records a political gesture.
The Iranian asylum-seeker Abas Amini, poet and
Communist activist, has sewn his mouth, eyes and ears
together to protest against British government policies.
Paradoxically, this loss of face in the literal sense can
be interpreted as a saving of face in the figurative sense.

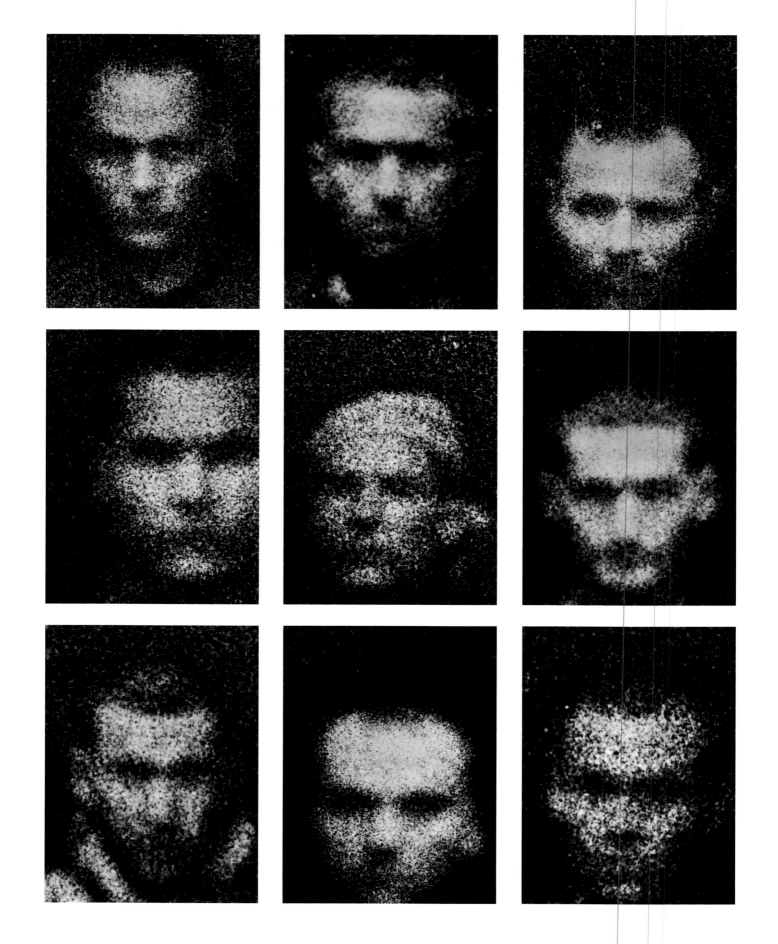

"The inertness that greets us in camera fodder from police superintendent Alphonse Bertillon's mug shots or Désiré Charnay's ethnographic forays in Madagascar survives to this day in passport photos and security cards. They are little icons within a monitor system, unrelated to the idea that a human may possess anything as intrusive and irrelevant as a soul." Max Kozloff, 2000

José Luís Neto's enlargement of faces taken from a single negative by Joshua Benoliel in 1913 (see p. 133) show Portuguese prisoners at a moment of great ceremonial import: an ancient law requiring them to be hooded has been abolished, and the photographer has been called in to bear photographic witness. Because Benoliel's original negative was of the entire group of men, Neto's individual recuperation and enlargement of the tiny heads has resulted in heavy grain, and the faces appear indistinct, like phantoms in a dream. Yet how individual these faces appear. The negative has saved enough information for us to have distinct impressions. If the government's decree gave each prisoner a measure of liberty and respect, Neto's symbolic act helps history to save its face.

overleaf ▶ Patrick Tosani has projected a fuzzy, diffuse portrait onto a page of Braille. All the Braille characters have been removed except for those on the face. This has the effect of augmenting the relief of those remaining characters. Through being photographed, however, they lose their tactility and become purely a visual sign. Likewise, it is impossible to 'read' the portrait because of the superimposition of the Braille and because of the photographic blurring, far removed from the usual language of portraiture. Paradoxically, you don't see what should be seen (the face) and you only see what should be touched (the Braille).

Murielle Michetti uses blur to push the limits of the image to the point of rupture, but she does not use it in isolation. Sudden holes violently punched through the work destroy any dreamy sentimentality. These holes lead the viewer through the surface of the image, creating an urge to peer in, to see what the face 'really looks like'.

José Luís Neto From the series '22475' 2003

Patrick Tosani *Portrait #17* 1985
Murielle Michetti *Untitled*, from the series 'Opaque' 2004

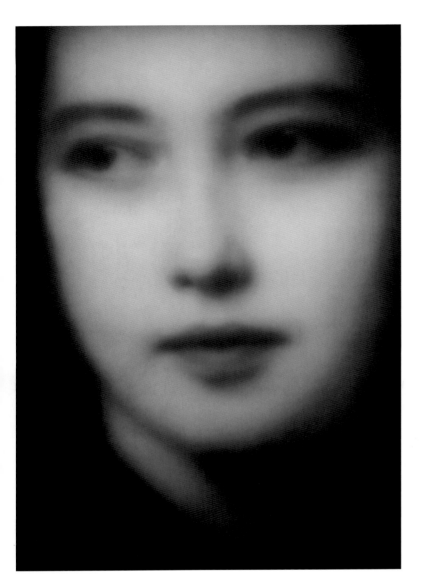
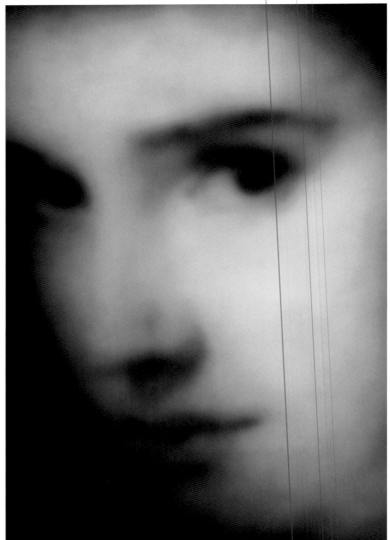

"It is naked, mysterious, commonplace. It haunts our work, our love and our fantasies. We read a face as we read a clock: to orient ourselves, to see what we are right now, right here, to place ourselves, and everyone else in the nervous entanglements of our own society." Ben Maddow, 1977

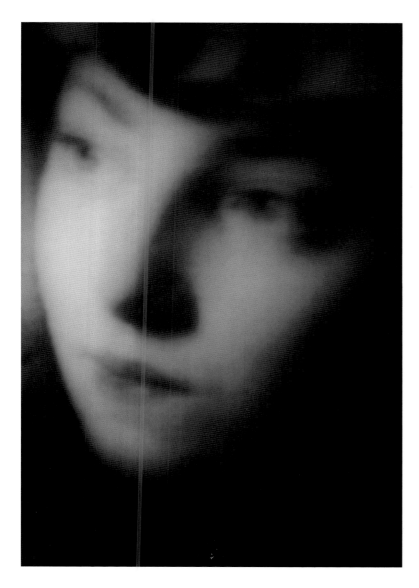

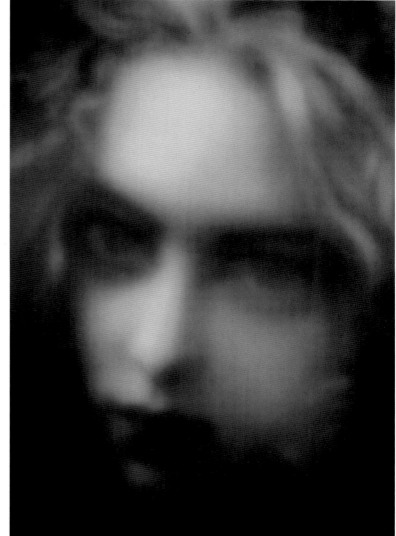

(from left to right) **Emmanuelle Purdon** *La comtesse Rimsky Korsakoff (F. Xavier Winterhalter); Hearts are trumps (Sir John Everett Millais); La Liégeoise (Anonymous); Ophélie (Ernest Hébert)*, from the series 'Femmes de mystère' 1997

Emmanuelle Purdon searches out women 'interred' in paintings of the past, almost always made by male artists who took pains to name the men portrayed while usually allowing the women to remain anonymous. Purdon recuperates these women photographically, controlling the focus to obliterate the give-away texture of the painting and stripping them of original context. She thus invests them with independent spirit, vitality and a degree of timelessness. Are we not tempted to read these faces as belonging to 1920s film stars?

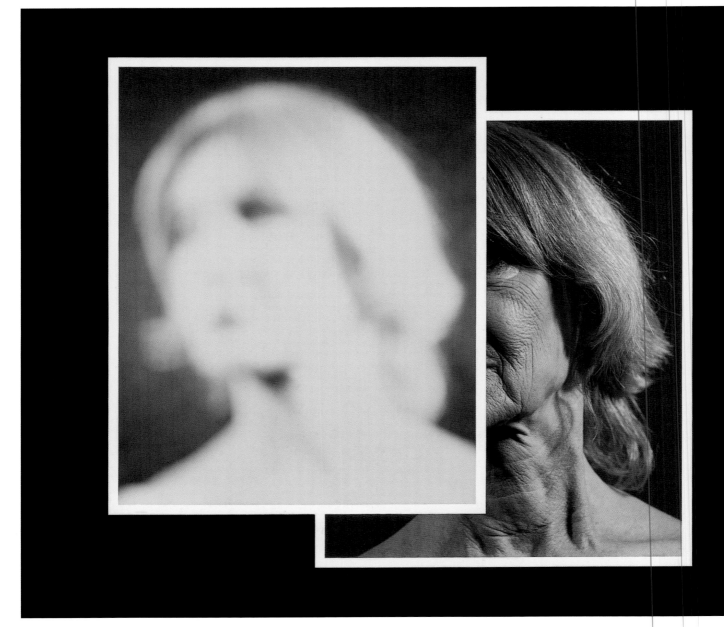

John Hilliard *Blonde* 1996

John Hilliard's overlapping 'portraits' remind us of the thinness of photographs. In front, we see a woman of evident youth, beauty and glamour, embodying the quintessential mystique of the Hollywood blonde. Behind, a tantalizing but partial view of another woman, much older.... Or is it the same woman, as the contours seem to suggest – the blonde, but photographed decades later? In fact, it is the same woman, but the two images were taken only seconds, not decades, apart. There are no tricks of make-up here, no darkroom

"Retouchers! Oh what ethical sins have you not to answer for! You compensate for all the crudities and deficiencies of nature.... To round the sharp edges of the features by the transfer of tissue from where it is not wanted to where it is needed.... To fill up the furrows dug by time.... Then enact the chiropodist upon facial excrescences. You do not believe that the man or woman exists who in his or her heart endorses the sentiment of Old Oliver Cromwell about being painted with wrinkles and warts. And you are right." The Photographic News, London, 1890

chicanery, no postproduction computer manipulation. Hilliard has just changed the focus, this simple manipulation being all that is required to restore to the blonde her youthful charisma (as well as possibly the subject's own image of herself – the 'interior face' that bears no trace of flaws or the passage of time). Despite Hilliard's drawing attention to the medium with his white borders and black background, how easily photography deceives. And on how many levels. No wonder Hilliard prefers to speak of his portrayals as 'anti-portraits'.

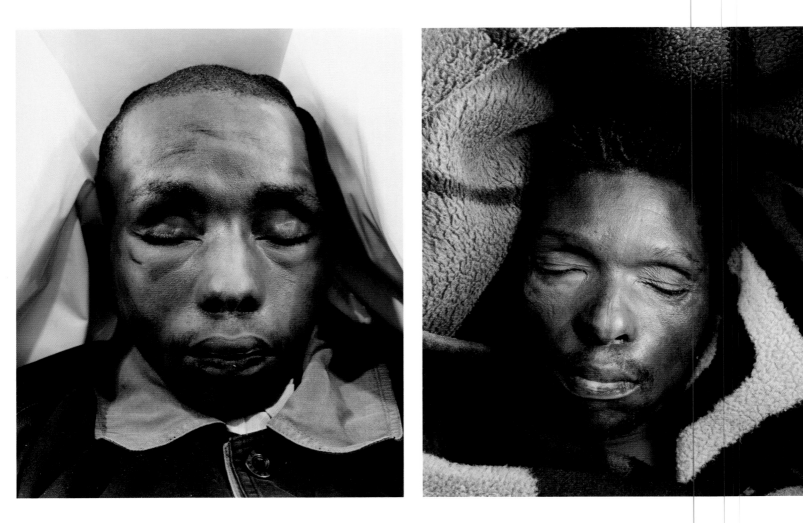

Pieter Hugo *Sixolile Bojana, 9 September 2005,*
Khayelitsha Mortuary, Cape Town 2005
Pieter Hugo *Nyameka J. Matiayna, 9 September*
2005, Khayelitsha Mortuary, Cape Town 2005

Like so many of his educated compatriots, the photographer Pieter Hugo is distressed at the unchecked progress of the AIDS plague in his country. But the dead, so often poor and disenfranchised, have no face in the media. They are statistics. Here Hugo pays his final respects to his countrymen. Photography has not been able to help these particular men, but communicating their faces to a wider audience may just help save face, and body, of others in the future.

Pieter Hugo *Thami Mawe, South Africa* 2003
Pieter Hugo *Thembile Mabaso, South Africa* 2003

In this series, devoted to those with the condition of albinism, Pieter Hugo presents a frank and unflinching portrait of people who are often social outsiders. In observing how an identity defined only by physical difference can affect social position and impact hugely on everyday life, Hugo attempts to rehabilitate the image of albinos. The viewer, faced with close-up studio portraits, must confront the subjects head-on, giving back to them what is so often denied – their humanity.

FAKING FACES
MAKING FACES

"Imagine! The photograph I recognized as one I made myself, patched together from three different men. My creature. Over six feet tall. Fantastic head, huge powerful nose and cheekbones, great forehead like the bust of Shakespeare. I had put him together with the help of my friend Tess McMahon. Chopped him up and glued him.... What resurrectionists we were–*lah*. Tess laid a sixty-five-screen stipple over it all, and the papers had to rescreen it. After that, no scars visible." Peter Carey, 2003

In the 1930s, the novelist and poet Ernst Fuhrmann proposed an intriguing idea connecting animals to plants. Animals, including humans of course, were actually plants, the only difference being that we had learned to pick up our roots and move around with them. It was fitting that the botanical photos Fuhrmann took were strangely anthropomorphic, with the blossoms suggesting heads with faces.

Something of this marvellous idea is captured in the word 'transplant'. Though we think immediately, of course, of the new domain of actual face transplants, the word also connotes more than the simple transfer of one thing to another, or the shifting of one state into another. It brings to mind the creation of a new entity through metamorphosis – something that did not quite exist before; in other words, a new (id)entity.

In one sense, *all* photographs are transplants. We don't think of them as pictures as much as simulacra – real things writ small. We don't usually say, *This is a photograph of my son*, but rather, *This is my son*. Magically, alchemically, 'my son' has been reborn, reconfigured in this portrait.

Magically indeed. Only a hundred and sixty-odd years ago most people were frightened to be captured by photographers – come to think of it, who today would want to be captured by anyone? – or they were at the very least ill at ease. We are wrong to scoff at native peoples' fears that photographs steal their souls. They were correct in assuming that something essential would be stolen from them. With the camera's 'theft' of their likeness came a theft of their identity and thus a depletion of their power ... just as we are fearful today that ever-increasing surveillance will ultimately restrict our individual freedoms.

Photographers make photographs, and the faces within them. All faces in photographs are fakes, counterfeits, façades, masks, even those that appear most like their 'originals'. What can one actually expect from a scrap of paper bearing a so-called 'portrait'? Are we to be fooled just because it is nicely matted and framed, and put reverently on a mantelpiece? None of us ever complain when we end up looking better in portraits than we think we actually are, but we grumble when we feel we look worse. We eagerly share a 'good portrait' with our friends and families, and tear up the 'bad' ones before anyone else sees our humiliation, though if the truth be told, the slight differences seem inconsequential to anyone else. This is why professional photographers always allow their clients a modicum of choice (another petty deception!), knowing the depths of human vanity.

Making and faking; making-up; make-believe.... For children, 'making faces' in front of the mirror or in front of friends is a huge enjoyment – and might just as well be called 'faking faces'. For adults, 'making faces' is a far more subtle game, and a constant one, but few would ever admit to going as far as actually *faking* their faces. Still, almost everyone placed in front of the lens knows instinctively it's a game, though a serious one with considerable stakes. As far back as 1858, one photographer complained to his fellows, 'Try as you may, the sitter will make their own face for the occasion.'[1]

Faces can be constructed and reconstructed by photographers optically, chemically, electronically, or with combinations of all three. They can build faces from scratch, combining hundreds of elements from dozens of other faces, alter expressions, make people younger, older, more beautiful and the like. Faces may be fabricated from rough bits of paper, caviar, diamond dust, or with two cleverly arranged hairpins. Or, disdaining such painstaking work, photographers might simply choose to photograph the lifelike new faces that industry is producing, soon to be available off the shelf, or else a 'face' provided for them by an obliging spacecraft that happened to pass by the planet Mars. Dressing up, making-up, using look-alikes, 'borrowing' someone else's face: photographers today are busy in their studios making and faking and taking from their photographic tool-kits the instruments they need for their work, all the while keeping pace with the scientists and engineers who are busy in *their* laboratories fabricating their human-faced robots and cyborgs. Together, they are all hard at work preparing brave new faces for a brave new world.

"For me, looking in the mirror produces a sense of wonder. I say, 'Who is that?' . . . And so, I started photographing myself, and found that I could see portions of myself that I had never seen before. Since I face just my face in the mirror, I know pretty much what it's like. When I see a side-view I'm not used to it, and find it peculiar. . . . So, photographing myself and discovering unknown territories of my surface self causes an interesting psychological confrontation." Lucas Samaras, 1976

vii Faking Faces

An actress holds an extraordinarily life-like silicone mask in her hands – a mask of her own face. This mask reminds us how close we might be to the era of elective face transplants, until now the stuff of fiction. Nanotechnology has produced a 'skin' that breathes, indistinguishable from the natural variety and mercifully free from blemishes and scars. How far away are we from a new 'face market'? How soon before we have to choose between off-the-shelf bargains (guaranteed one year) and designer brands (no refund, but replacement guaranteed)? And if many resist the temptation for a complete make-over, who would deny the opportunity for the mangled victim of a car accident? And what shall we do if such creatures end up with faces more beautiful than our own?

Overleaf Alison Jackson playfully mocks the conventions of photography that have grown up to service the cult of celebrity. In an age of electronic manipulation of the image, we'd be forgiven for assuming that her cast of regal characters are pixellated avatars, but in fact they are look-alikes who stage alternative realities based upon imaginary but plausible scenarios. Jackson's photographs, therefore, are 'straight', and as objective in character as any classic reportage. On the one hand, she references paparazzi photography (the 'stolen' image), on the other the formal portrait sitting of an 'official' studio photographer like Lord Snowdon. As with the real Diana, whose face cultural critic Camille Paglia reminds us makes her the last silent film star, Jackson's Diana here carefully controls her image, playing the role of the tender mother, utterly focused on her child.

Sarah Leen *The Mask* 2001

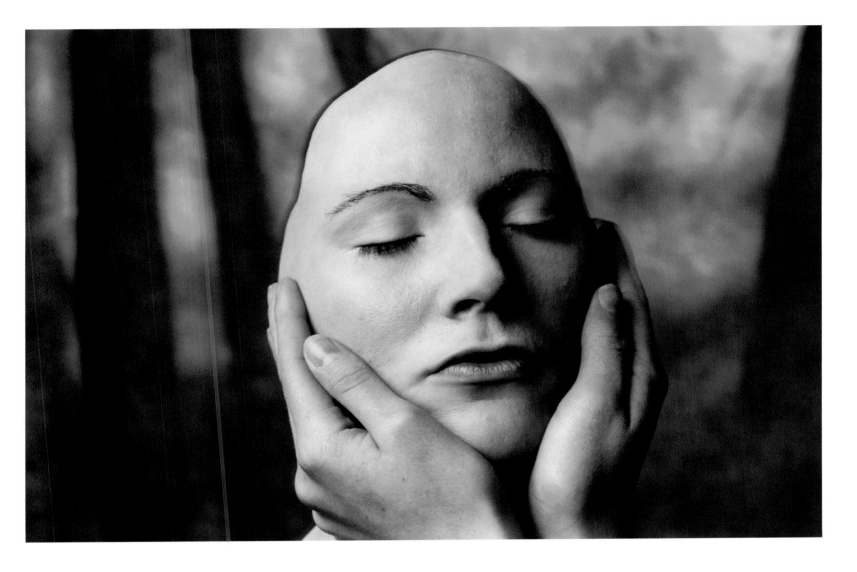

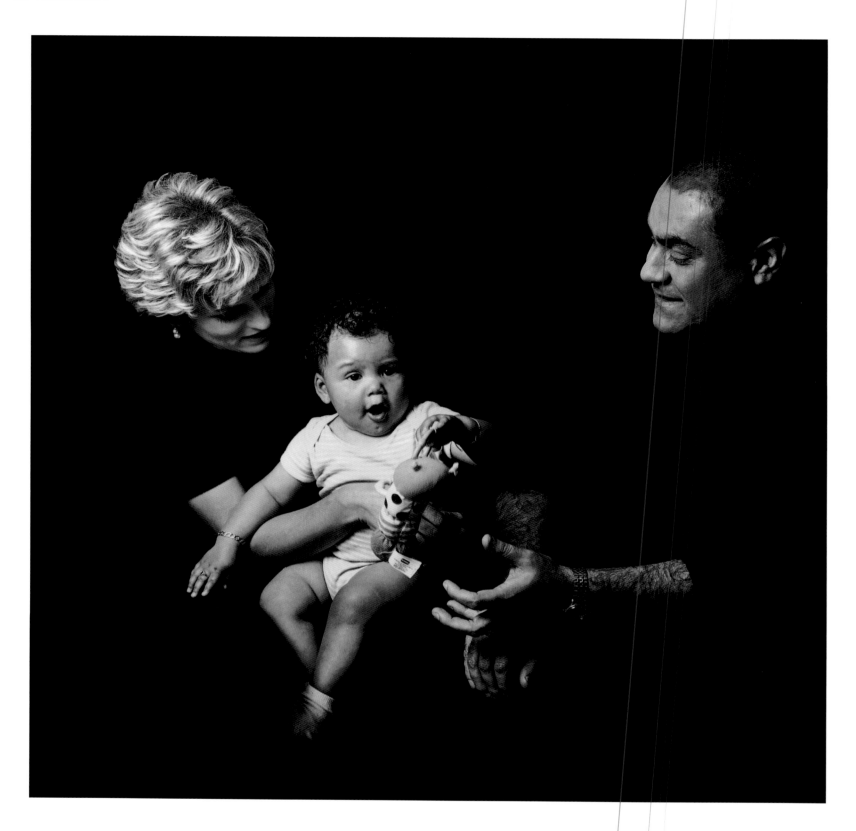

Alison Jackson *Di, Dodi and Baby* 1998

"Is it true or merely a *canard*, that the French photographers have introduced property babies into their studios to do duty instead of the squalling, kicking, little darlings which so often destroy the tempers of the most amiable of operators? … I remember hearing it stated that the portrait of a baby which was published some time ago in conjunction with the Princess of Wales was not a royal baby at all. Infant royalty had rebelled, and spoiled a good negative in which the Princess was perfect." The Photographic News, London, 1870

overleaf ▶ The designer and art director Tibor Kalman poses an intriguing question. He asks the readers of the appropriately named Benetton magazine *Colors*, 'What if?' What if the Hollywood actor/politician Arnold Schwarzenegger were black? Or the Queen of England? On the mock evidence he presents, we conclude that the faces would appear no less interesting or intelligent, and are possibly even more attractive. It would have been unthinkable for a nineteenth-century Kalman to do what he has done. He'd have been flogged! But today, every citizen has the right to imagine, or even propose, how their leaders should appear, or indeed how they might have appeared had history dealt a different hand.

Arnold Schwarzenegger

Tibor Kalman From the series 'What if...?', published in *Colors* (Issue 4) 1993

Queen Elizabeth
Königin Elizabeth

Tibor Kalman From the series 'What if...?', published in *Colors* (Issue 4) 1993

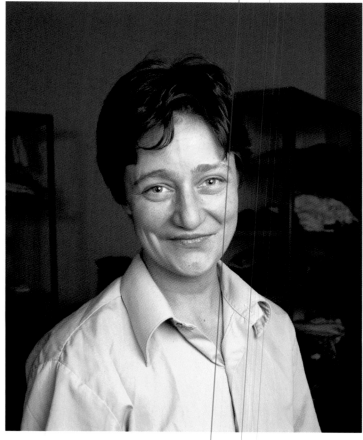

"I live in the facial expression of the other, as I feel him living in mine...."
Maurice Merleau-Ponty, 1964

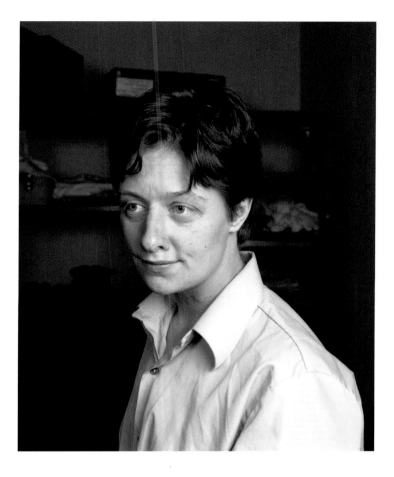
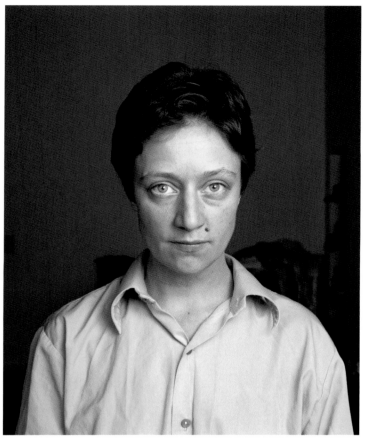

(from left to right) **Vibeke Tandberg** *Faces #1*; *Faces #6*;
Faces #8; *Faces #5* 1998

In this series of portraits, our capacity for pattern recognition kicks in instantly and we 'see' the same individual in various poses. But if the eye is allowed to linger, doubt seeps in: is this really one individual? Some strange shape-shifting seems to be pulling the face this way and that, teasing our gaze. Vibeke Tandberg investigates concepts of resemblance and individuality. Using her own portrait as a point of departure, and keeping the same clothing and hairstyle to add to the confusion, she uses digital photography to mix features of male and female friends with those of her own, creating a half-real, half-fictive, bi-gendered persona.

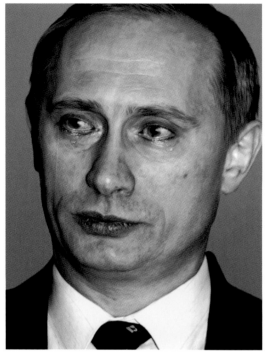
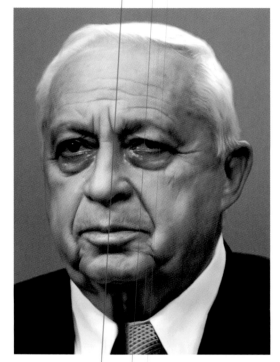

(from left to right) **Jiří David** Bush – No compassion; Putin – No
compassion; Sharon – No compassion; Schröder – No compassion;
Blair – No compassion; Chirac – No compassion 2002

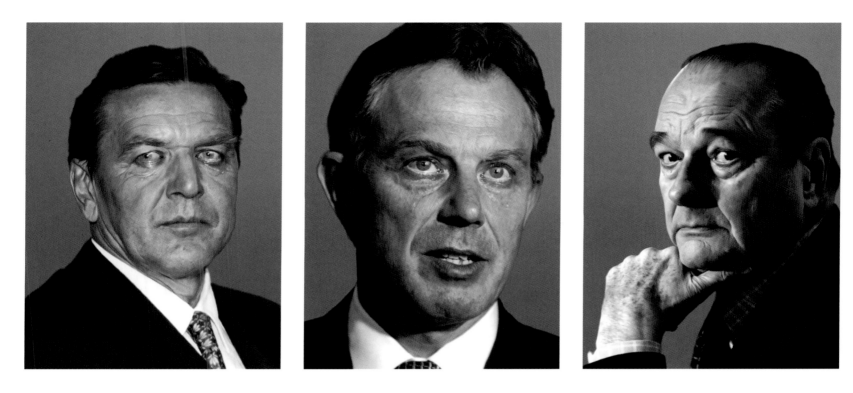

The successful modern politician is adept at image management, or is at least smart enough to employ experienced professionals to do the work – that is to say, feed the public with portrayals that reek of sincerity, confidence, radiant health and bonhomie. It was therefore difficult for Jiří David to amass atypical photographs of the world's leaders. Once found, however, the artist went to work reddening the eyes and, via computer, adding to each face the benediction of his own (scanned) tears. The faces that result speak far more eloquently of the state of the world than any of these 'photo-opportunists' could imagine.

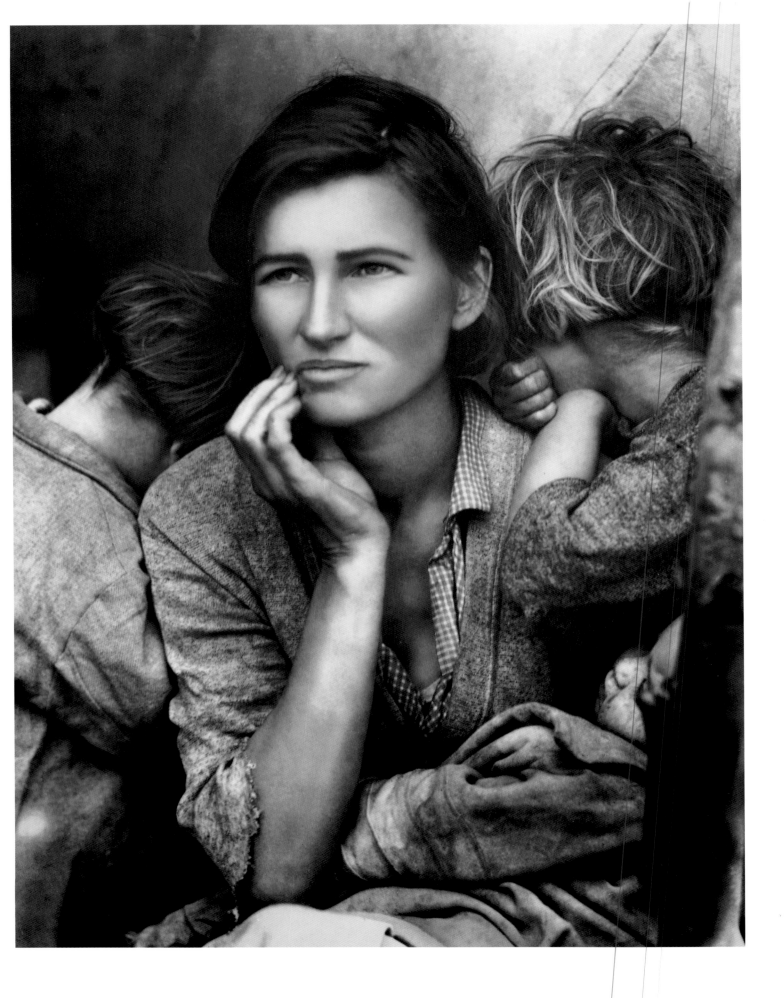

"Society is frantic to deny loss ... we do not want to see the evidence of age and experience, especially in women.... As cosmetic surgery becomes more prevalent, our eyes will become more habituated to the 'look' of the eternally young face and our reservations about cosmetic surgery will disappear. Faces will become more homogenized. It will be the triumph of Velveeta." Kathy Grove

Kathy Grove *The Other Series: After Lange* 1989-90

Dorothea Lange's migrant mother is one of the most vivid icons of America's Great Depression, her handsome face etched nobly with worry, fatigue and determination. But artist Kathy Grove notes that while Lange's masterpiece occupies a secure niche in art history (we will always make room for an updated Madonna with Child), most women today consume vast amounts of imagery with a diametrically opposed message – stereotypically beautiful faces excised of the slightest imperfection, carefree and eternally youthful. Grove, who has been a professional retoucher for the fashion industry and is an artist in her own right, asked herself how the Migrant Mother might have been presented today, had she been targetted by fashion magazines. Grove applied herself to the task, quite literally cleaning up the subject, and, lo, a Cover Girl emerged, a worthy candidate for substantial advertising contracts vaunting the merits of Botox or 'the immediate lifted look' and other 'extraordinary new face-maintenance technologies'.

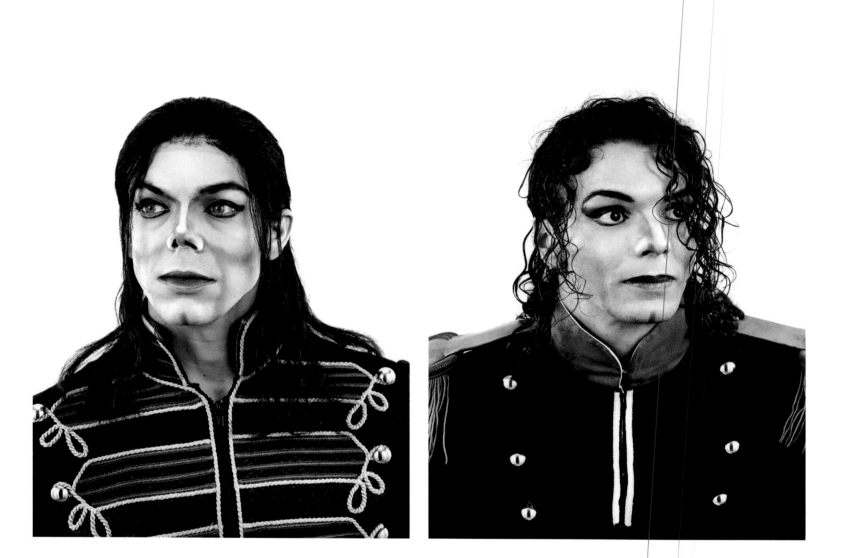

"I am visible, I am image."
Jean Baudrillard, 1993

Valérie Belin all *Untitled* 2003

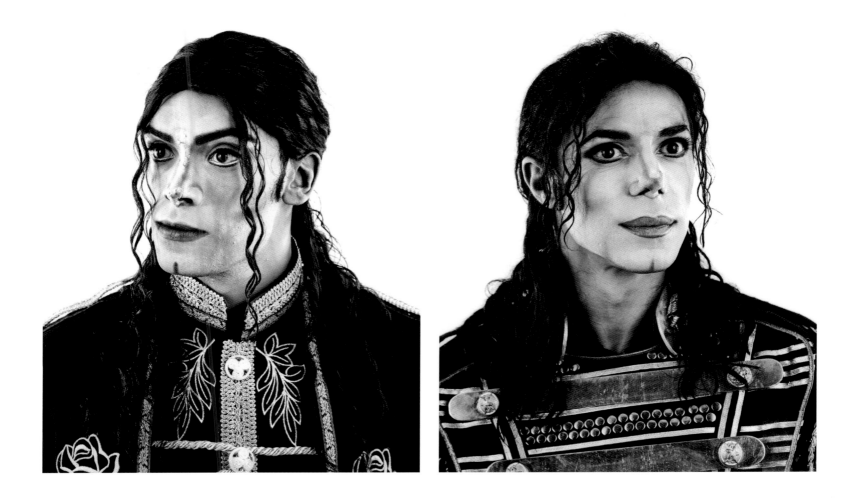

What's wrong here? Are we looking at playful incarnations of the star himself (no real need to mention the name, such is the face etched in the collective consciousness) or are we looking at wax models? None of the noses, it seems, is quite right, but then wasn't the real nose replaced long ago? Real, unreal…. Isn't the Star himself an artificial construct – literally, a self-made wo/man? According to photographer Valérie Belin, all these subjects are impersonators, but if one of them were to claim to be the real thing, how would he ever convince us? Certainly not on the basis of photographic evidence.

Eva Lauterlein From the series 'chimères' 2002

Real, yes, but something tells us that these beings are not fully human. There is a disengaged, robotic quality to them. Yet Eva Lauterlein's subjects are real, and human – to a degree. Or rather to several degrees. Their faces and bodies are computer-aided reconstructions

from photographs of real men and women she knows, with as many as forty different photographs employed. Lauterlein might well have gone on to create freaks, but in her eerie (re)creations she cleverly skirts the line between attraction and repulsion.

Eva Lauterlein From the series 'chimères' 2002

dana__2.0

id no.: da_745482645848-mn
date of birth: 23.1.1999
age: 25
current employment status: genetic engineer
neuro implant year: 2019
chip generation: nx7-2.0
special features: genetically defined liver spot
character traits: reserved, sexually inactive, cyber virgin
enhanced abilities: implant to enhance pain threshold
multiple virtual identity capacity rating: 5
last consciousness file back-up: yesterday

Michael Najjar *dana_2.0*, from the series 'nexus project part I' 1999/2000
Michael Najjar *dieter_2.0*, from the series 'nexus project part I' 1999/2000

dieter_2.0

id no.: di_985836487595-mn
date of birth: 5.7.1988
age: 36
current employment status:
 cutter for neuro ad clips
neuro implant year: 2023
chip generation: nx7-2.0
special features: implanted
 nano-tracking control unit
character traits: introverted,
 inquisitive
enhanced skills: masters 17
 different kung fu styles
multiple virtual identity
 capacity rating: 9
last consciousness file
 back-up: 9 days ago

Michael Najjar's interest lies in a future stage of brain enhancement, whereby miniaturized computer chips will be implanted in the neuronal structures. This will result in the much-vaunted 'cyborg', a human platform with machine attributes. It makes sense that the eyes of such a being will have the capacity to register megabytes of information, make their own movies, take their own still pictures, even illuminate environments. The faces themselves seem disturbingly credible, raising terrifying ethical questions. Will there be two races of human, biological and enhanced? Two classes, masters and slaves? If human life is currently valued higher than the existence of a machine, what will happen when man and machine commingle to an indistinguishable unity?

Nancy Burson's images are the earliest successful computer artworks to composite photographed faces, and they are also among the most complex and intriguing of such composites on the conceptual level. Far from being rote composites (faces of particular groups sandwiched together merely out of curiosity), Burson's work begins with intelligent hypotheses that address collective fears and add a dose of piquant critique. Her *Mankind*, therefore, is not really a composite image of 'the three races' but merely of three individual representatives of those races. However, by weighting the visual information according to population statistics, she allows the Asian to dominate, thus giving voice to the unspoken if irrational fear that Asians will soon come to dominate the world.

Burson's *Warhead I* is composited of the faces of the leaders of the nuclear powers in 1982, here weighted according to the number of weapons each controlled: Reagan 55%, Brezhnev 45%, then Thatcher, Mitterrand and Deng with less than 1% each (for these minor players, evidently, having a weapon or two was primarily a question of saving face). Not surprisingly, the big guns, Reagan and Brezhnev, have emerged as front-runners in the face-race, though in 1982 it still appeared to be a stalemate.

Nancy Burson *Mankind* 1983-85
Nancy Burson *Warhead I* 1982

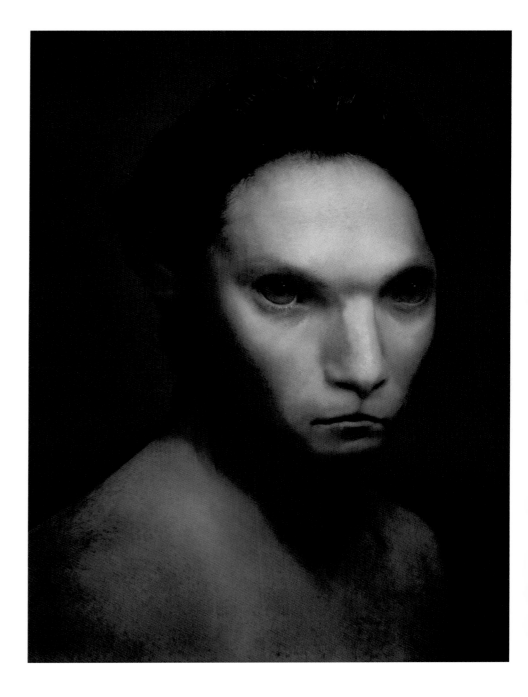

Daniel Lee *1960 – Year of the Rat*, from the series 'Manimals' 1993

In Chinese mythology, the zodiac is comprised of a cycle of twelve animal signs, and a person's behaviour and personality traits are associated with the animal representing one's year of birth. Daniel Lee believes that we humans have forgotten just how 'animal' we remain under our civilized veneer. Here, like a science-fictional or fairy-tale beast with strangely human features, a thoroughly socialized 'ratman' poses confidently for his portrait.

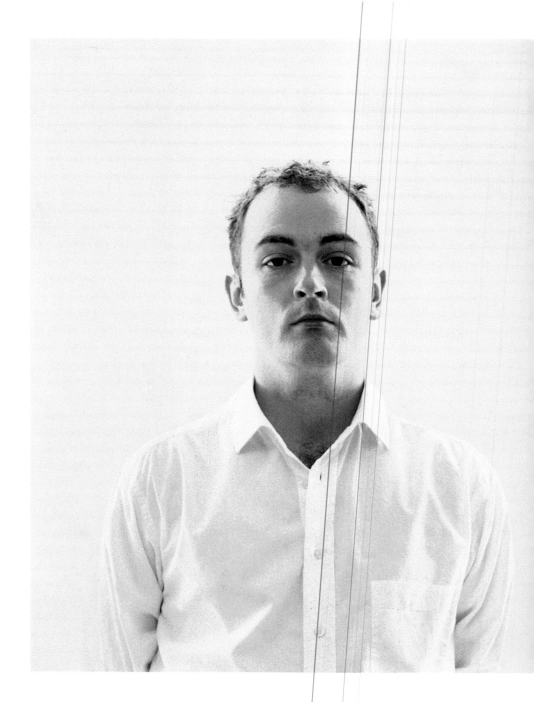

"Primate facial displays are evolutionarily designed devices to elicit a response from the receiver." Signe Preuschoft, 2000

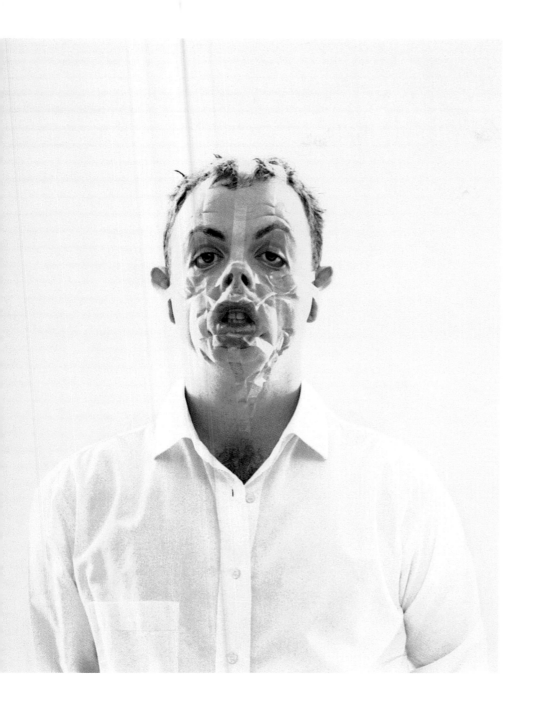

Douglas Gordon *Monster* 1997

Douglas Gordon is clearly intrigued by fears and super-stitions, and his works often address the body as a site of anguish and conflict. *Monster* presents two sides of the same coin, one seemingly rational and reasonable, the other hideously distorted in the vein of Hollywood B horror flicks, especially those in which the nice boy next door turns out to be the serial killer. It doesn't take much to shift from one face to the other: the transparency of the mask is thus literal and figurative. Civilized humans are all a hair-breadth away from monstrous behaviour.

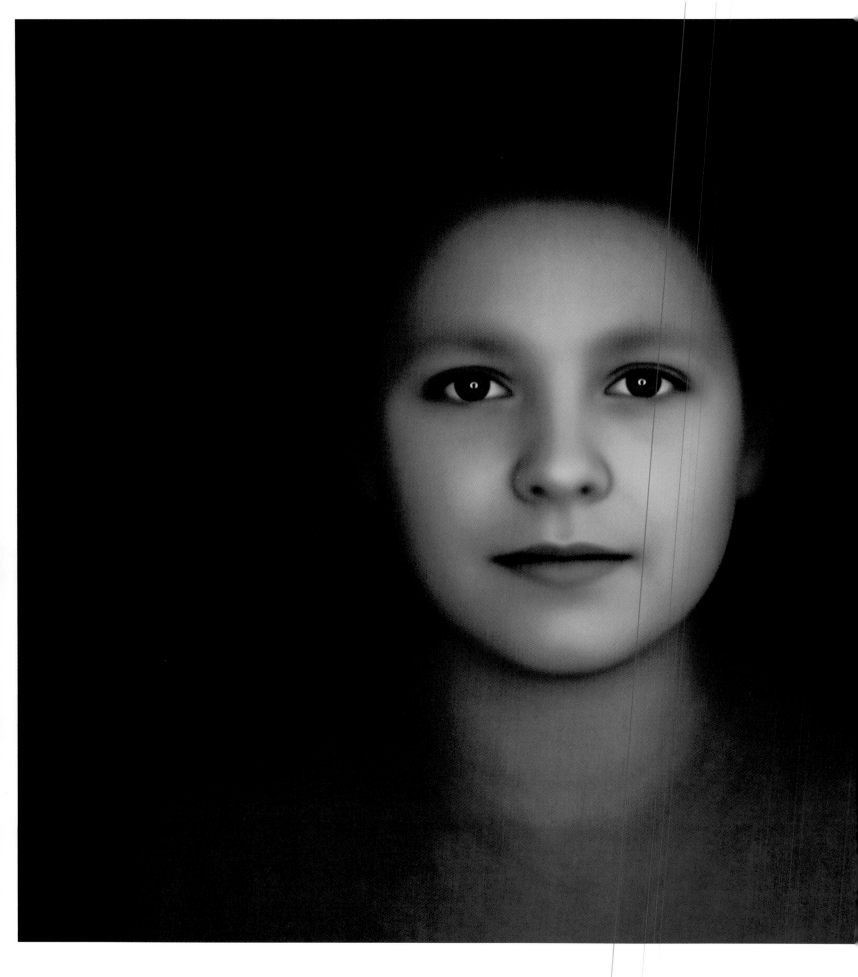

Chris Dorley-Brown *The Face of 2000* 2000

"His visage, the faintly smiling outline of his lips and his straight clear forehead reminded me of features I had seen on earth. The curves, the gleaming, the charm of all the faces I had ever loved — the features of people who had long since departed from me — seemed to merge into one wondrous countenance." Vladimir Nabokov, 1923

Here we see, in the beautiful face of the year 2000, a radiant composite of two thousand faces. The youngest face is that of a two-year-old child, the oldest a person of seventy. All are inhabitants of a small town in England, and Dorley-Brown's portrait thus pays tribute to the face of a town, the face of a nation and the face of a time. The composite photograph as a technique dates to the nineteenth century, but the composites of our day are usually amalgams of photographs and computer manipulation. All composites, however, exhibit a similar property: the sum of the parts is more beautiful than any single part, and the more people composited, the more exquisite the resulting face ... which is also to say that our concept of human beauty is, paradoxically, based upon the mean or average, rather than the extremes of the continuum. We are drawn to a beautiful face, therefore, because it is closer to the core essence of human *being*.

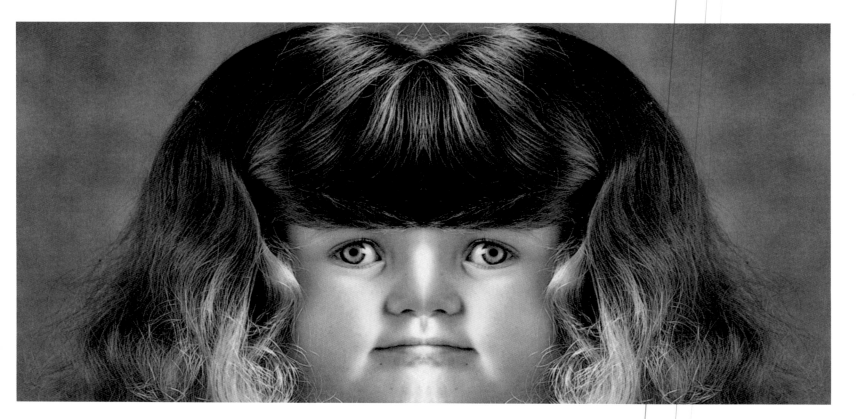

"Most, perhaps all, of our mirrors
are inaccurate and uncomplimentary,
though to varying degrees and in
various ways. Some magnify, some
diminish, others return lugubrious,
comic, derisive, or terrifying images."
W. H. Auden, 1962

John Stezaker *Angel 2* 1997-99
John Stezaker *Demon* 1997-99

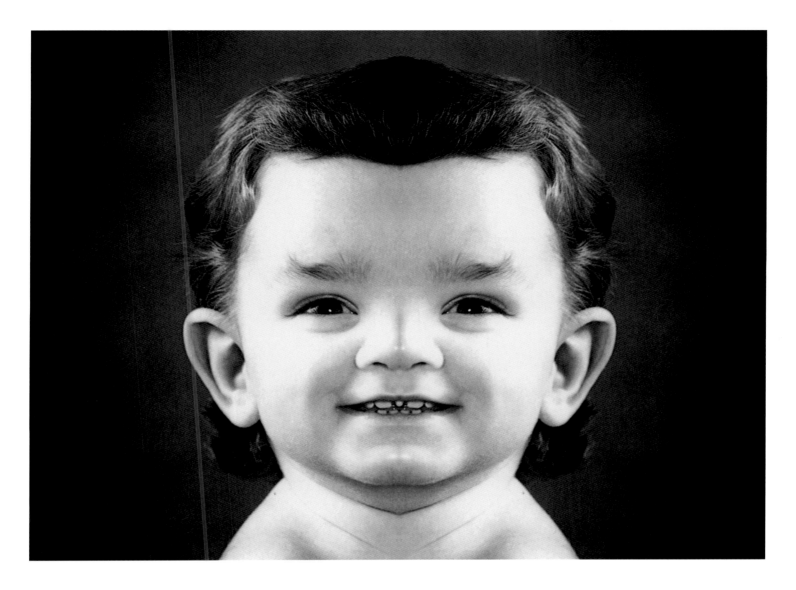

John Stezaker often works with found photographs, hunting through magazines for photographs of children which he appropriates for his own ends, casting some in the role of demons, others as angels. His technique involves the most subtle transformations, but these radically alter meanings of the original images. By mirroring one side of the face in kaleidoscopic fashion, and cropping the faces cleverly, he turns conventionally attractive children's faces into grotesque and threatening beings; even his angels have a diabolical air. Perfect symmetry is supposed to make for exceptionally beautiful faces, but in Stezaker's hands, 'perfection' comes back to haunt us. Cosmetic surgeons and genetic engineers, take heed.

viii Making Faces

If words can never fully come to grips with a human face, can numbers? The Gerlovins think so, but reject the 'bookish page' as the place to do it, preferring to use human skin as parchment for their 'figures of speech'. And what better skin than that on the face, both window and mirror of experience? In the magic square, any three numbers in a row - horizontal, vertical, diagonal - add up to 15, with the central number, 5, a numerological sign for Man (also depicted as a five-pointed star). The Ancient Greeks had decided that odd numbers were male and even numbers female, but that the number 5 was androgynous. The Gerlovins reject the notion that the magic square is merely an intellectual exercise or a game; instead, they believe it is a key which, along with others, will eventually unlock the mysteries of the mind. 'Abstract theory', one is tempted to say ... but by inscribing their magic numbers on the face itself, the Gerlovins remind us that for the Greeks, *theoria* meant 'direct sight'.

"In spite of the proverbial saying that beauty and brain seldom mix, we link them together.... The human skin becomes a parchment for a sort of organic metaphysics."
Rimma Gerlovina and Valeriy Gerlovin

Rimma Gerlovina, Mark Berghash and Valeriy Gerlovin
Magic Square 1987

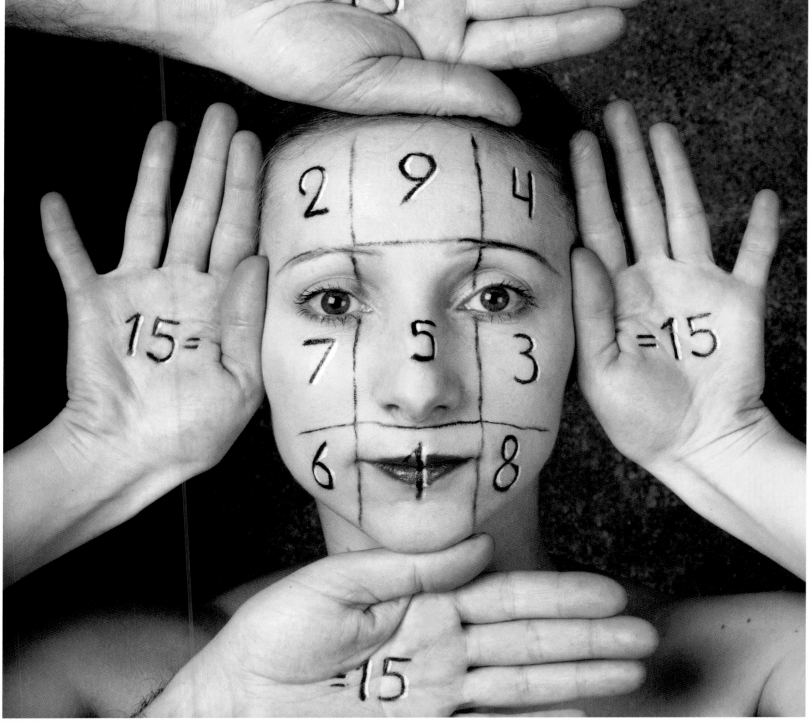

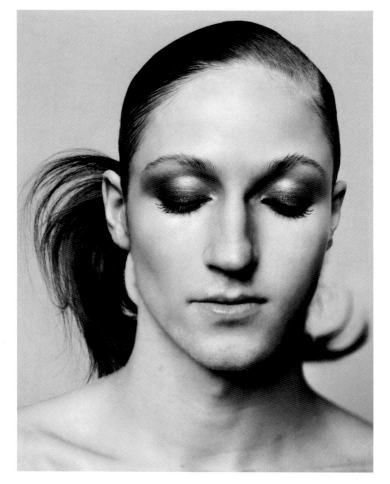
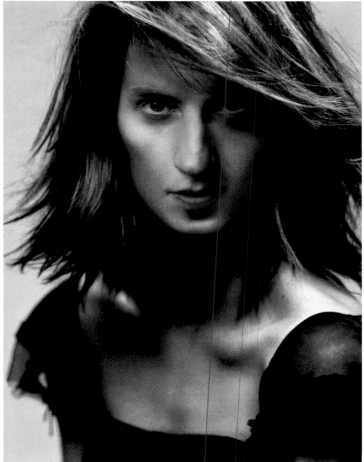

"It is our peculiar fascination with celebrity that may be responsible for a culture in which appearance is a shimmering illusion, one that changes from day to day."
Jonathan Lipkin, 2005

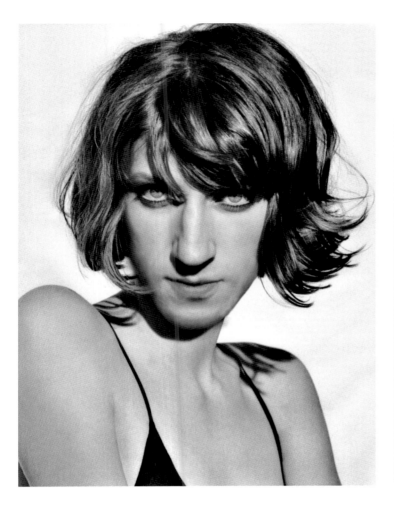

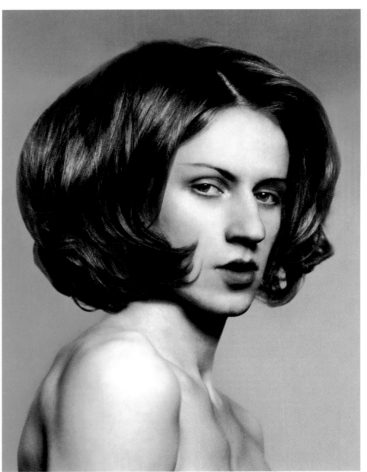

Arnaud Delrue From the series 'Mythology' 2005

And why not me? If beauty is merely a question of buying and applying the appropriate products, as advertising – or, in Marshall McLuhan's more wry and apt phrase, 'commercial education' – maintains, can't we all be stars? Ah, but consumption is not enough, as Arnaud Delrue instructs us: image production is also a fundamental requirement. Some decades ago, sociologist Erving Goffman wrote about the necessity of grooming oneself for presentation in 'everyday life', but Delrue reminds us that the grooming we really need today is for purposes of representation in the virtual domain. But he also reminds us, hilariously and painfully, that all the tricks of the image-trade cannot disprove one old adage: you cannot make a silk purse out of a sow's ear.

"It may be averred that, of all the surfaces a few inches square the sun looks upon, none offers more difficulty, artistically speaking, to the photographer, than a smooth, blooming, clean washed and carefully combed human head." Lady Eastlake, 1857

(from left to right) **Martin Parr** *Amsterdam, Holland*, from the series 'Autoportrait'
2000; *New York, USA*, from the series 'Autoportrait' 1999; *Guadalajara, Mexico*, from
the series 'Autoportrait' 2003; *Benidorm, Spain*, from the series 'Autoportrait' 1997

Parallel to his peripatetic reportage assignments, Martin Parr had the brilliant idea of visiting photography studios while on his travels. He made himself a pliant sitter, subject to the styles and approaches of studios ranging from the savvy and sophisticated to those producing kitsch and folk art. By remaining neutral and allowing himself to be moulded by other image-makers, Parr has provided us with a marvellous catalogue of handcrafted imagery, often retouched and collaged, with little mises-en-scène – a twentieth-century practice that is sadly dying out. Though gently mocking both the idea of the 'telling' portrait and the petty vanity of the individual sitter, Parr insists on paying homage to the myriad small-scale craftsmen who are, if 'distant relatives', still part of his 'family'.

"The grand debate of art in our time has not been the debate between figuration and abstraction, it has been the debate between the representation of the face and its impossibility."
Jean Clair, 2002

Edith Roux all *Untitled*, from the series 'Les médusés' 2000

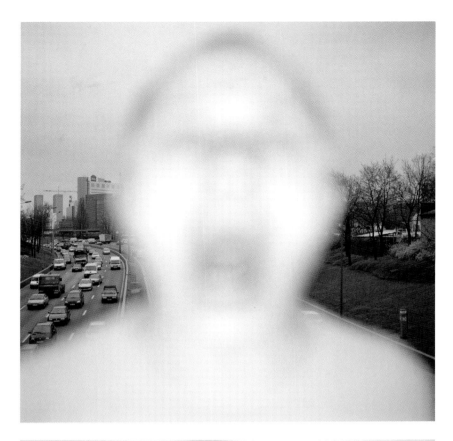

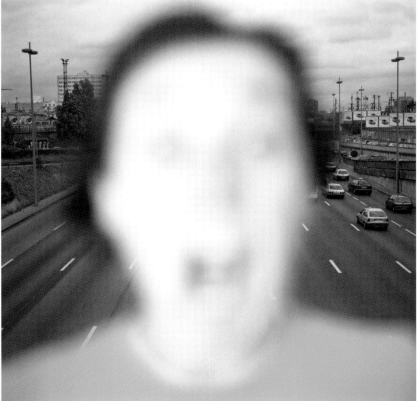

Edith Roux positions her subjects on Parisian *périphérique* overpasses, where they hover like phantoms above rivers of concrete flowing briskly with containers of human cargo. The viewer is reminded that the modern urban environment is a living organism, constantly in flux. Are Roux's subjects shouting at us? Are we being warned? Roux tells us nothing about the messengers, whose agony is palpable. Her images have a nightmarish, Munch-like sense of desperation. With her subjects' eyes and mouths forced wide open, and with her camera lens opened to its maximum size to take the photographs, Roux explores the fluid boundaries of a city, the frontier between figuration and abstraction, and the tension between the permanent and the ephemeral.

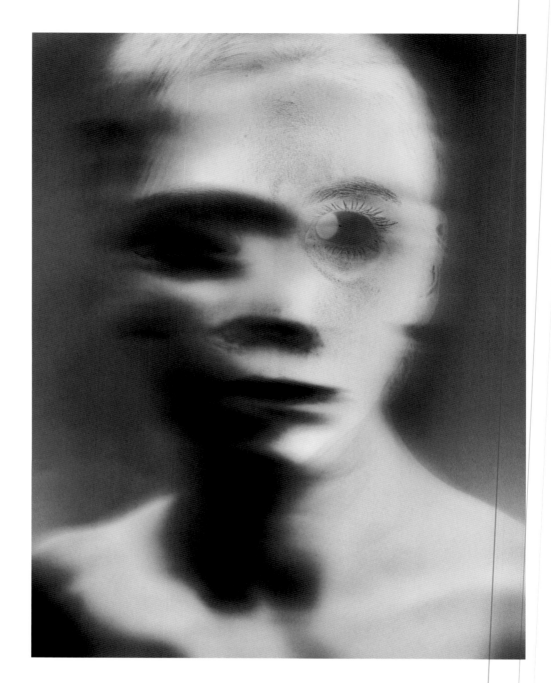

Negatives are rarely intended as the end result in photography, but they are the indispensable means to an end. Laurence Demaison plays with 'dark matter' (which, we are told, comprises most of the universe) and exploits the properties of the negative in her self-portraits to break through 'the mask' of the positive. She first paints her face black, then her lips, eyebrows and so on white, becoming, in essence, a negative. The photographic negative of this material produces a haunting, even beautiful transcription of reality.

Laurence Demaison From the series 'Visages spirites' 2002

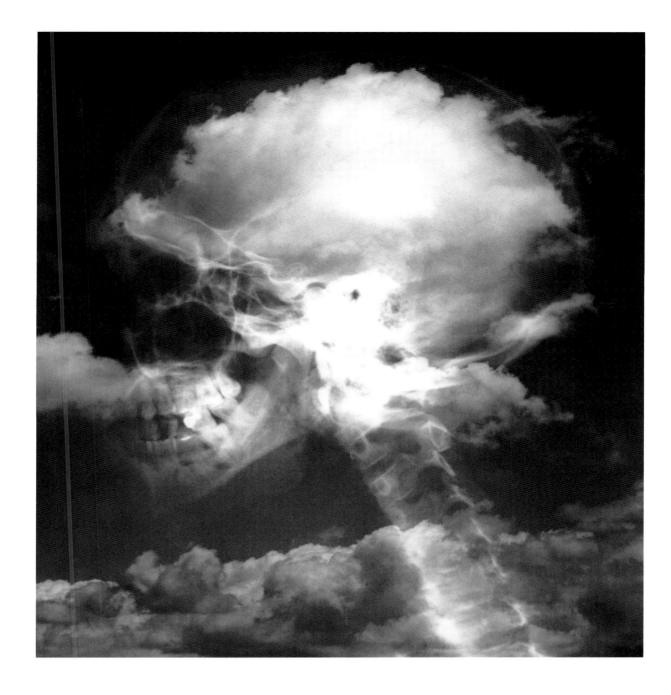

Chema Madoz's vaporous self-portrait speaks eloquently of the mysteries of the mind. Its container, the skull, is shown to be a wafer-thin, permeable membrane. Thoughts and emotions form and dissolve, flow in and flow out, shape-shifting continually. A towering column transmits forecasts to the body far below. For the moment the weather is good, but those may be storm clouds gathering on the horizon.

Chema Madoz *Untitled* 1999

Susan Derges *The Observer and the Observed #14* 1991

Susan Derges explores the role of the observer ... observed. A jet of water has been made to vibrate, and she has then illuminated it with a strobe light vibrating at the same frequency as a pre-programmed sound. The water thus appears as stationary droplets, suspended in time and place. When the observer (Derges) is placed behind the droplets, each acts as a tiny lens focusing an image of her face. The viewer is then confronted with a paradoxical illusion: by focusing on the minuscule faces in the drops, the blurred face behind seems to swim into focus. But when our gaze refocuses on the face, it once again loses its clarity. Derges reminds us of the profound gap between what we see and what we perceive.

Brian Oglesbee *#49*, from the series 'Waters' 1999

For Brian Oglesbee water is a rich material for visual exploration of the human form. It is transparent and dynamic. It is also refractive, acting as a mirror and a lens. Oglesbee builds sets and devices to create wave forms and fields of lensing bubbles, each of which seems to have trapped the spirit of a tiny water sprite – a portrait in miniature.

Tomoko Sawada admits to a long-standing inferiority complex about her appearance, but discovered that her anxiety dissolved once she was in disguise. Over a period of two years she made hundreds of visits to a photobooth dressed as different individuals. Part of the charm of the four-hundred-strong series is the slow erasure of the 'original' Sawada. Indeed, can one any longer speak of an 'original'? Aren't they all? In addition, can one now confirm that an ID picture, taken in a photobooth, serves to prove the identity of the sitter?

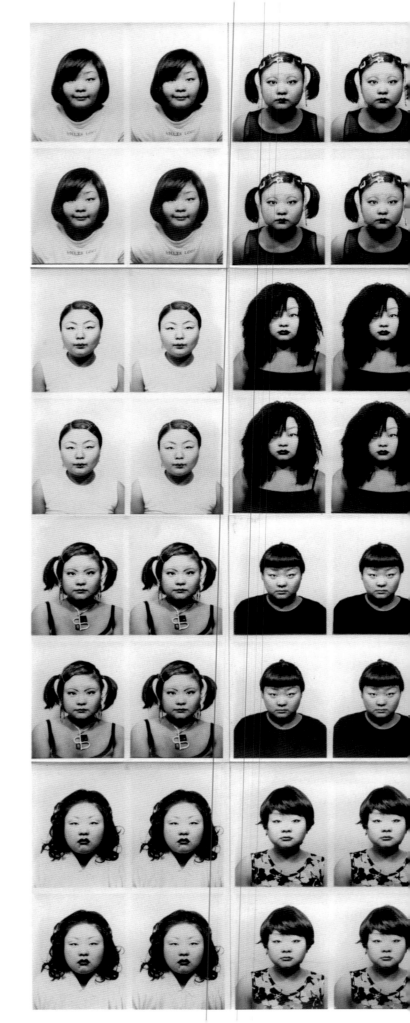

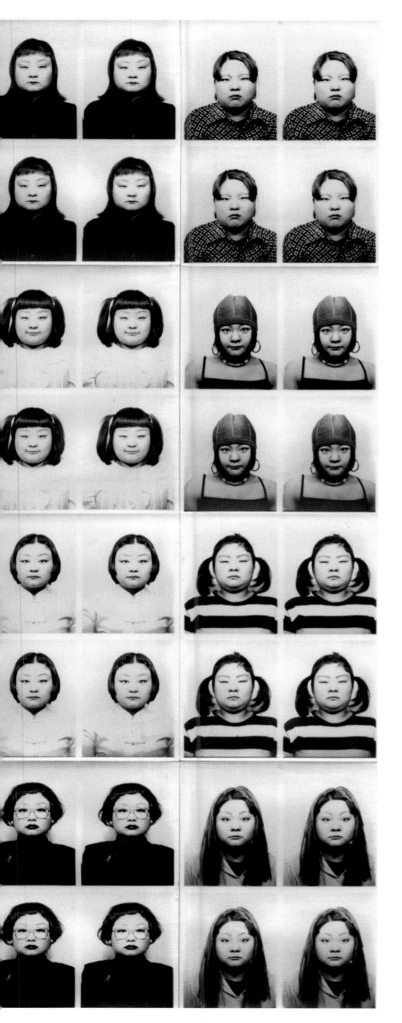

"It is said that there is always a moment to be seized when the most ordinary being, or the most masked, reveals their secret identity. But what is interesting is their secret otherness. And rather than looking for the identity behind the mask, one must look for the mask behind the identity – the face that haunts us and turns us away from our identity – the masked divinity that in fact haunts every one of us, for an instant, at one time or another." Jean Baudrillard, 1998

Tomoko Sawada *ID 400* 1998 (detail)

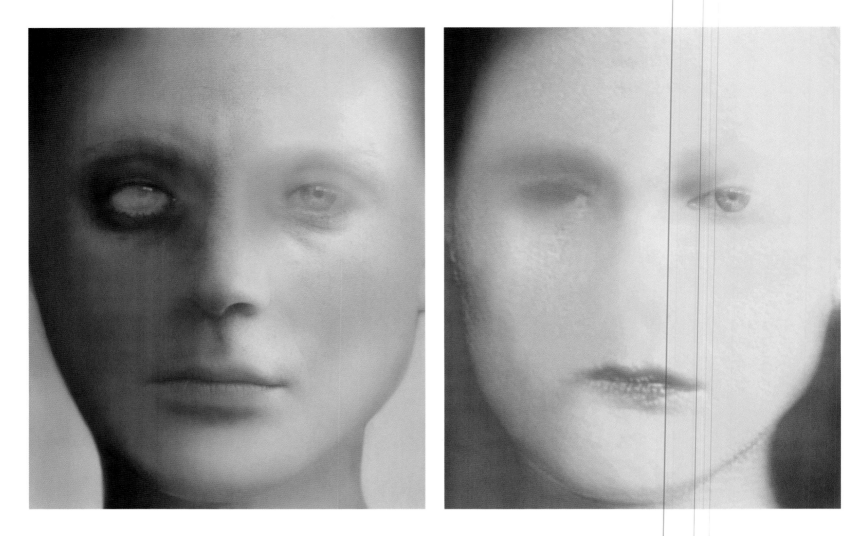

"There is a white hole in the wall, a mirror. It is a trap. I know I am going to let myself be caught in it. I have. The grey thing appears in the mirror. I go over and look at it, I can no longer get away. It is the reflection of my face."
Jean-Paul Sartre, 1938

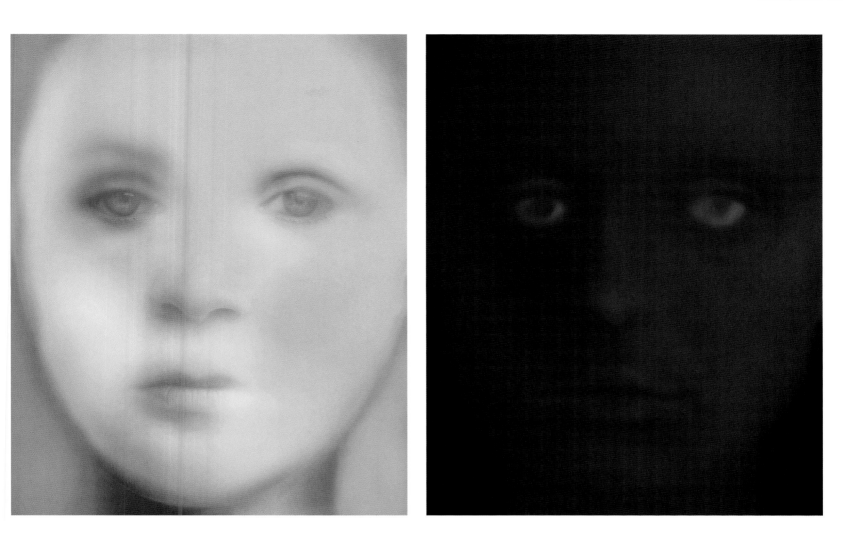

(from left to right) **Yotta Kippe** *#4; #13; #20; #213*,
from the series 'Precious Moments' 2003-04

How is that we know, instinctively, when a face is truly human? What is it that comes through, even when images have been heavily reworked? Yotta Kippe uses digital means to fabricate self-portraits of ethereal transcendency. They evoke the softest, most delicate pencil drawings, in which erasure is used to remove all but the essential. They radiate *mind*.

(from left to right) **Bill Armstrong** *Portrait #301*; *Portrait #300*;
Portrait #318; *Portrait #312*, from the series 'Infinity' 2001

At a distance, or in low light, we see faces indistinctly, yet we have learned since childhood to scan them rapidly for signs of emotion and intention. Bill Armstrong asks: just how much information does it take to 'suggest' a face? Does a face have to exist in order to be photographed? Evidently not. Armstrong photographs wads of paper in such a way that faces seem to appear. Sometimes we can even read male and female characteristics in them (does anyone *not* see two males on the left-hand page, for example?) Scientists tell us that there are two parallel processes at work in the reading and identification of faces. First, data is transmitted via specialized neurons from the visual cortex to the temporal lobe, where identification of the face is made, but in a neutral manner. Simultaneously, facial information is treated in the amygdala – seat of fear, pleasure and emotion. Perception means, essentially, the combination of these readings. Photographs like Armstrong's confound perception, as our brains desperately search for or impose meaning.

"The visible world is no longer a reality and the unseen world no longer a dream." W. B. Yeats

(clockwise from top left) **Helen Sear** *2XJP*; *2XDH*; *2XST*; *2XLP*, from the series 'Twice...once' 1998-2000

For each of these portrayals of acquaintances, Helen Sear has superimposed two negatives. The result is a penetrating but affectless gaze that is discomfiting, 'seen through', as it were, the victims of some new surveillance programme. 'What is secret and hidden is also ghastly,' comments photographer and writer Valerie Reardon, noting how Sear's vision corresponds to Freud's notion of the *Unheimlich*. It is not that we want to see or know more about these faces; we are instead *self*-conscious, more conscious of being looked at than of looking. But the question 'why' goes unanswered.

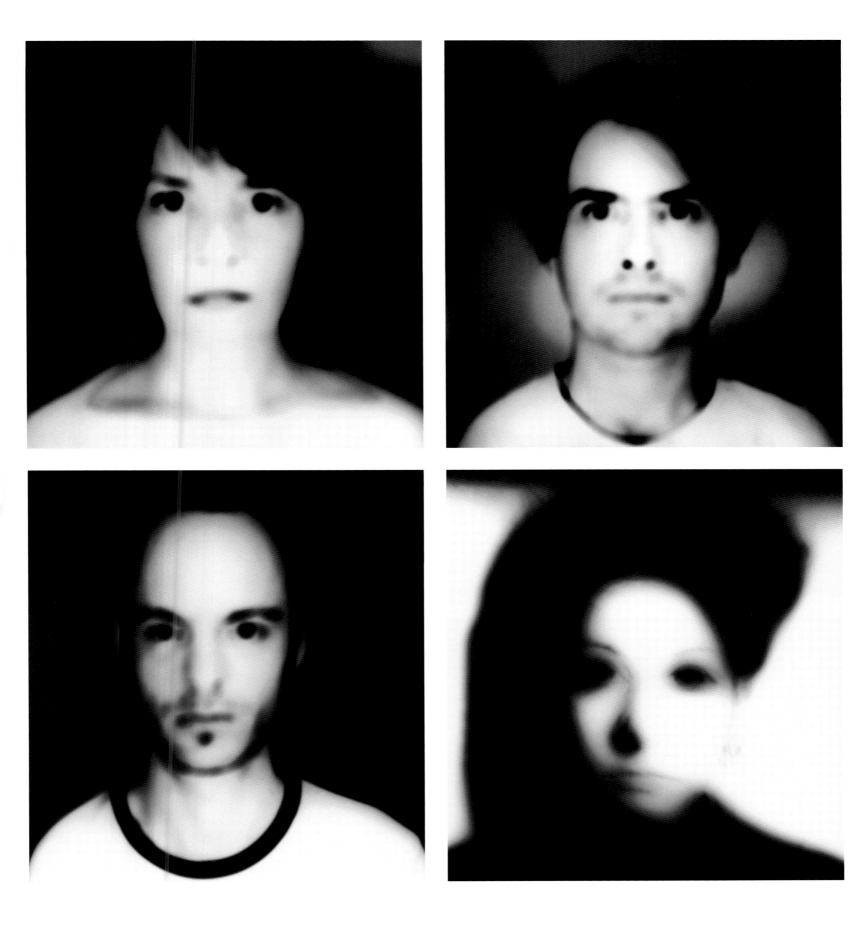

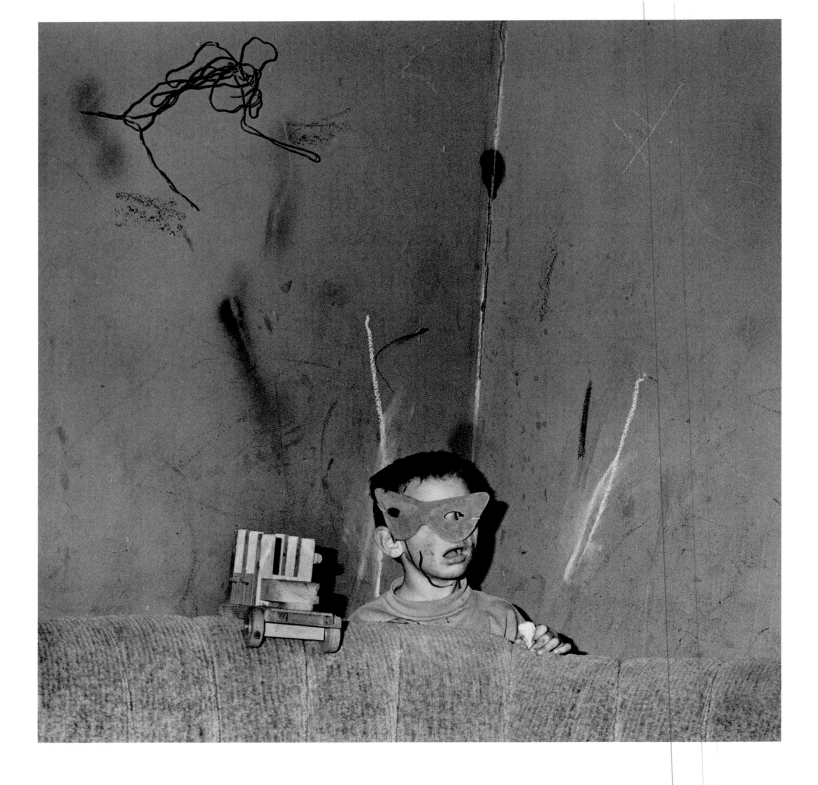

Roger Ballen *Skew Mask* 2002
Roger Ballen *Dustbin* 2004

For thirty years Roger Ballen has been collaborating with miners, railway workers, guards, their families and others from the impoverished and marginal white communities of South Africa. What torments are etched in the faces he depicts in his 'shadow chamber'; what desperation, what silence.... He photographs his subjects among their own furniture and objects, encouraging

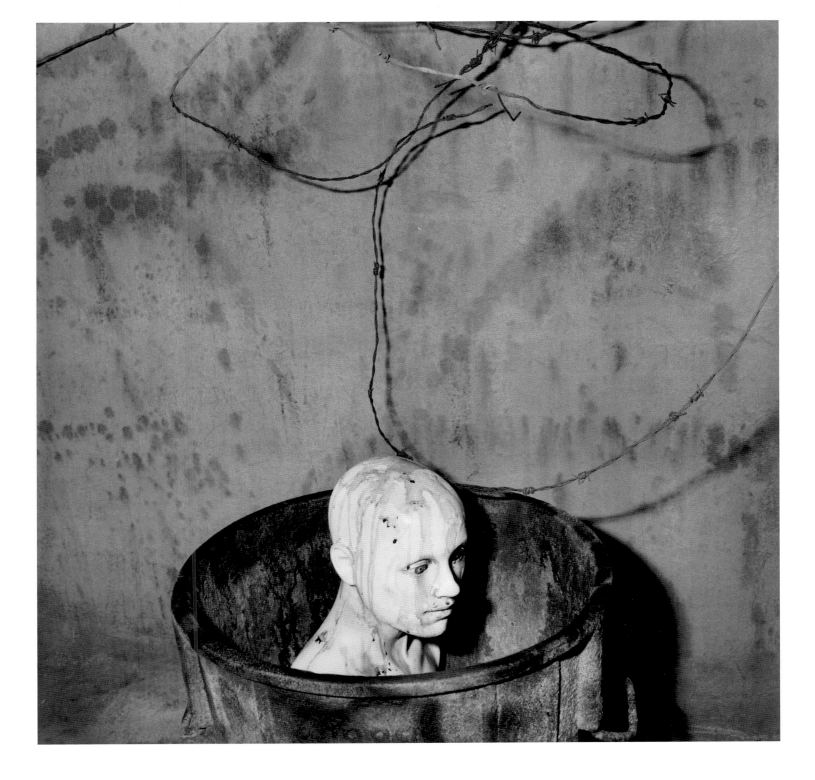

them to suggest their own mises-en-scène and to enact their own nihilistic dramas. The wires, symbols of chaos and danger, the prison-like scrawls on the walls, the bodies dwarfed, the faces in hiding – Ballen's subjects hover between madness and mayhem. But can we file them away in the drawer marked 'Others'? Or are they, in the popular phrase, 'our own worst nightmare'?

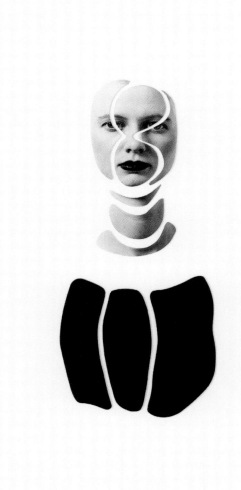

"What is the function of a portrait? What degree of manipulation is correct, acceptable, between the sitter and the photographer, and should art concern itself with accuracy? Shouldn't photography worry about that even more?"
Richard Avedon, 1993

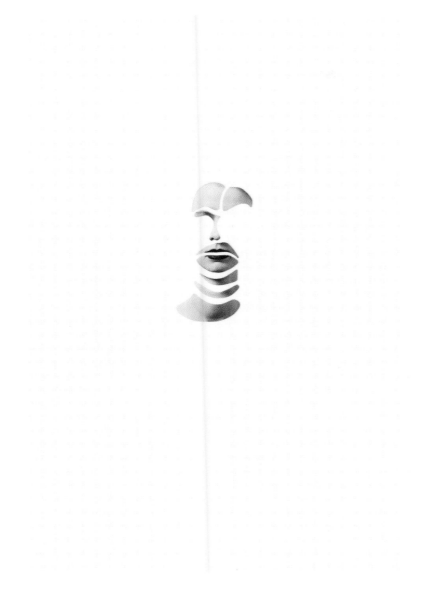

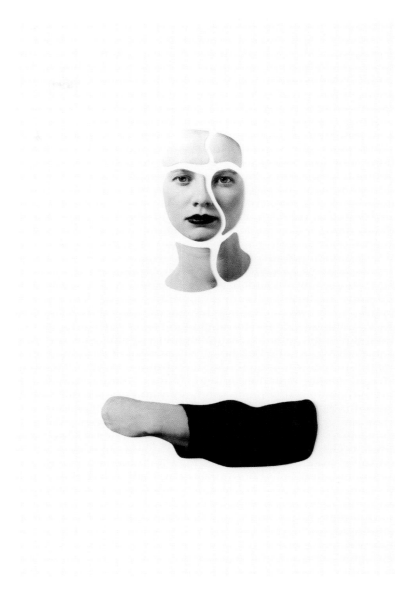

Claus Goedicke all *Untitled* 2000

How does one free the face from social stereotyping and psychological analysis, Claus Goedicke wonders. And how to free it from the prison cell of traditional portrait photography – that all too neat, all too resolved rectangle that passes in our society for the only and the last word on individual identity.... Appropriately, Goedicke uses scissors to escape from these confines, incising rivers and rivulets through face and body, searching to renew, remake and reimagine: a brutal poetics, and a poetics of beauty.

Hiro American Beauty cover for *Mirabella* Magazine September, 1994

When Hiro received a commission from *Mirabella* magazine to represent the face of American beauty, while somehow representing the population's varied ethnicity, he decided on a single image which would meld the features of seven women. The resulting face is indeed beautiful, both vividly real (its components) and mirage (its composite artifice). *Mirabella* knew that its readers, not to mention its advertisers, were keen for any signpost to the future. Which face would be desirable? Which face was inevitable?

Vik Muniz *Reversal Grey Marilyn*, from the series 'Pictures of Diamond Dust' 2003
Vik Muniz *Grey Marilyn*, from the series 'Pictures of Diamond Dust' 2003

Marilyn Monroe … the face of a star, the quintessence of femininity, worshipped by millions and destined to shimmer eternally. Warhol's famous homage is a portrait with which we have long been familiar, but here it is rendered in diamond dust by photographer Vik Muniz. Diamond dust! What more fitting medium could there be to reimagine Marilyn? Yet does not dust blow away with the slightest breath? Muniz reminds us of the old adage 'here today, gone tomorrow'. Postmodern diamonds are decidedly not forever.

Chema Madoz *Untitled* 2000

Two ordinary hairpins? Or a face of Ancient Egypt, exquisitely stylized? Or both? Chema Madoz delights in word/image games. The hairpin – a modest instrument almost certainly dating back thousands of years and used to fasten back the hair, thereby revealing, framing and emphasizing facial attributes – here serves as the fine 'line' drawing of a face itself.

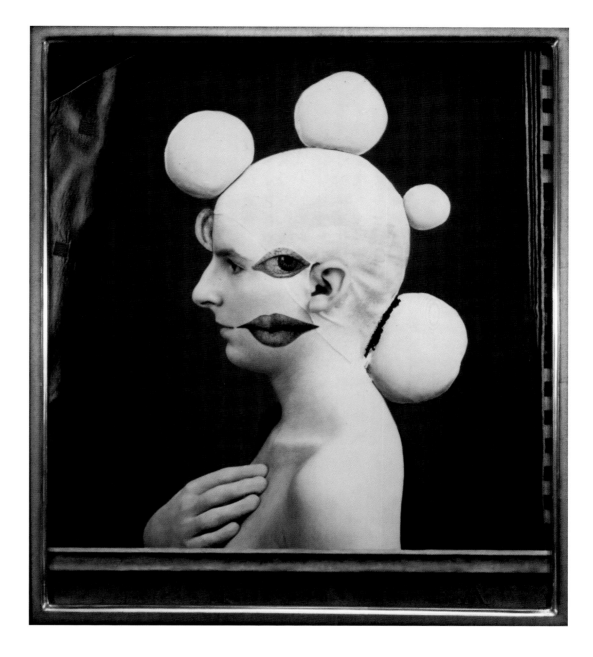

Joel-Peter Witkin *Portrait of Clemence L.* 2002

Part of this Picassoesque portrait is thoroughly traditional (although profiles are usually associated with policework). This part shows an intelligent face, otherwise unremarkable save for its bizarre, encompassing white coat. But our gaze flicks across to another being inhabiting the suit, and here everything is wrong, though real. So bizarre are the organs – the oversized eye, the asymmetrical mouth, the ear poking out of the forehead – that it comes as a shock to discover that the other, seemingly outsized ear is actually perfectly in proportion and perfectly harmonious with the 'classic' portrait.

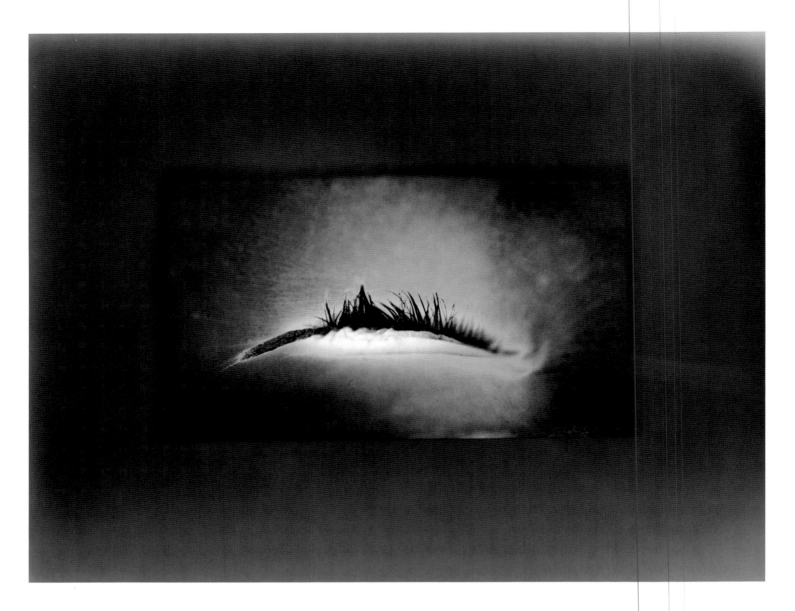

Ann Mandelbaum *Untitled #117* 1995

Ann Mandelbaum is fascinated by the topography of the face – an oasis of meaning (a distant isle, as seen above) or a distant planet (p. 226). It is the power of transformation that interests this artist, not photography's easy capacity to transcribe reality.

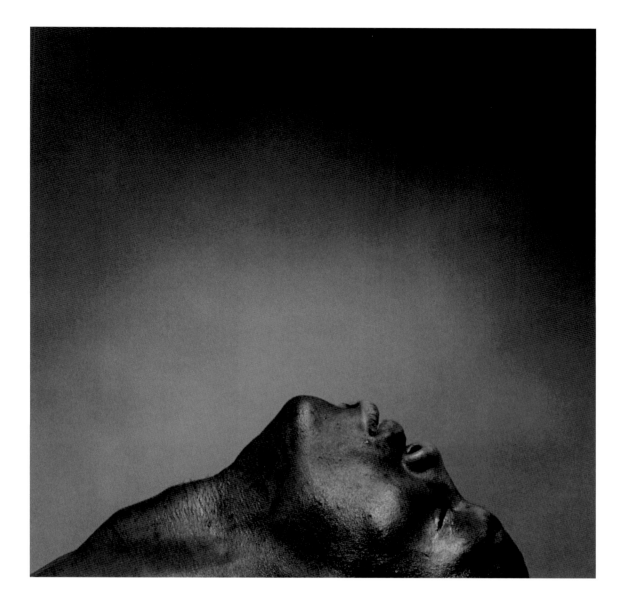

"You had leaned over the still pool of some Greek woodland and seen in the water's silent silver the marvel of your own face. And it had all been what art should be – unconscious, ideal, and remote." Oscar Wilde, 1891

Robert Mapplethorpe also wanted to get beyond photography's literal transcriptions, yet remain faithful to its realism. Fascinated by the human physique – and in particular that of the black male – Mapplethorpe photographed the naked body as sculptural form. Here he gives us a precisely delineated head and tells us to whom it belongs. But has a neck ever been photographed with such attentive concern? Has a face ever been quite so ennobled by its comparison with a majestic mountain range?

Robert Mapplethorpe *Alistair Butler* 1980

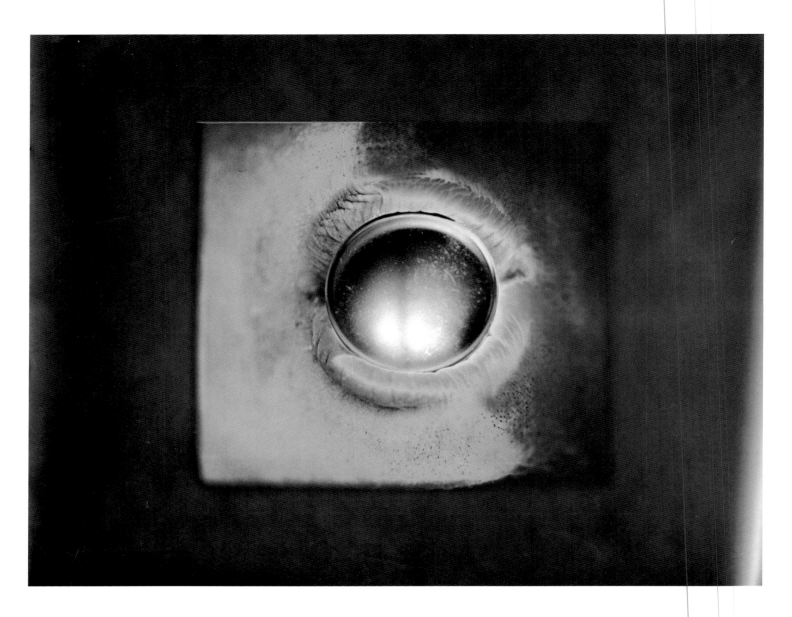

"Composite portraits are absolute quackery! What next, composite landscapes?"
The Photographic News, London, 1888

Lucas Samaras, opposite, is known for his extraordinary self-portraits, and in particular for his unusual manipulations of Polaroid photographs, (ab)using the chemistry in such a way as to unlock the creative possibilities of this unique medium, undreamt of by the manufacturer. Here Samaras imagines his face as a shifting field of expressions and emotions, like the surface of a planet too hot and airless for human life. Smouldering, changing direction, flaring into life, seething: only the all-seeing eye remains dead calm at the heart of the storm.

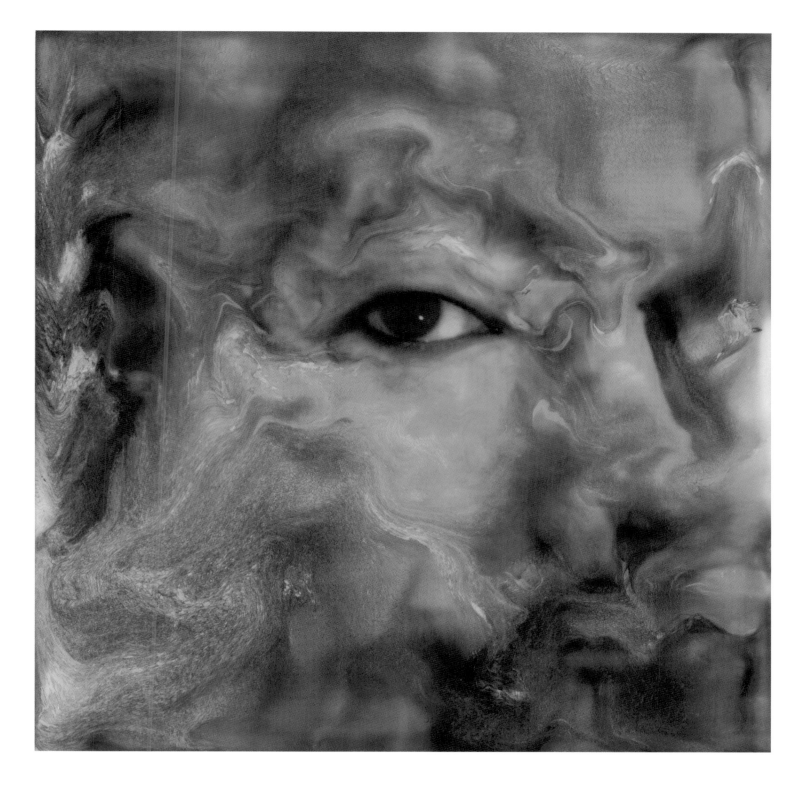

Lucas Samaras *Photo-Transformation* November 1, 1973
Ann Mandelbaum *Untitled #119* 1996

"A man gives himself the task of drawing the world. As the years go by, he fills a space with images of provinces, kingdoms, mountains, bays, ships, islands, fish, rooms, instruments, stars, horses and people. Just before he dies, he discovers that this patient labyrinth of lines is a trace of his own face."
Jorge Luis Borges, 1960

Mathieu Bernard-Reymond From the series 'Vous êtes ici' 2002

We often talk about the face as a kind of terrain – 'rugged', 'craggy' and so on – but Mathieu Bernard-Reymond has taken this literally. The little figure you see at the bottom of the picture is in the process of visiting a strange landscape: that of her own face. This has been scanned and fed into a software programme which renders the input as landscape. The result is a vast, desert-like space – uninhabited, except by its 'owner', whose face, turned and flattened, can be clearly seen in the middle of the picture.

NASA *Surface of Mars, Viking 1 Orbiter* July 25, 1976

Human radar is acutely sensitive to faces, and anything resembling a face in natural formations is sure to imprint itself instantly on the mind. The 'face of Jesus Christ', for example, is often seen in clouds or rock formations. Believers evidently have a clear mental image to begin with and, when the vague patterns or contours of natural forms align, the association is triggered. But it is only fitting that such a face discovered on another world should evoke majesty, monumentality – Ozymandias, King of Kings…. Anything to reassure that there is meaning and order in the universe and, best of all possible meanings, a universe with a human face!